THE ART OF
Flowers

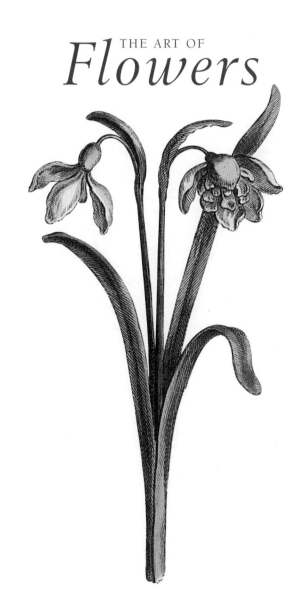

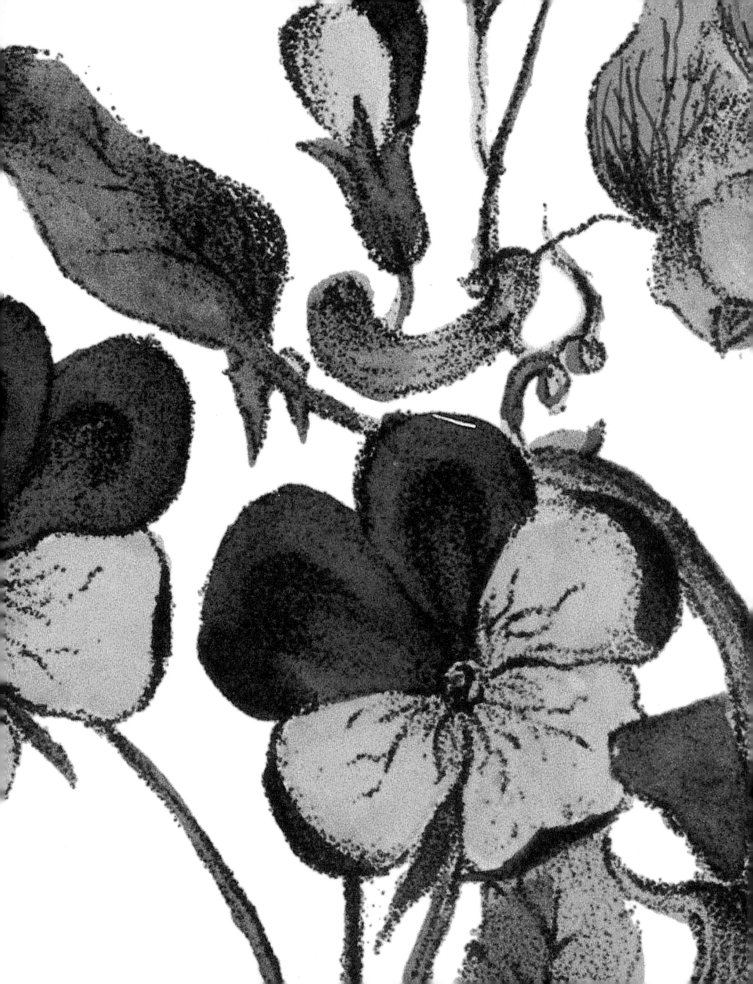

THE ART OF
Flowers

JACK KRAMER

Photography by Eric Strachan

WATSON-GUPTILL
PUBLICATIONS

NEW YORK

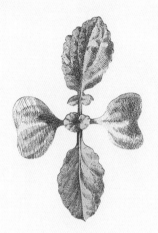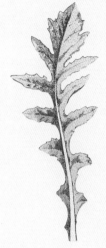

ABOVE: *Leaf forms by F. Edward Hulme*

OPPOSITE: *Daisies from* The Moral of Flowers, *edited by Rebecca Hey*

PAGE 1: *Single and double snowdrop by Augustin Heckle*

PAGES 2–3: *Detail of pansies attributed to Mrs. William Duffield but likely done by an anonymous artist (see also page 98)*

PAGES 6–7: *Assorted garden flowers by Augustin Heckle*

SENIOR ACQUISITIONS EDITOR: CANDACE RANEY
EDITORS: MARY BETH BREWER AND JULIE MAZUR
DESIGNER: ARETA BUK
PRODUCTION MANAGER: ELLEN GREENE
TEXT SET IN 11-PT. BERKELEY BOOK

SOME OF THE ILLUSTRATIONS APPEARING IN THIS BOOK FIRST APPEARED IN *WOMEN OF FLOWERS* (STEWART, TABORI & CHANG, 1996).

FIRST PUBLISHED IN 2002 BY
WATSON-GUPTILL PUBLICATIONS,
A DIVISION OF VNU BUSINESS MEDIA, INC.,
770 BROADWAY, NEW YORK, NY 10003
WWW.WATSONGUPTILL.COM

LIBRARY OF CONGRESS CATALOGING-IN-PUBLICATION DATA
KRAMER, JACK, 1927–
 THE ART OF FLOWERS / BY JACK KRAMER.
 P. CM.
INCLUDES BIBLIOGRAPHICAL REFERENCES (PP. 172–173).
 ISBN 0-8230-0311-6
 1. BOTANICAL ILLUSTRATION. 2. FLOWERS IN ART. I. TITLE.
QK98.2 .K73 2002
582.13'022'2—DC21

 2002003175

PRINTED IN CHINA

FIRST PRINTING, 2002

1 2 3 4 5 6 7 8 9 / 10 09 08 07 06 05 04 03 02

Who does not love a flower,

Its hues are taken from the light,

Which summer's sun flings pure and bright,

In scattered and prismatic hues.

That shine and smile in dropping dews,

Its fragrance from the sweetest air.

Its form from all that's light and fair—

Who does not love a flower?

BRAINARD, AS QUOTED IN *WILD FLOWERS OF AMERICA* (1859), BY MRS. C. M. BADGER

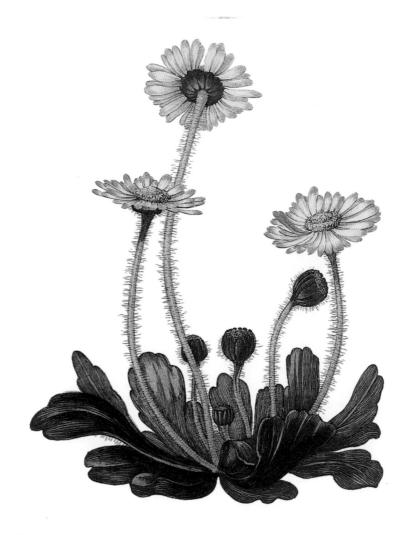

Contents

Artists Explain How to Draw Flowers 78

A Gallery of Artists 136

Preface

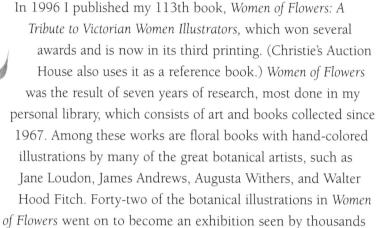

In 1996 I published my 113th book, *Women of Flowers: A Tribute to Victorian Women Illustrators,* which won several awards and is now in its third printing. (Christie's Auction House also uses it as a reference book.) *Women of Flowers* was the result of seven years of research, most done in my personal library, which consists of art and books collected since 1967. Among these works are floral books with hand-colored illustrations by many of the great botanical artists, such as Jane Loudon, James Andrews, Augusta Withers, and Walter Hood Fitch. Forty-two of the botanical illustrations in *Women of Flowers* went on to become an exhibition seen by thousands at botanical gardens throughout the United States. The popularity of the book and this exhibition, along with the increasing numbers of classes being offered in botanical art at various arboreta, is evidence of a definite renaissance of the craft.

Tulips, by Clarissa Badger, from Floral Belles from the Green-House and Garden *(1867)*

During the Victorian era, dozens of beautiful books (known as *florilegia*) appeared, depicting flowers from orchids to tulips, as well as hundreds of how-to-draw-and-paint flower books filled with colored and uncolored illustrations and explanatory text. Some of these nineteenth-century volumes are in my library and form the basis for this new work, *The Art of Flowers,* intended to explain why and how the work of these botanical artists manages to maintain its popularity today. My focus here is on eighteenth- and nineteenth-century botanical artists; I do not address contemporary artists or landscape botanical artists.

Please note one caveat concerning the publication dates of books cited in this work. Flower books of the nineteenth century and earlier were often issued in parts; other times a book's illustrations were published ahead of its text, or vice-versa. As a result, the publication of one book often spanned several years. I acknowledge this by providing ranges instead of individual years where appropriate.

The Art of Flowers is an inspirational book rather than a how-to-draw work, although I do touch on the latter subject. It is my effort to bring to you the golden age of botanical art, as well as the artists who contributed to that era and the methods they used. I hope it succeeds in opening the door to fledgling artists and flower lovers everywhere.

Acknowledgments

The Art of Flowers involves research done since 1986, so thanks goes to the several librarians at various institutions who answered my questions about botanical art. Also thanks to horticultural antiquarian book dealers such as Jim Hinck from Hinck and Wall in Washington, D.C., and Brad Lyon and Joanne Fuccello, both of whom volunteered their knowledge on the subject. I would also like to thank Candace Raney of Watson-Guptill Publications, who immediately grasped the premise of this work.

For their advice and suggestions I owe gratitude to Neil Soderstrom and Julie Mazur, my editor, who read and reread my copy. Jan Deas gets a big vote of thanks for computing various revisions of this manuscript. And to Eric Strachan, photographer, my special gratitude for his excellent work.

A special thanks to Benjamin Witsler for the German translation of *Blumenmalekunst*.

Most of all, my thanks go to the fine botanical artists of the nineteenth century, whose books I treasure in my personal library. And finally, to the several arboreta and gardens in the United States where my *Women of Flowers* exhibit of nineteenth-century illustrations has appeared, my most heartfelt gratitude.

Detail of Clematis, by Charlotte Caroline Sowerby

INTRODUCTION
Flowers for Everyone

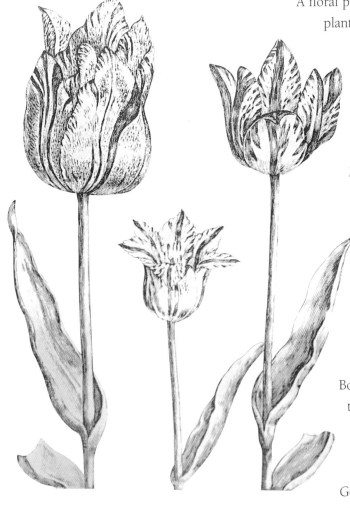

A floral portrait, however crudely drawn, can identify a plant better than words. In the great early herbals, woodcuts of plants were the main sources of illustration, and the floral pictures were colored by hand. In 1614, in his work *Hortus Floridus*, the Dutch engraver Crispin de Passe published detailed text on how to color plates of flowers. *Curtis's Botanical Magazine* used hand-colored portraits until 1848, though color printing processes had been perfected decades earlier. In the 1700s, the truly illustrated flower book developed, and it was in the first half of the nineteenth century that flower books blossomed by the hundreds—artists, engravers, and printers could now do full justice to an image.

Today there is a renaissance of botanical art. Botanical gardens throughout the United States teach courses, and the demand for botanical illustrations from the art's golden age is increasing. Framed flower pictures by masters such as Pierre-Joseph Redouté, Georg Ehret, and Jane Loudon are favorites among interior designers. This appreciation of plants and flowers in the new millennium harks back many centuries. The wealth of flower books—sentimental language-of-flower books, how-to-paint flower books (known as copy books), and florilegia—and periodicals comprise a great heritage. Some information about famous artists exists but there is little about how these artists accomplished their fine botanical art.

Here we present information on many artists, as well as a fascinating look at language-of-flowers books, and copy books that indicated, step by step, how the drawings were composed—information seldom available since it first appeared centuries ago. I hope this work fills the void.

Uncolored tulips from Crispin de Passe's Hortus Floridus, *the English version of which came out in 1614. Instructions were provided for readers to color the plates themselves.*

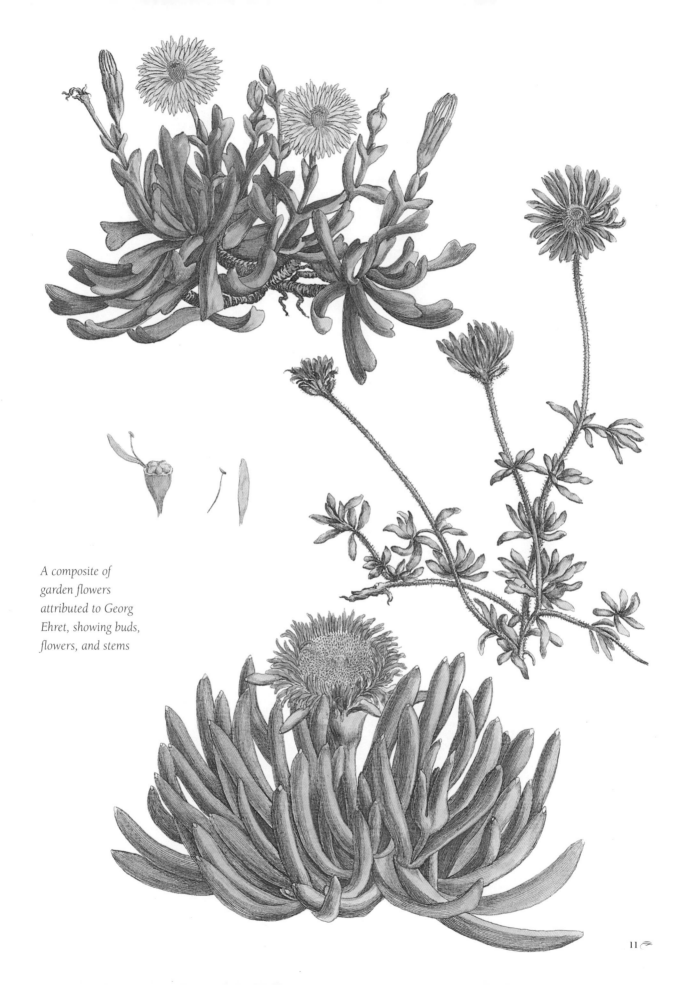

A composite of garden flowers attributed to Georg Ehret, showing buds, flowers, and stems

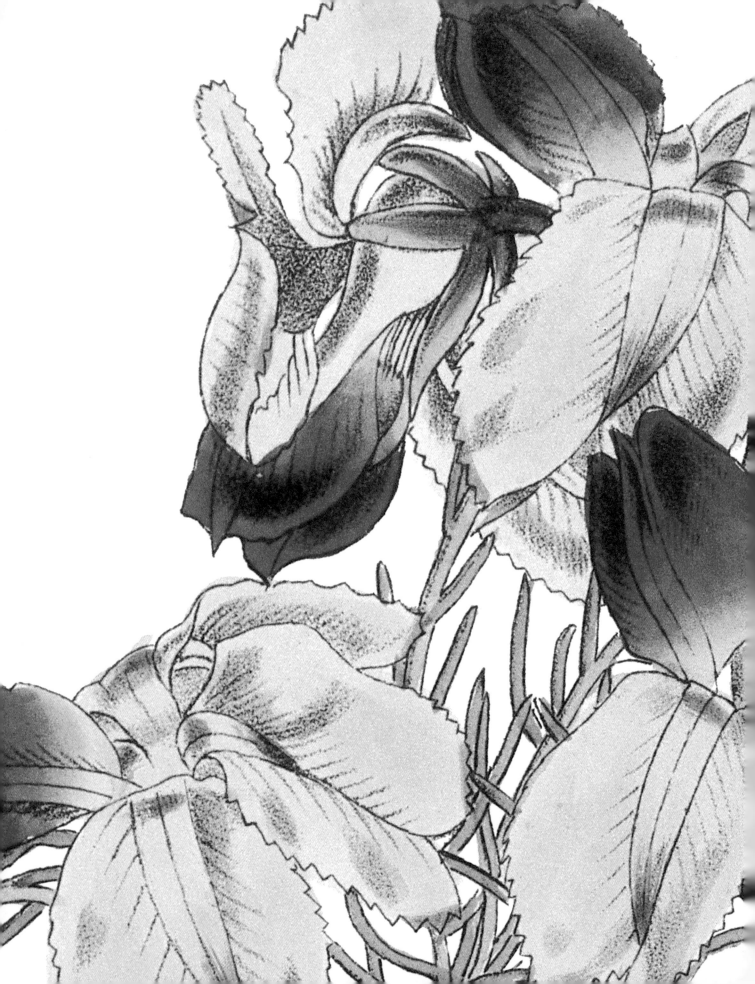

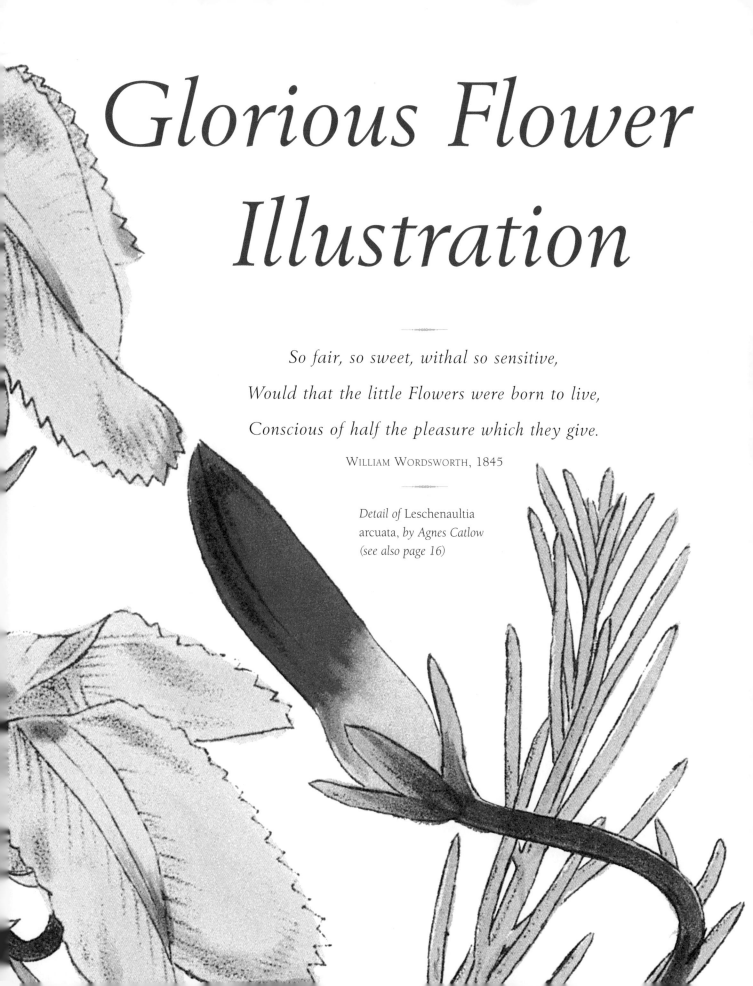

Glorious Flower Illustration

So fair, so sweet, withal so sensitive,
Would that the little Flowers were born to live,
Conscious of half the pleasure which they give.

WILLIAM WORDSWORTH, 1845

Detail of Leschenaultia
arcuata, *by Agnes Catlow*
(see also page 16)

The Victorian credo was that God created perfect beauty when he created flowers. In this sense, the artist competes with perfection when trying to represent flowers. A fresh, live flower is an artist's best teacher—and best inspiration.

As many botanical artists have found, drawing plants that have been dried can be extremely difficult. Their colors have faded, their petals withered, the stems have lost their vigor. A flower that was once brilliant crimson with lush petals, borne on a vivid green stem, may look pale, with tissuelike petals and a grayish-green stem. The glory of the flower is simply lost. Yet until the nineteenth century, dried specimens were generally all that artists had available most of the year. Even when artists had the luxury of working with fresh flowers, cuttings were perishable, often losing their form and color faster than an artist could work—a challenge that remains true today.

Indeed, early floral art shows that accuracy was generally lost in the process of reproduction. Woodcuts of medicinal plants in herbals of the sixteenth and seventeenth centuries, such as those of George Culpepper, William Salmon, and John Hill, were primitive and usually inaccurate. Ironically, these illustrations were intended for identification purposes. This type of botanical illustration continued into the nineteenth century, side by side with what would become a growing appreciation for flowers and a quest for botanical accuracy: Artists began appreciating that to capture a flower's original beauty, they had to understand how the plant looked when it was living.

In the early eighteenth century, the English became increasingly interested in flowers, despite the fact that their system of identification was imprecise. Different scientists used different names for the same plant, making it difficult to communicate accurately. This changed forever in 1735, when the Swedish naturalist Carl Linnaeus created a unified system for classifying living things. Each plant or animal was given a binominal made up of a genus name and a species name.

Linnaeus's system increased the demand for plants and helped lay the foundation for the great age of Victorian floral art. Scholars, growers, and merchants now wanted botanical illustration to be as accurate as possible. To become a great botanical artist, it was necessary to understand and appreciate the general form, color, and texture of the entire plant. Stems and leaves have an infinite variety of shapes and designs, and capturing them correctly became vital. Armed with both drawing skills and a grasp of botany, artists could create exquisitely detailed flower replicas in vellum and on paper and canvas. As interest in botany grew, flowers—long associated with beauty and intense religious significance—became increasingly important to a widening audience.

Even by the late eighteenth century, the illustrations in many herbals were meant to identify plants and flowers, not to depict their beauty. These illustrations come from Jean-Emmanuel Gilibert's Histoire des Plantes d'Europe ou Elements de Botanique Pratique *(1798).*

BOTANY BOOKS

By the mid-nineteenth century, books exploring botany became extraordinarily popular. In 1840, Mrs. E. E. Perkins, a well-known professor of botanical painting at Chelsea, illustrated James H. Fennell's *Drawing Room Botany,* dedicating it to Jane Loudon, one of the most successful botanical artists of the time. Perkins urged students to understand the structure of plants and flowers if they hoped to illustrate them accurately, a concern shared by other botanical artists. Pictured below and on pages 17 through 21 are images from some other exceptional volumes of the time.

Agnes Catlow did a series of botanical books, including Popular Garden Botany *(1855) and* Popular Greenhouse Plants *(1857), but has been given little credit for her contribution to botanical art. This drawing of* Leschenaultia arcuata *is both detailed and attractive.*

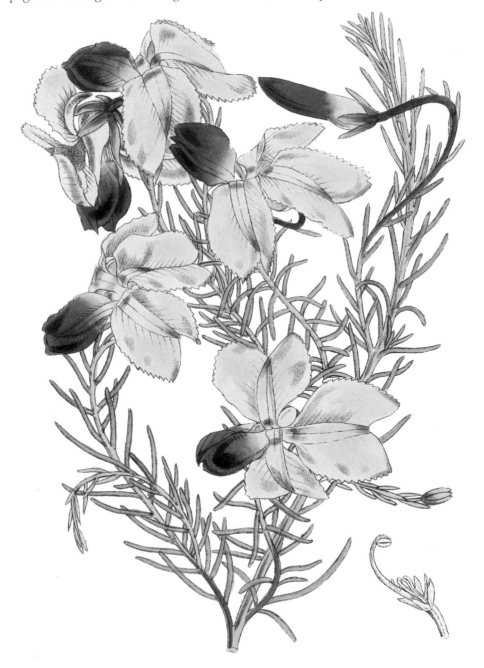

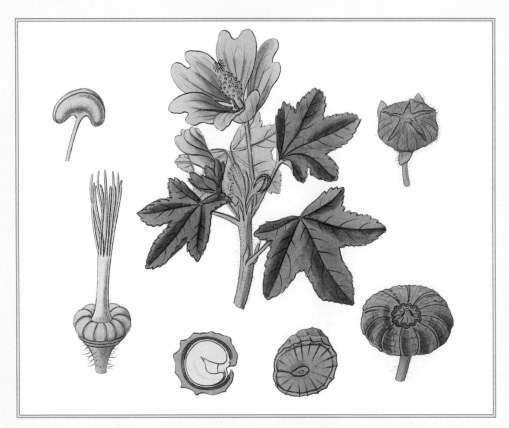

Sarah Anne Drake was a prolific artist who contributed to dozens of books. Here are two detailed sectional drawings done for John Lindley's Ladies Botany (1865). The illustration on top is from the mallow group (the larger mallow); the one below is from the orange tribe (the sweet orange).

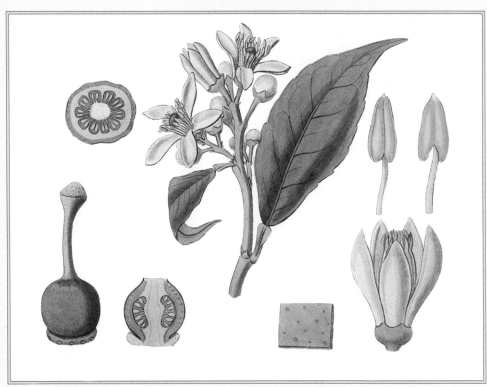

Priscilla Wakefield's An Introduction to Botany in a Series of Familiar Letters (1798) was an extraordinarily popular book written in the form of letters to children. Its illustrations show various parts of plants, clearly indicating how flowers are formed.

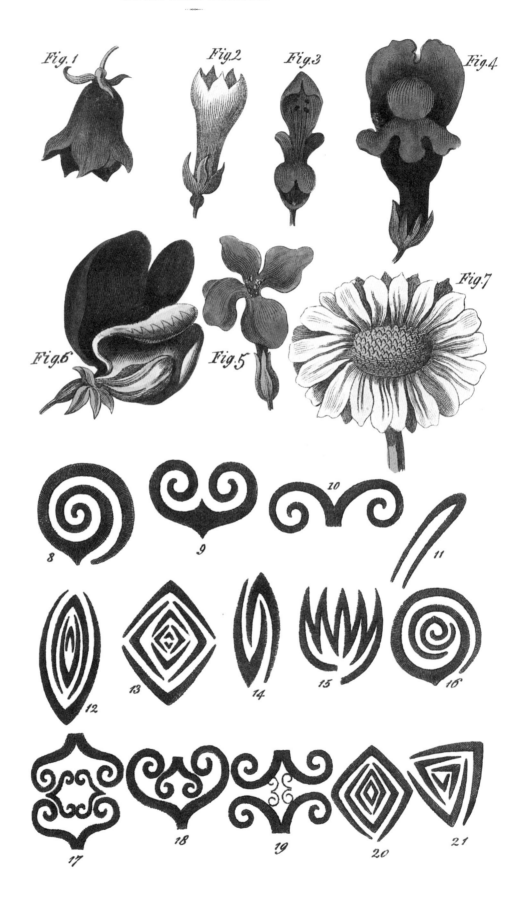

Hilda Margaret Godfrey, a trained botanist, drew plates for her husband's book Monograph and Iconograph of Native British Orchidaceae, *published in 1933 after her death. Though her husband, John Masters, was the contemporary authority on British and European orchids, the book may never have attained as much prominence as it did without Godfrey's superior illustrations, such as this one of* Orchis militaris *(soldier orchid).*

CROCUS LUTEUS GARDEN CROCUS

Under the grey drift of the town

The crocus works among the mould

As eagerly as those that crown

The Warwick spring in flame and gold.

JOHN DRINKWATER

VINCA MAJOR GEUM URBANUM

PELARGONIUM TOMENTOSUM

CONVALLARIA MAJALIS POTENTILLA ANSERINA

VIOLA TRICOLOR

SOLANUM TUBEROSUM

VERBASCUM THAPSUS SAMBUCUS NIGRA

In his book Plants: Their Natural Growth
*(1874), F. Edward Hulme delineates the
parts of plants—from stems, to leaves, to
flowers.* ABOVE: *detailed work on* Crocus
luteus *(garden crocus);* RIGHT: *flower forms;*
OPPOSITE: *leaf forms.*

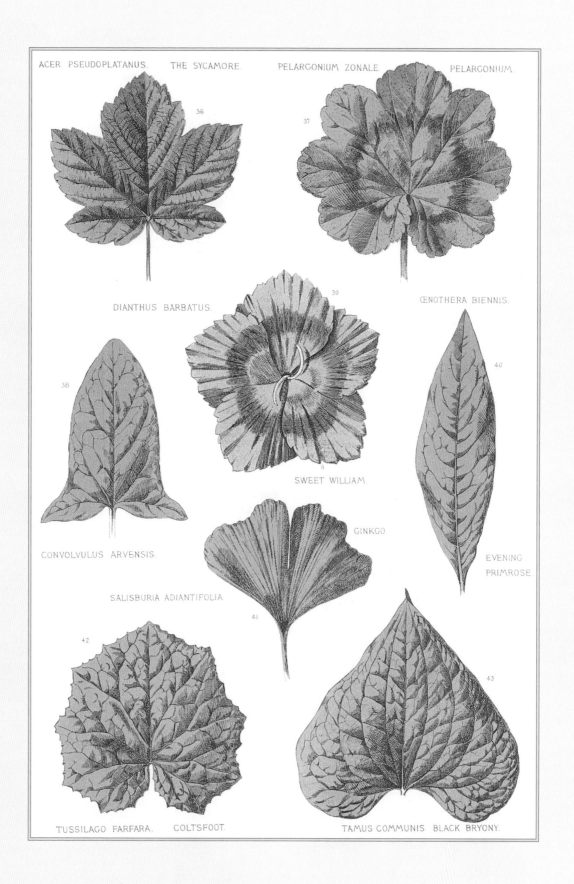

ACER PSEUDOPLATANUS. THE SYCAMORE. PELARGONIUM ZONALE. PELARGONIUM.

DIANTHUS BARBATUS. ŒNOTHERA BIENNIS.

SWEET WILLIAM.

CONVOLVULUS ARVENSIS. GINKGO EVENING PRIMROSE.

SALISBURIA ADIANTIFOLIA

TUSSILAGO FARFARA. COLTSFOOT. TAMUS COMMUNIS BLACK BRYONY.

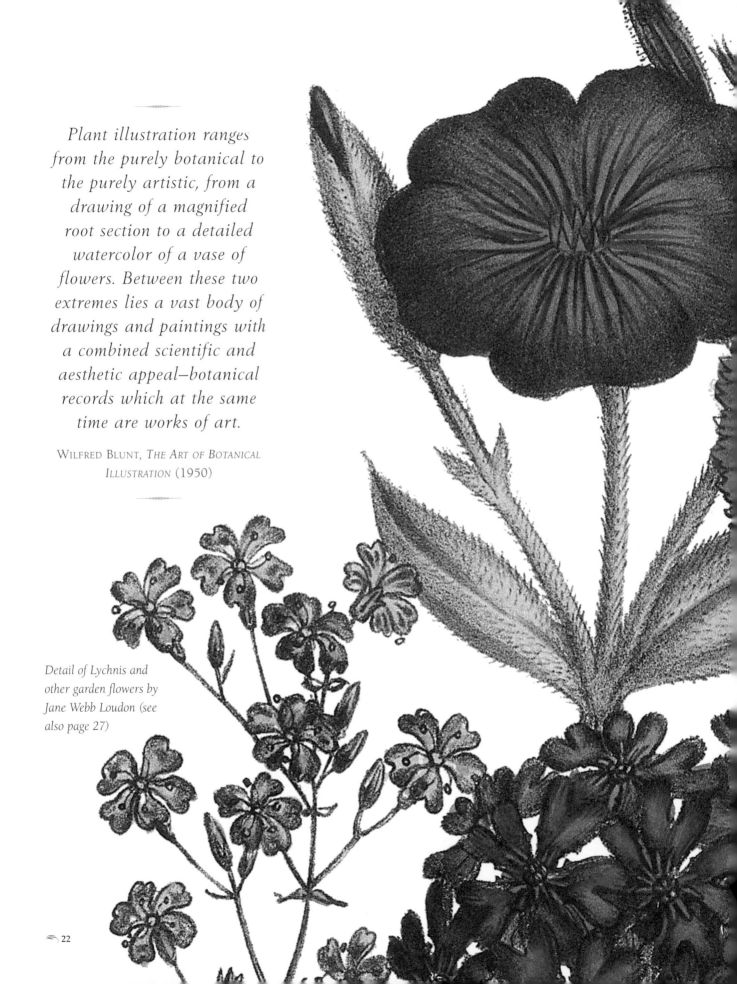

Plant illustration ranges from the purely botanical to the purely artistic, from a drawing of a magnified root section to a detailed watercolor of a vase of flowers. Between these two extremes lies a vast body of drawings and paintings with a combined scientific and aesthetic appeal—botanical records which at the same time are works of art.

WILFRED BLUNT, *THE ART OF BOTANICAL ILLUSTRATION* (1950)

Detail of Lychnis and other garden flowers by Jane Webb Loudon (see also page 27)

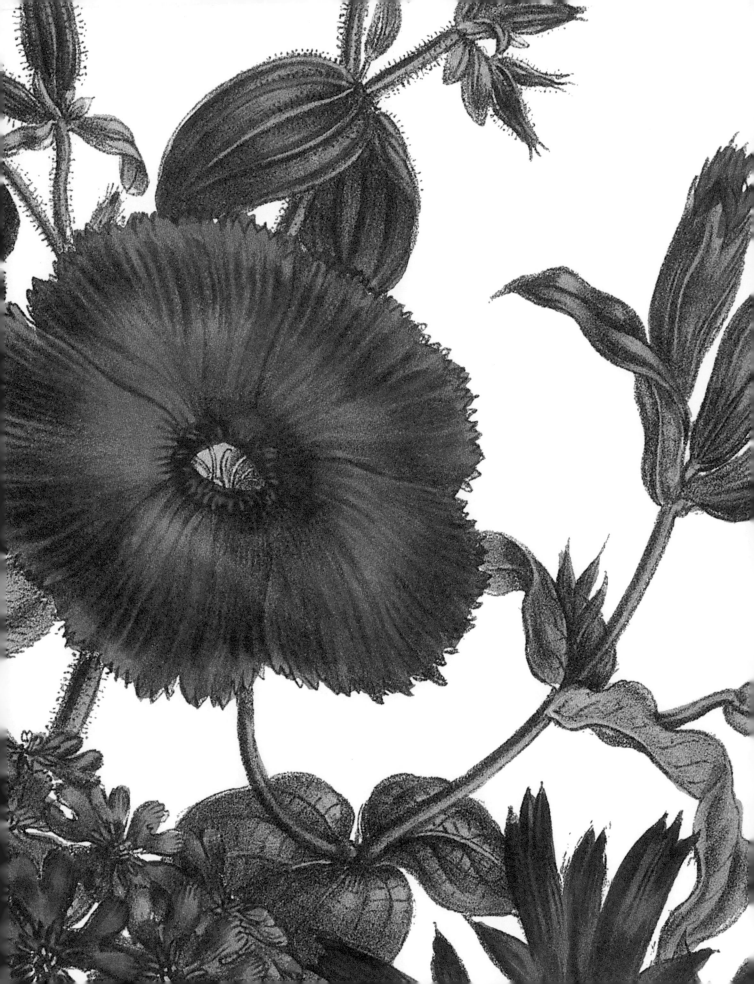

FLORILEGIA

In 1787, *Curtis's Botanical Magazine* was launched in London; soon, flowers became acceptable in their own right as artistic subject matter, not simply as elements in still-life painting. In fact, decorative flower painting became the more popular of the two genres. Flowers were glorified in *florilegia*, large picture books by artists such as Pierre-Joseph Redouté and Georg Ehret.

The calyx is nothing but the swaddling clothes of the flower, the child-blossom is bound up in it.

JOHN RUSKIN

Considering how beloved floral illustration has become, it should be remembered that as late as the early 1800s, many noted authorities held floral art in low regard. Sir Joshua Reynolds, founder of England's Royal Academy, declared that no mature artist should waste his time on flowers. Fortunately, others argued that flowers were aesthetically of interest and ideal for painting. The English critic John Ruskin, for example, believed that artists avoided flowers as subjects because they were difficult to paint, not because they were not worth painting.

RIGHT: *Pierre-Joseph Redouté was known as the "Raphael of roses," but he also did other plants, such as this succulent Mesembryanthemum (aloe). Redouté's depictions show botanical accuracy with a decorative touch.*

OPPOSITE: *A bouquet of fritillaria out-standing and shrubs in the foreground, rendered by Louisa Anne Twamley*

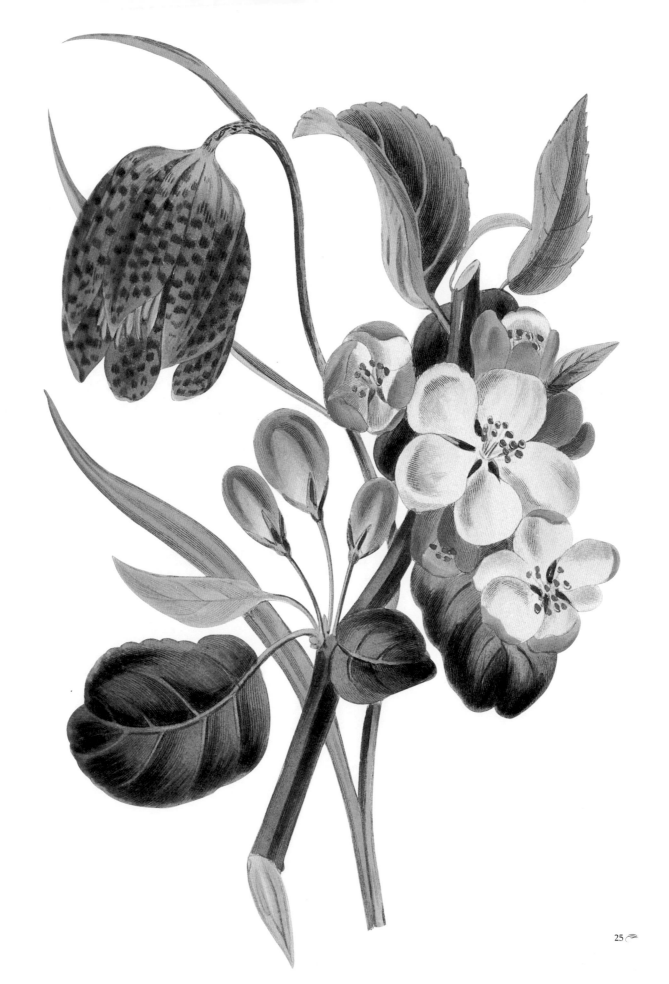

As the florilegia came into prominence, artistic effect became increasingly important. Prior to this, in most horticultural periodicals of the nineteenth century, plants were drawn to introduce them to would-be gardeners; neither publishers nor readers expected decorative art. Now, however, it was no longer enough for an illustration to simply resemble a flower; it had to *be* the flower, to serve as both an aid for identification and an aesthetic celebration of its beauty. The elements of composition—perspective, balance, shape, horizontal and vertical space, mass, line, and color— became critical to capturing the essence of a flower. Though publishers hoped for both beauty *and* accuracy in their botanical illustrations, some artists went to extremes—making a leaf longer or shorter, perhaps enlarging a flower—to create more beautiful overall pictures.

Jane Webb Loudon (1807–1858) was a master of botanical art, no doubt thanks in part to her knowledge as a gardener. Equally important was that as an artist, she possessed great knowledge of composition and could picture the finished drawing in her mind. Like Loudon, Walter Hood Fitch (1817–1892) was acquainted with the earth as well as being a skilled artist with an innate understanding of composition and floral form.

Walter Hood Fitch is especially noted for the many illustrations he did for Curtis's Botanical Magazine. *Able to visualize a flower in his mind's eye, Fitch produced exceptional art.*

Both Loudon and Fitch superbly balanced vertical and horizontal space. Squint your eyes and look at the negative and positive spaces in their designs, shown above and opposite. The best compositions are never strictly horizontal or vertical, but contain elements of both. Loudon and Fitch position their subjects perfectly to keep you within the frame of the picture. And the strong colors they use add to the beauty of their works.

The development of the camera led some to believe that photographs would replace the work of botanical illustrators. But artists soon came to see that although the camera could capture a flower accurately, it could not select what it wanted to show, or reposition parts to more clearly convey the precise physical makeup of a plant. Botanical illustration was a necessary art unto itself—one that only an artist could capture first hand—and was about to launch into full bloom.

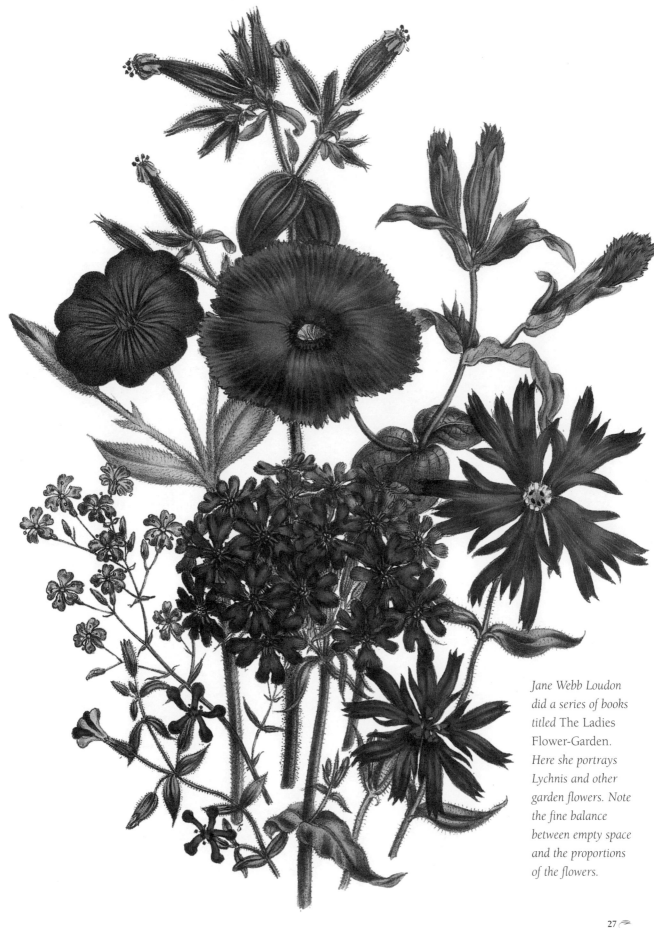

Jane Webb Loudon did a series of books titled The Ladies Flower-Garden. Here she portrays Lychnis and other garden flowers. Note the fine balance between empty space and the proportions of the flowers.

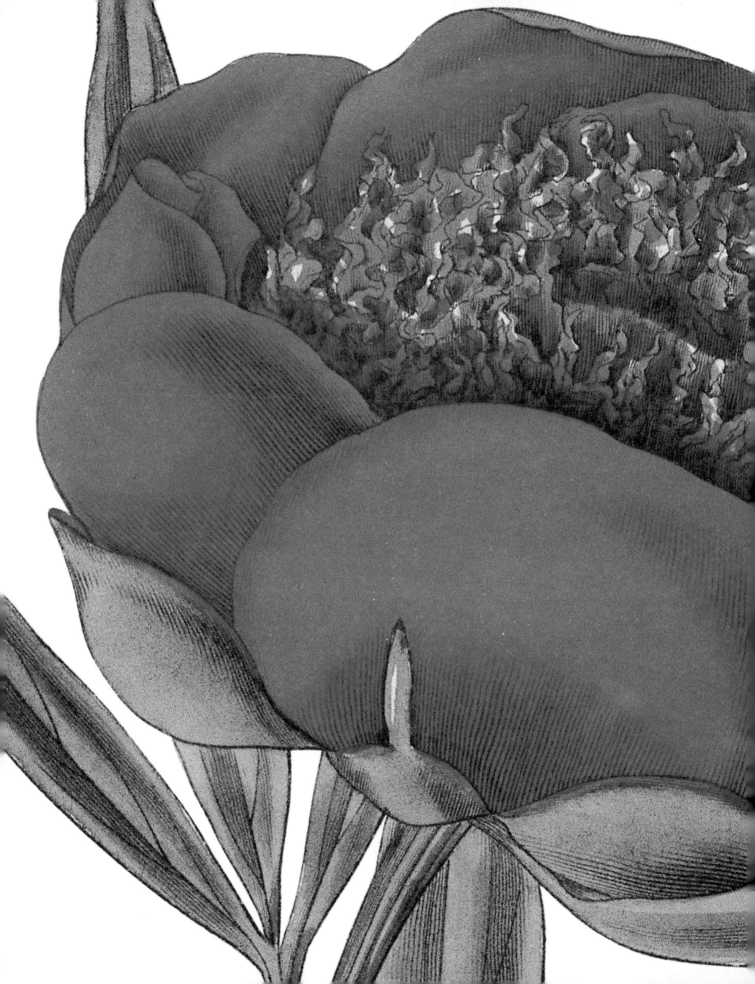

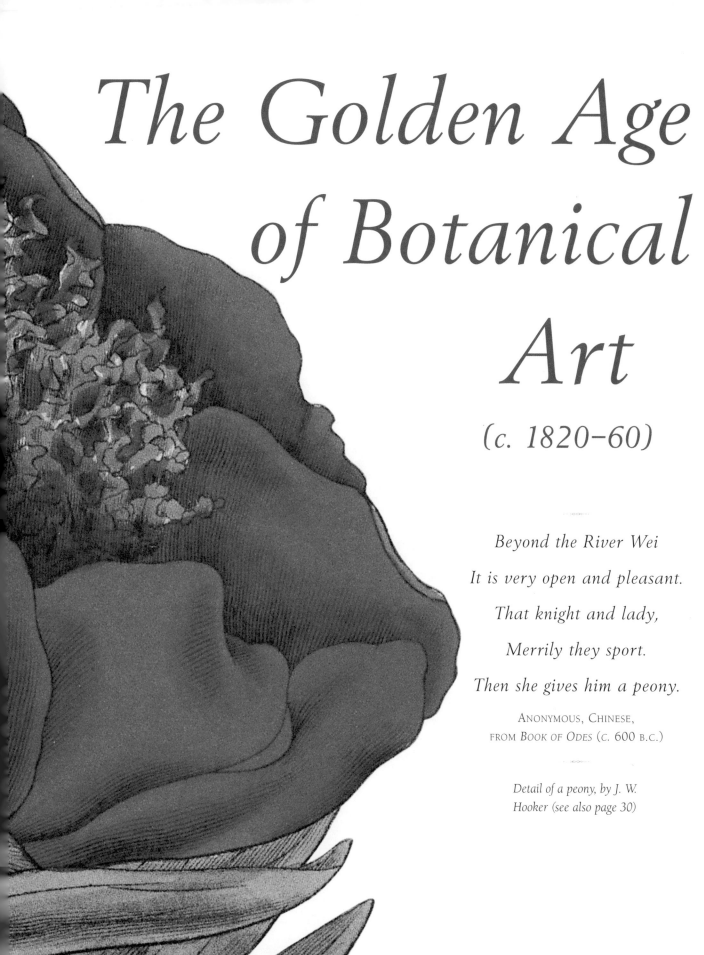

The Golden Age of Botanical Art

Art

(c. 1820–60)

Beyond the River Wei

It is very open and pleasant.

That knight and lady,

Merrily they sport.

Then she gives him a peony.

ANONYMOUS, CHINESE,
FROM BOOK OF ODES (C. 600 B.C.)

*Detail of a peony, by J. W.
Hooker (see also page 30)*

Exotic plants were the mainstay of the golden age of botanical art. The peony, illustrated here by J. W. Hooker, caused a sensation when it was introduced into cultivation in the mid-nineteenth century.

Although exploration for new plants began in the fifteenth and sixteenth centuries, it wasn't until the 1700s that interest in plants from exotic lands heightened. The eighteenth and nineteenth centuries were immensely exciting times for plant lovers. Plants from South and North America, Australia, the East and West Indies, South Africa, Japan, Italy, Spain, India, and other countries were brought into cultivation in Europe. Royalty, the nobility, and the wealthy contributed to this exploration, supporting the horticultural extravaganza for philanthropic reasons and because of its prestige.

It was essential that the new plants being seen and collected were accurately recorded. Since live plants could seldom withstand the rigors of a lengthy journey back to Europe, botanical artists often accompanied plant explorers to record them in the field. Artists—too many to mention, including famous ones such as the Bauer brothers—accurately portrayed the intriguing plant life discovered on these expeditions. Back in England, the taste for exotic flowers soon eclipsed that for native garden flowers.

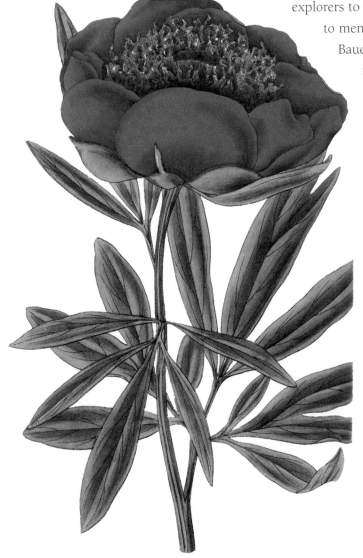

As flowers began to be cultivated more for their beauty rather than for their medicinal and culinary value, appreciation for them became the vogue. The most important devotees of botanical art in England at this time were well-bred ladies. Those of privilege had unlimited time and money to devote to gardening, and they pursued flower art with fervor. The lore of flowers, their secrets and legends, and a new "language" of flowers filled their often-idle hours. Flowers appeared everywhere—on wallpaper, in embroidery, on clothing. George III and Queen Charlotte took a keen interest in flowers. In the royal household and in great manor houses throughout the land, books filled with exquisite, exotic flower portraits were prominently displayed in

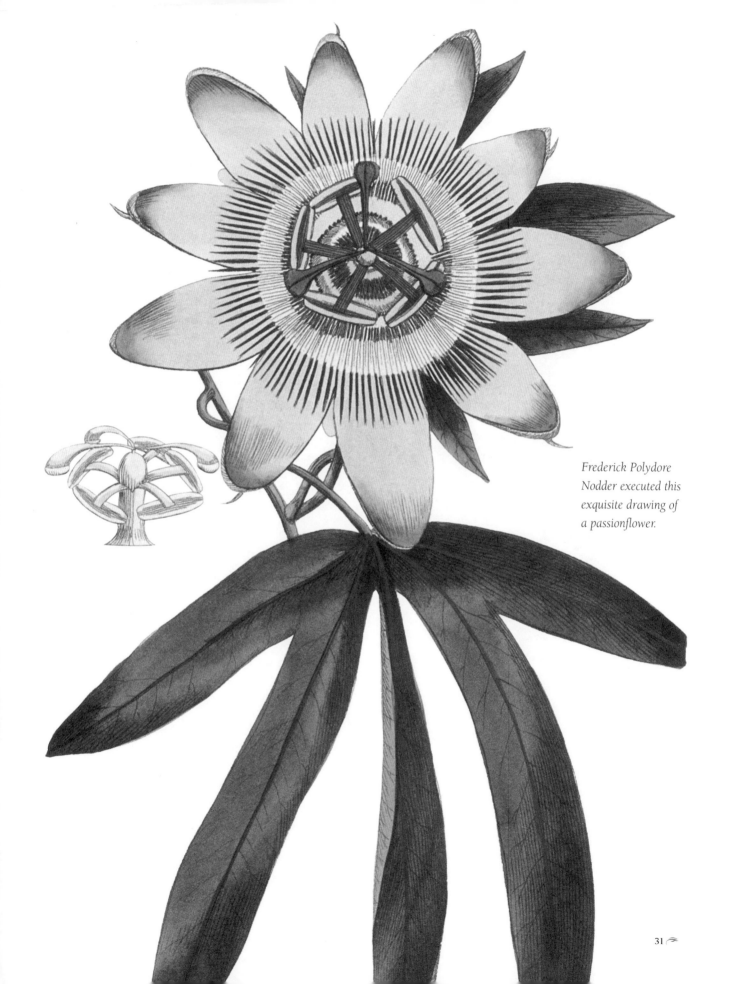

Frederick Polydore Nodder executed this exquisite drawing of a passionflower.

libraries and drawing rooms. At the Château La Malmaison, near Versailles, the French Empress Josephine created a magnificent garden filled with rare plants imported from all parts of the world. Josephine became the patron of Pierre-Joseph Redouté, who would become known as a genius of botanical art.

When Victoria ascended the throne in 1837, England's passion for flowers reached new heights. By this time, advances in printing and technology were making illustrated books more affordable, allowing larger segments of society to enjoy colorful images of exotic plants. Prior to this time, from about the start of the eighteenth century, color plates had been engraved on copper, printed, and then colored by hand. Lithography, invented in 1798, became widespread in about 1830 and was both cheaper and quicker than engraving. By the end of the nineteenth century, chromolithography became the preferred process, which was even less expensive and did not require coloring by hand, although hand coloring was still done. The process lost some of the artistry of the original hand-colored illustrations, but still afforded adequate, and sometimes even beautiful, floral renditions.

In her day, Rebecca Hey was considered a moralist rather than a botanical artist. She commissioned William Clark, a prolific and very competent artist of the time, to illustrate violets for her popular book The Moral of Flowers (1833).

The mid-nineteenth century is now known as the golden age of botanical art. Flowers became an everyday part of Victorian life; drawing rooms and fireplaces were richly adorned with nature's bounty. There were "dials of flowers" (also known as floral clocks), which told time depending upon when the flowers opened or closed, and birthday books featuring flowers. Flower calendars gave the reader an inkling as to her lover's "flower sign." Floral playing cards appeared, and are available again today, with varying species featured on the front of the cards.

England's love for all kinds of flowers became an obsession, shared by both men and women. With the advent of greenhouses (then called conservatories), men, too, began growing exotic flora. There was a competitive spirit: People vied to see who could cultivate the rarest specimens. No respectable estate was without a conservatory. They were not only stylish, but were considered educational as well. Almost every family, even those with little means, dabbled in plants to some extent.

The Royal Botanical Gardens at Kew opened to the public early in Victoria's reign. Sir William Jackson Hooker, a keen observer of nature, became its director in 1841. Under Hooker's direction, the gardens were expanded from eleven to almost six hundred acres; he wanted all Londoners to view nature to the fullest and enjoy the garden's expanding collection of exotic plants. In 1848, Hooker completed Kew's Palm House, an impressive glass structure that, with its never-before-seen exotic plant life, became a major attraction. The Palm House inspired major interest in plants, and flowers became a necessary part of living.

Drawing flowers was thought to be a healthful pastime and an opportunity to share God's pure bounty. The era's romantic view of natural beauty had made its mark upon theology— for some, a love of nature was elevated to a form of worship known as Pantheism, exemplified in the poems of Wordsworth and the writings of Rousseau.

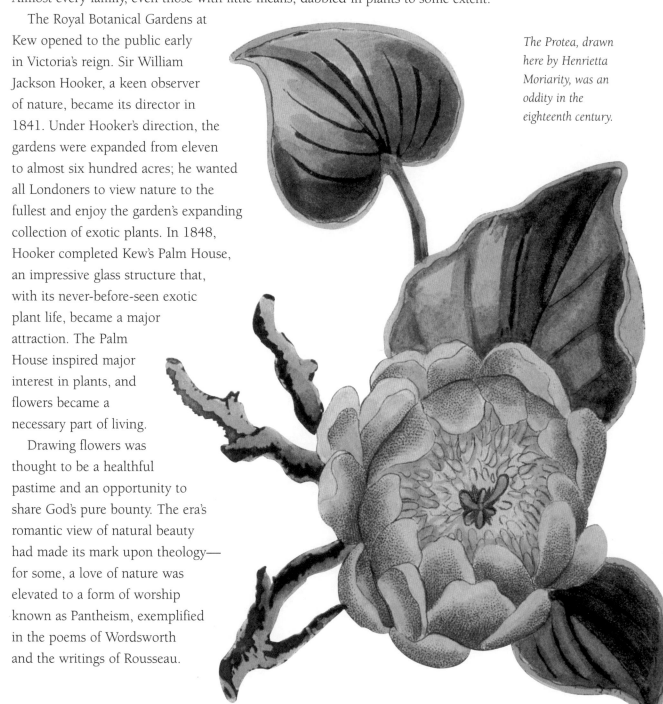

The Protea, drawn here by Henrietta Moriarity, was an oddity in the eighteenth century.

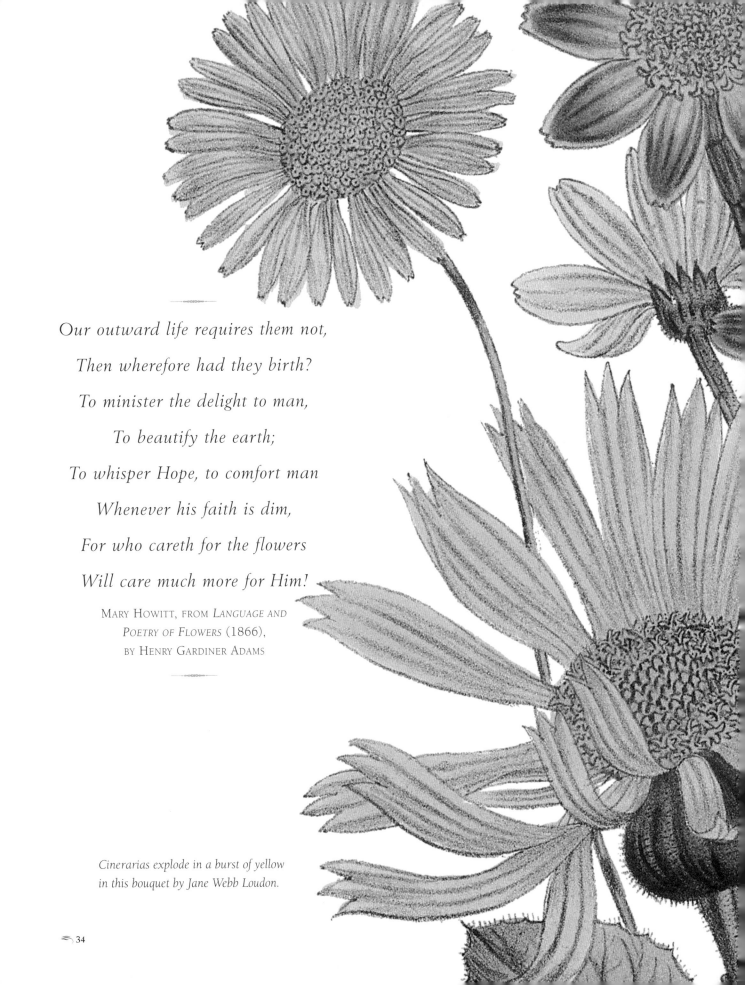

Our outward life requires them not,

Then wherefore had they birth?

To minister the delight to man,

To beautify the earth;

To whisper Hope, to comfort man

Whenever his faith is dim,

For who careth for the flowers

Will care much more for Him!

MARY HOWITT, FROM *LANGUAGE AND POETRY OF FLOWERS* (1866), BY HENRY GARDINER ADAMS

Cinerarias explode in a burst of yellow in this bouquet by Jane Webb Loudon.

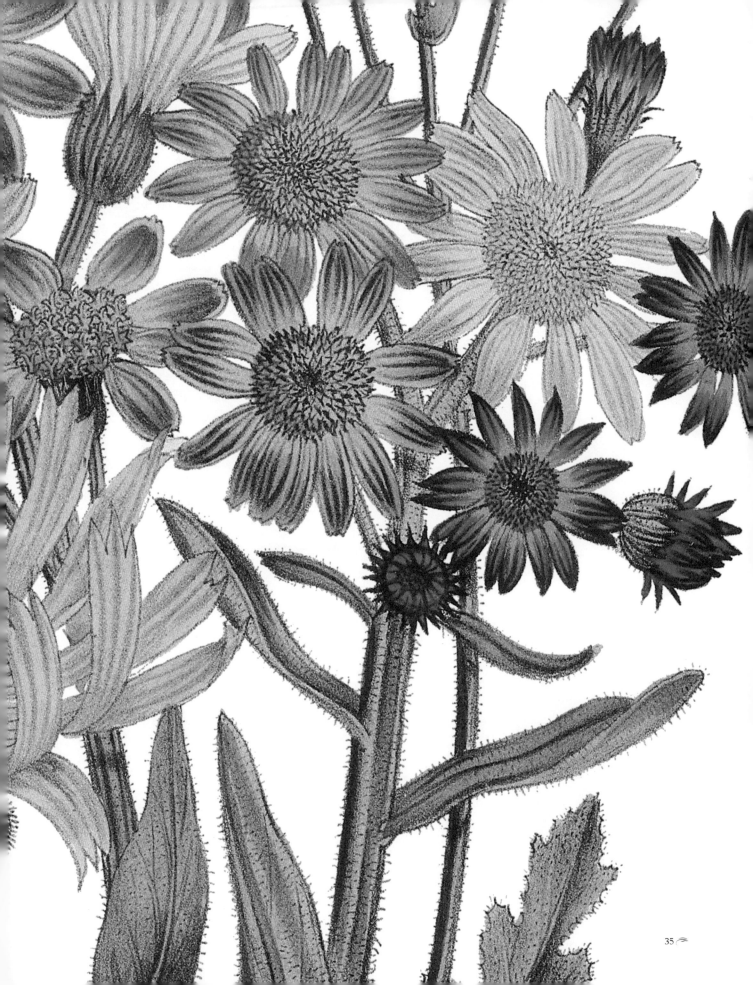

BOTANICAL MAGAZINES AND PERIODICALS

Along with the increase in illustrated books, an explosion of botanical magazines and periodicals in the mid-nineteenth century helped rush England into bloom. With so many floral forces at work, scores of artists drew all kinds of flowers, from orchids to geraniums, keeping floral art blossoming week by week and month by month. So great was the demand for information about plants—especially rare and exotic species—that within one fifty-year span, from approximately 1790 to 1840, thirty-five botanical magazines debuted. Some ran for only a few volumes, others for thirty or more.

Botanical magazines and periodicals that first appeared in the eighteenth century took off in the nineteenth century. It was truly the golden age of flowers and gardens. A look through William Curtis's famous *Curtis's Botanical Magazine* (still in print) as well as a perusal of, for example, Benjamin Maund's *Botanic Garden* and *The Botanist,* clearly indicate that the illustrations were what separated the good publications from the bad.

Curtis's Botanical Magazine was the earliest botanical magazine, first published in 1787. Its purpose was to satisfy requests from members of botanical gardens who wanted to know about plants being introduced to England and how to grow them. Today, hand-colored plates from early issues of this magazine are much sought after. Many of the plates are unsigned, but in my copies the name Sydenham T. Edwards clearly appears in the lower-right or -left margins of drawings 147 to 162. From plate 163 to plate 233 there is no signature, but from plates 234 to 243 the name Sydenham Edwards appears again. Thus Edwards did almost all the work for the magazine's first twenty-eight years, with Francis Sansom as engraver. Some of the unsigned drawings in the periodical's first volume were the work of James Sowerby and William Kilburn. Curtis himself supposedly also contributed.

Sydenham Edwards, carnations, from Curtis's Botanical Magazine

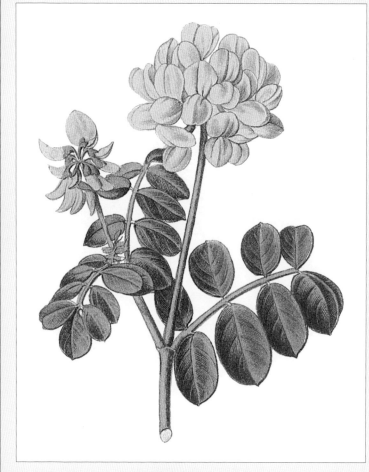

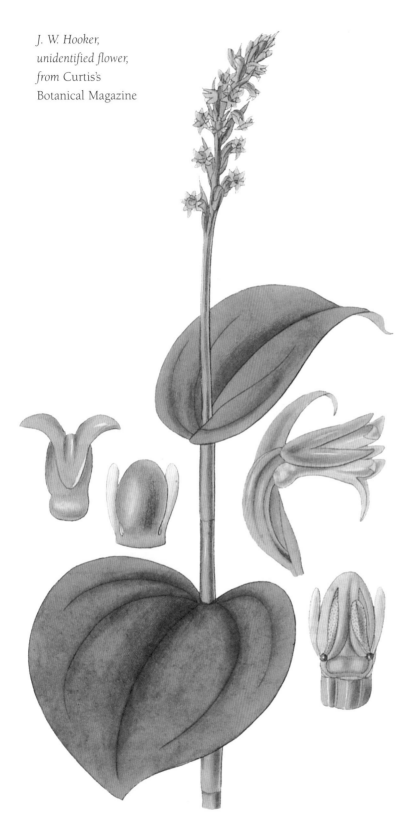

*J. W. Hooker,
unidentified flower,
from* Curtis's
Botanical Magazine

In 1815, Edwards left *Curtis's Botanical Magazine* and started his own publication, *The Botanical Register,* which sold well until 1847. In fact, Edwards's publication did so well that it pulled many readers away from *Curtis's Botanical Magazine. The Botanical Register* was noted for its fine drawings and accurate text: Perfection was Edwards's watchword.

After Edwards left *Curtis's Botanical Magazine,* John Curtis (no relation) and William Herbert executed the periodical's drawings until Sir William Jackson Hooker took over the magazine in 1826. In 1841, when Hooker became director of the Royal Botanic Gardens at Kew, *Curtis's Botanical Magazine* and the gardens became closely aligned. Although first thought of as a ladies' drawing book, the magazine's emphasis on botany quickly made it reputable among scholars. In 1834, Walter Hood Fitch replaced Hooker at the magazine, soon becoming its only draftsman. After 1845, Fitch also served as lithographer.

Fitch left *Curtis's Botanical Magazine* in 1877. After that, several artists did drawings for the magazine; Matilda Smith did many illustrations, with John Nugent Fitch, Walter's nephew, doing the lithography. Both Fitches—equally talented and fine draftsmen—deserve a great deal of credit for the quality of the magazine's drawings.

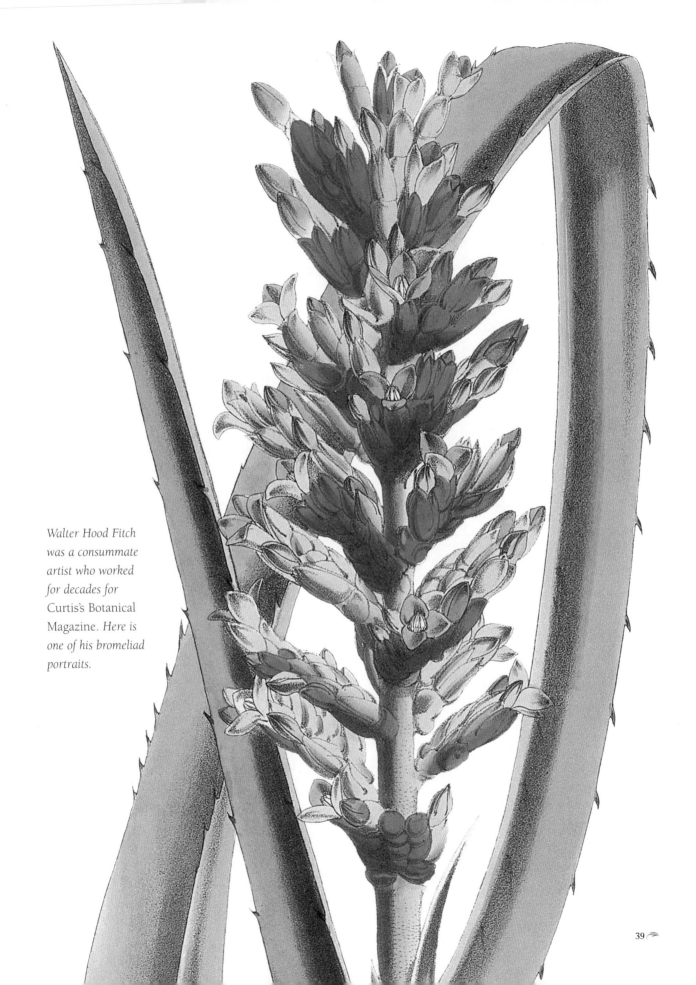

Walter Hood Fitch was a consummate artist who worked for decades for Curtis's Botanical Magazine. Here is one of his bromeliad portraits.

George Cooke,
Linum trigynum,
from Botanical
Cabinet

Conrad Loddiges, an excellent botanist and collector of plants, started *Botanical Cabinet* in 1817. This publication was more a nursery-man's catalog than a botanical record. Accuracy was thrown out the window; the pictures were pretty but said little to amateur or experienced growers. Most of the illustrations were rendered by George Cooke and George Loddiges, Conrad's son. The artwork actually advertised Loddiges's own nursery firm, and the magazine lasted for only fifteen years.

Curtis's Botanical Magazine reigned supreme among plant publications until Benjamin Maund's *Botanic Garden* and *The Botanist* appeared, the former in 1825, the latter in 1836. Maund was a chemist, printer, and bookseller, and had an astute eye for business. He was a good gardener and a hybridizer of plants as well. Edward Dalton Smith excellently illustrated the first few issues. When Augusta Withers, Mrs. Edward Bury, and Miss S. Maund (one of Benjamin's daughters) started contributing illustrations to *The Botanist,* it soon contained some of the most beautiful (and accurate) botanical works ever seen.

J. C. Loudon's *The Gardener's Magazine* appeared in 1826. This publication, intended for experienced gardeners, working gardeners, and plant men, was immensely popular until Sir Joseph Paxton's and Joseph Harrison's *Horticultural Register* appeared in 1831, with excellent illustrations. Paxton and Harrison's partnership dissolved soon after the magazine's inauguration; Harrison brought out both the *Floricultural Cabinet* and Paxton's *Magazine of Botany* in 1833. Other publications included *Revue Horticole* (1829), *The Florists* (1849–50), *The Flower Magazine* (1872–81), and *The Floral World* (1858). The existence of so many periodicals made the depiction of flowers competitive, with one magazine trying to outdo the next, thus contributing greatly to the growth of botanical art.

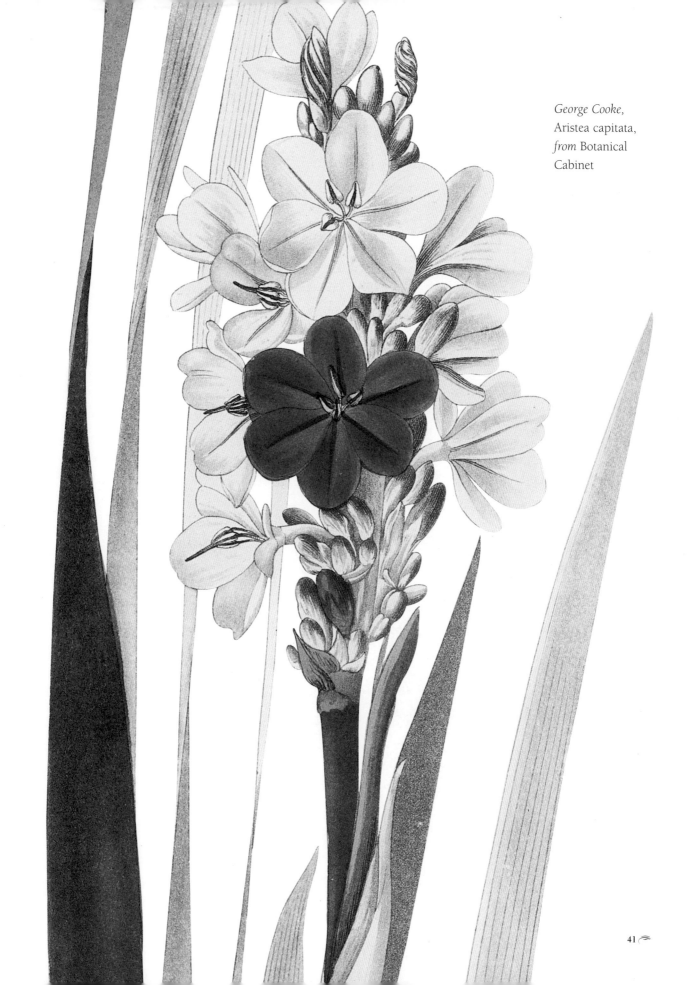

THE CRAZE IN THE UNITED STATES

Plant mania soared not only in England, but also in the United States. Hundreds of newly discovered plants were sent to England as seeds, grown, then sent back and forth between English and American explorers and botanists.

As in England, the Americans' love of plants spawned many periodicals, perhaps the best known being A. J. Downing's *The Horticulturist and Journal of Rural Art and Taste,* started in 1846. It was published for almost thirty years before being united with *Gardener's Monthly* to form *The Gardener's Monthly and Horticulturalist of Philadelphia.* The new publication, however, featured landscape gardening and general horticulture—not the exotics that Europe loved.

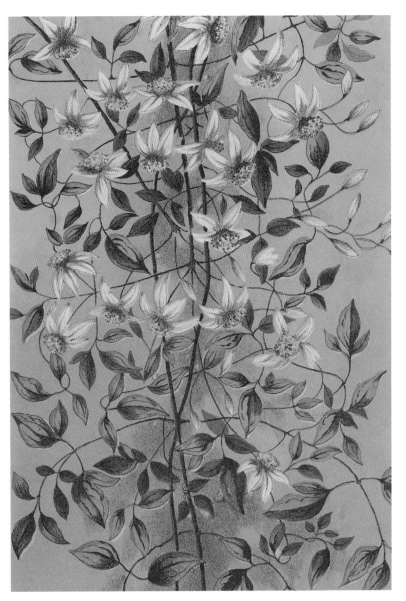

Clematis flammula *from* Vick's Monthly Magazine

Published in Germantown, Pennsylvania, Thomas Meehan's *Meehan's Monthly,* a magazine of horticulture, botany, and kindred subjects, dealt mainly with landscape subjects, although it included some information on specific plants. Published from 1891 to 1902, the magazine's 138 chromolithograph plates by L. Prange are not outstanding, but they are pleasing to the eye. Meehan also produced *Gardener's Monthly and Horticultural Advisor,* started in 1859 and then absorbed by *The American Garden* in 1887. *Vick's Monthly Magazine,* by James Vick, which ran from 1878 to 1906, aimed to meet the demand for information on gardening, and contained handsome color lithographs of flowers, fruits, and vegetables. *Hovey's Magazine of Horticulture* was one of the very first horticultural publications, lasting from 1835 until 1868.

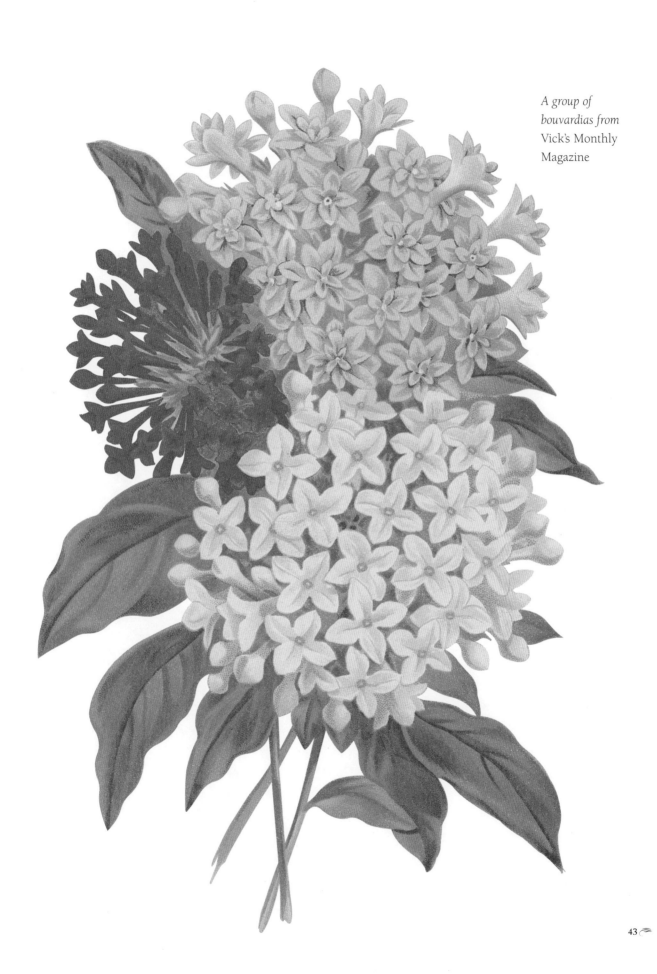

*A group of
bouvardias from
Vick's Monthly
Magazine*

FLORAL VOLUMES, DECORATIVE BEAUTY

Back in eighteenth-century England, the new printing process of etched, or engraved, copperplates ushered in the era of florilegia, large-format volumes that presented superb color illustrations of flowers for their own sake.

By the early to mid-nineteenth century, smaller-format books featuring illustrations of flowers also became enormously popular, especially among women. These sentimental volumes were often books of poetry or on morals, and were perfectly suited to the era's romanticism. Almost all contained color illustrations of flowers to add beauty to the books' religious and moral content. Female artists participated in this explosion of publishing, but were rarely credited for their work.

The floral portraits in these books were executed by some of today's best-known names in botanical illustration, such as Pierre-Joseph Redouté, Georg Ehret, Jane Loudon, and Maria Sibylla Merian. Theirs are the flower books that now command high prices at auctions as collectors outbid each other for pieces of history. At one Redouté sale in the early 1990s, bidders had to get a lottery number to participate. Robert Furbur, Augusta Withers, Elizabeth Blackwell, the Hooker brothers, the Sowerby family—all are artists who contributed to this golden age of botanical illustration. Walter Hood Fitch, so prominent in his day and responsible for the drawings in the famous *Curtis's Botanical Magazine,* was another key figure in the movement of floral art, as were the many artists who contributed to other magazines that flourished in the nineteenth century.

Tis my belief that every flower enjoys the air it breathes.

<small>WILLIAM WORDSWORTH</small>

A floral detail by John Keese, from his book The Floral Keepsake

Selected—and Spectacular—Flower Books

I mention here only a few of the great botanical books that fetch thousands of dollars at auction today, with the artists noted in parentheses. For a complete resume, see *Great Flower Books, 1700–1900* by Sacheverell Sitwell and Wilfred Blunt (London: Collins, 1956).

A Curious Herbal (Elizabeth Blackwell), 1739

Delineations of Exotic Plants Cultivated in the Royal Gardens at Kew (Franz Bauer), 1796

Fleurs Desinees d'Apres Nature (Gerard van Spaendonck), 1801

Florae Novae Hollandiae (Ferdinand Bauer), 1813

Flora's Gems (James Andrews), 1830

The Florist Guide (Robert Sweet), 1827–32

Groups of Flowers (George Brookshaw), 1819

The Heathery (Henry C. Andrews), six volumes, 1804–12

Icones Plantarum Medicinalium (Johannes Zorn), 1799

The Illustrated Bouquet (Edward and Andrew Henderson), 1857–64

The Ladies Ornamental Flower Garden (Jane Loudon), four volumes, 1844–49

Les Liliacées (Pierre-Joseph Redouté), eight volumes, 1801–16

Metamorphosis Insectorum Surinamensium (Maria Sibylla Merian), 1705

Monandrian Plants (William Roscoe), 1825

The Natural History of Carolina, Florida and the Bahama Islands (Mark Catesby), 1747

A New Treatise on Flower Painting (George Brookshaw), 1816

Les Orchidaceae (Paul Emile DePuydt), 1880

The Orchidaceae of Mexico and Guatemala, (James Bateman), 1837–43

Plantae et Papiliones Rariores (Georg Ehret), 1748–59

Plants of the Coromandels (William Roxburgh), 1795–1819

Recuile des Plantes (Denis Dodart), 1788

Reichenbachia (H. G. Moon), four volumes, 1888–94

The Rhododendrons of Sikkim-Himalaya (Sir Joseph Dalton Hooker), 1849

Les Roses (Pierre-Joseph Redouté), three volumes, 1817–24

A Selection of Hexandrian Plants (Mrs. Edward Bury), 1831

The Sentiments of Flowers (Robert Tyas), 1840

Temple of Flora (Robert John Thornton), 1799–1807

Twelve Months of Flowers (Robert Furbur), 1730

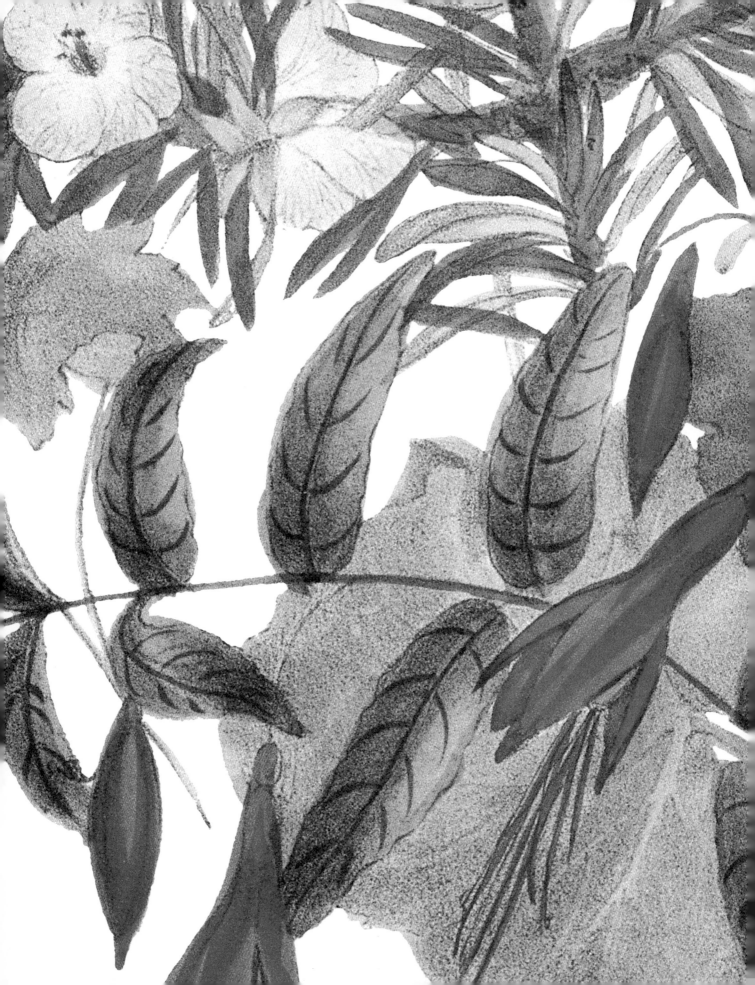

The Language of Flowers

*Then gather a wreath
from the garden bowers,*

*And tell the wish of the
heart in flowers.*

PERCIVAL, AS QUOTED IN *FLORA'S
DICTIONARY* (1855),
BY MRS. E. W. WIRT

*Detail of a bouquet, by Mrs.
E. W. Wirt (see also page 74)*

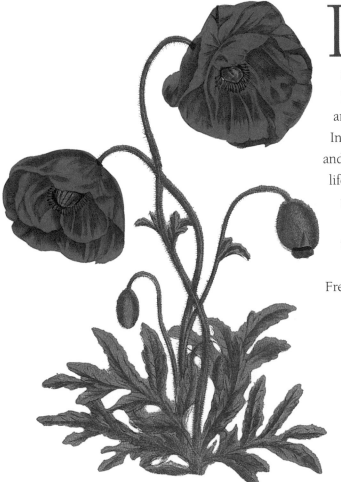

It was in France that the concept of a secret language of flowers became synonymous with books of floral illustrations accompanied by sentimental, sometimes beautiful, poetry and prose. The genre began with a book written by an Englishwoman, Lady Mary Wortley Montagu. In her *Turkish Embassy Letters*, penned in 1718 and published in 1763, Lady Montagu described life in Turkey, where women could not communicate with men, especially about love. Instead, women sent their sentimental or passionate thoughts to men using flowers.

In his book *The Language of Flowers* (1839), Frederic Shoberl described this history:

John Keese was a better botanical artist than he's given credit for. This beautiful illustration of Papaver rhoeas *appears in his book* The Floral Keepsake, *published in the mid-nineteenth century.*

> *The language of flowers is much*
> *employed in the Turkish harems, where*
> *the women practice it either for the sake*
> *of mere diversion in their solitude, or*
> *for the purpose of secret communication.*
> *A nosegay, a garland of flowers,*
> *ingeniously selected, and put together*
> *for the purpose of communicating in*
> *secret and expressive language the*
> *sentiments of the heart, is in the East called*
> *a Saam (salutation). It often happens that a female slave, the object of the*
> *Sultan's favor, corresponds openly with her lover merely by the various*
> *arrangement of flower pots in a garden. Written love-letters would often be*
> *inadequate to convey an idea of the passionate feelings which are thus*
> *expressed through the medium of flowers. Thus, orange flowers signify hope;*
> *marigolds, despair; sunflowers, constancy; roses, beauty; and tulips represent*
> *the complaints of infidelity.*
>
> *This hieroglyphic language is known only to the lover and his mistress. In*
> *order to envelope it the more completely in the veil of secrecy, the significations*
> *of the different flowers are changed, in conformity with a preconcerted plan:*
> *For example, the rose is employed to express the idea which would otherwise be*
> *attached to the amaranth, the gillyflower is substituted for the pomegranate*
> *blossom, etc.*

If one looks further, the origins of a language of flowers probably began in Asia, where features of a flower, such as the shape of its petals or the season of its flowering, were used to derive meaning. A peach blossom, for example, which blooms in the spring, came to symbolize matrimony. Further meanings were derived from a flower's name, which was linked to similar-sounding or -appearing words and phrases. All of these elements combined to form a complex language of flowers.

The revival of a secret language of flowers was spurred by Charlotte de la Tour's book *Le Langage des Fleurs* (1819), which had a tremendous influence in both the United States and England. Some have suggested that Louis Aime Martin actually wrote the book; later it was held to be the work of Louise Cortambert. Whoever its actual author, the book inspired a waterfall of teary, sentimental, language-of-flowers books, some with fine—and some with awful—illustrations. While other French books based on the language of flowers followed, the type really flourished in England, many authored by "anonymous" or "a lady." The number of books explaining what different flowers meant, often using romantic and sentimental language, ran into the hundreds. Most contained color illustrations, many of which were removed and framed as household decoration.

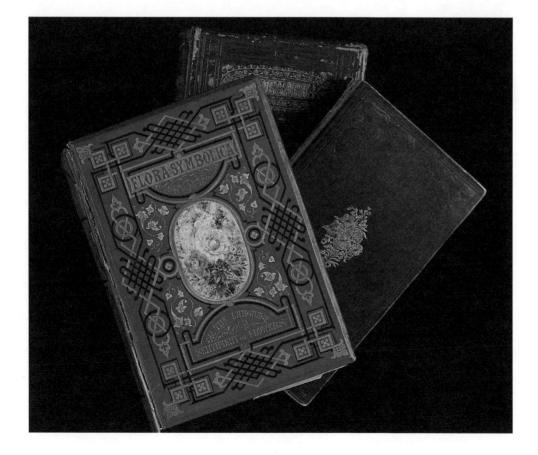

Some examples of the decorative covers used for language-of-flowers books

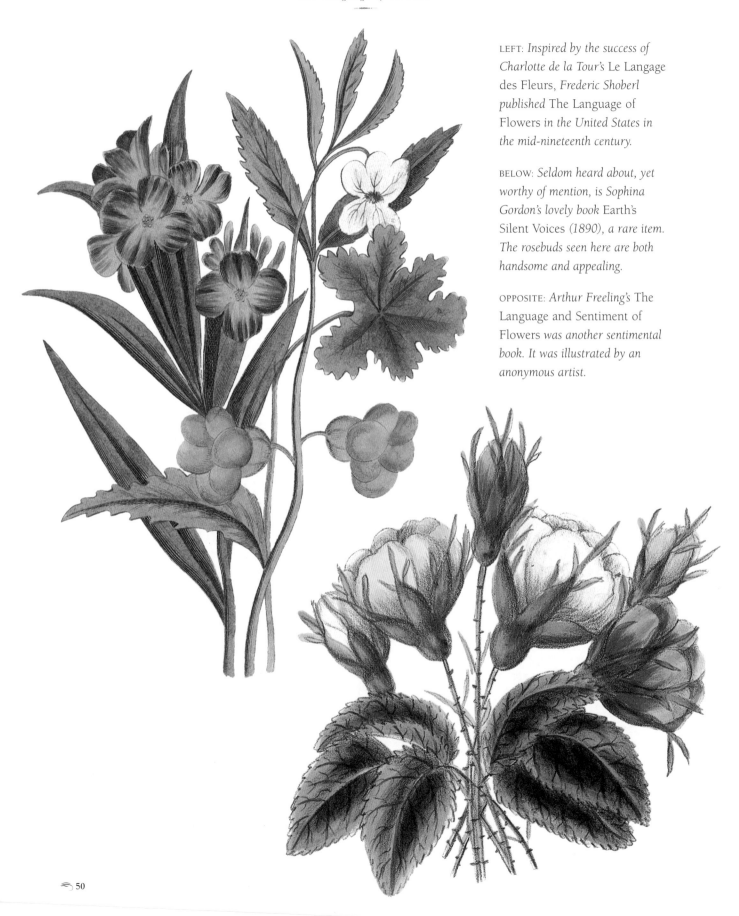

LEFT: *Inspired by the success of* Charlotte de la Tour's Le Langage des Fleurs, *Frederic Shoberl published* The Language of Flowers *in the United States in the mid-nineteenth century.*

BELOW: *Seldom heard about, yet worthy of mention, is Sophina Gordon's lovely book* Earth's Silent Voices *(1890), a rare item. The rosebuds seen here are both handsome and appealing.*

OPPOSITE: *Arthur Freeling's* The Language and Sentiment of Flowers *was another sentimental book. It was illustrated by an anonymous artist.*

OPPOSITE: *Robert Tyas was the prince of the language-of-flowers books. Here we see his rendition of blue bottles, dog roses, and garden anemones. According to Mrs. E. W. Wirt, author of* Flora's Dictionary, *blue bottles signify "a maiden's revenge" and anemones "expectation."*

The language-of-flowers book was a true phenomenon. The Victorian era was one of romantic zeal, and what could more perfectly express the age's language of love and passion than flowers? A host of authors attached emotional and romantic meanings to every flower, from the dandelion to the zinnia. Confusingly, the same flower was often given multiple meanings. The rose, for example, might mean "love forever" or "I love you" or "accept me." There was no one set vocabulary, grammar, or comprehensive dictionary. Meanings changed constantly from publication to publication. In *The Language of Flowers*, Shoberl lays out one such set of meanings:

> But little study will be requisite for the science, which we teach. Nature has been before us. We must, however, premise two or three rules. When a flower is presented in its natural position, the sentiment is to be understood affirmatively; when reversed, negatively. For instance, a rosebud, with its leaves and thorns, indicated fear with hope; but, if reversed, it must be construed as saying "you may neither fear nor hope." Again, divest the same rosebud of its thorns, and it permits the most sanguine hope; deprive it of its petals, and retain the thorns, and the worst fears may be entertained. The expression of every flower may be thus varied by varying its state or position. The marigold is the emblematical of pain; place it on the head and it signifies trouble of mind; on the heart, the pangs of love; on the bosom, the disgusts of ennui. The pronoun "I" is expressed by inclining the symbol to the right, and the pronoun "thou" by inclining it to the left. These are a few of the rudiments of our significant language.

The selection of artists and authors on the following pages, chosen from my personal library, represents the vanguard of the language-of-flowers movement.

THE FOLLOWING IS A PARTIAL LIST OF ATTRIBUTES GIVEN TO VARIOUS FLOWERS IN FREDERIC SHOBERL'S *THE LANGUAGE OF FLOWERS*. OTHER BOOKS, OF COURSE, CONTAIN OTHER LISTS.

ACACIA *Friendship*	HOLLYHOCK *Ambition*	NETTLE *Cruelty*
ALOE *Grief*	IRIS *Marriage*	OAK *Hospitality*
BASIL *Hate*	IVY *Friendship*	PEPPERMINT *Warm feelings*
BROOM *Humility*	JONQUIL *Desire*	POPPY *Consolation*
CANTERBURY BELL *Constancy*	JUNIPER *Protection*	QUINCE *Temptation*
CONVOLVULUS *Night*	LILY *Majesty*	ROSEBUD *A young girl*
DAFFODIL *Self-love*	LONDON PRIDE *Frivolity*	SNOWDROP *Hope*
DAISY *Innocence*	MARIGOLD *Grief*	TUBEROSA *Dangerous pleasures*
HAWTHORN *Hope*	MYRTLE *Love*	TULIP *Declaration of love*

Henry Gardiner Adams
(1811–1881)

Little is known about Henry Gardiner Adams. His two most well-known language-of-flowers books are *Flora Poetica*, published in 1834, and *Language and Poetry of Flowers*, published in 1866.

*The Lord of all
Himself diffused*

*Sustains and is the
life and lives.*

*Nature is but a name
for effect*

Whose cause is God.

He finds the secret fire

*By which the mighty
process is maintained.*

WILLCOCKS,
FROM *FLORA POETICA*

*A bouquet with irises,
attributed to H. G. Adams*

Adams's book Language and Poetry of Flowers *contains some rather amateurish floral drawings, but their primitive rendering gives them a certain charm.*

Clarissa W. Munger Badger
(1806–1889)

When I first wrote about Clarissa Badger in my book *Women of Flowers,* I had no idea that what I wrote would contribute to her increased recognition today. Her drawings show a gift for superb decoration, although the flowers are hardly accurate botanically. There is a great deal of romance and flair to her work, and her flower portraits, especially those of the night-blooming Cereus and passionflower, are full of beauty and emotion. She drew with both her brush and her heart.

In 1828, Clarissa married the Reverend Milton Badger. We know that the couple lived in Andover, Massachusetts; New York City; and Madison, Connecticut. In 1859 she published *Wild Flowers of America,* and later *Floral Belles from the Green-House and Garden.* Proficient at single flower portraits, Badger also did some great bouquets and had a flair for dramatic composition.

Clarissa Badger's popularity was dwarfed by her male counterparts; only now is she being applauded as a fine botanical artist. This rendition of moss rose comes from her book Wild Flowers of America.

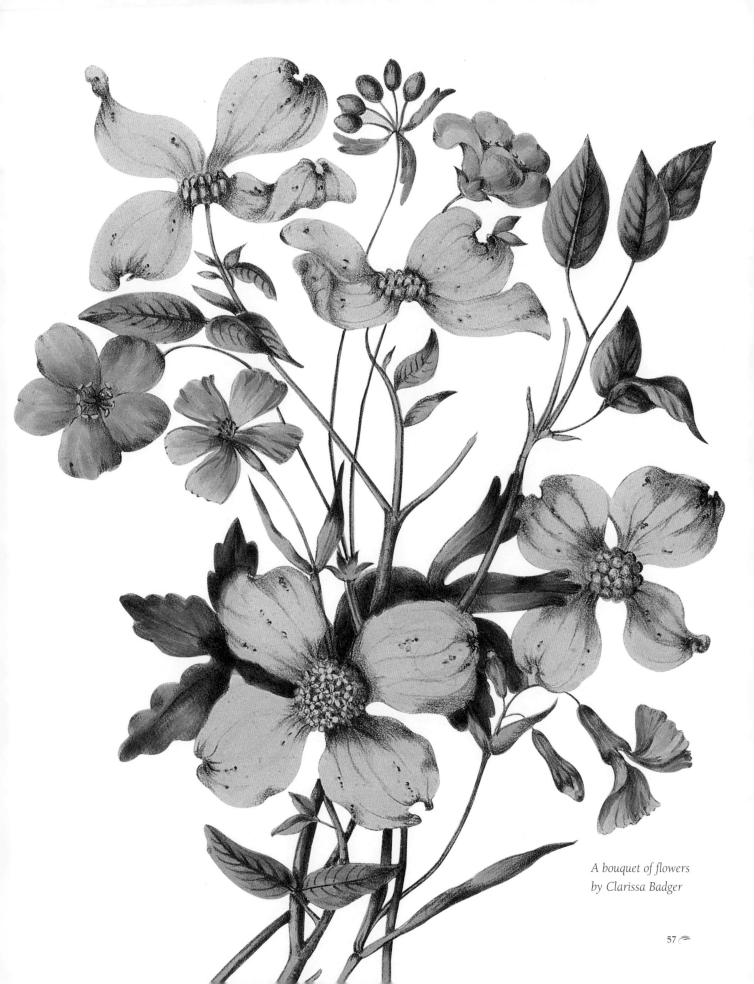

*A bouquet of flowers
by Clarissa Badger*

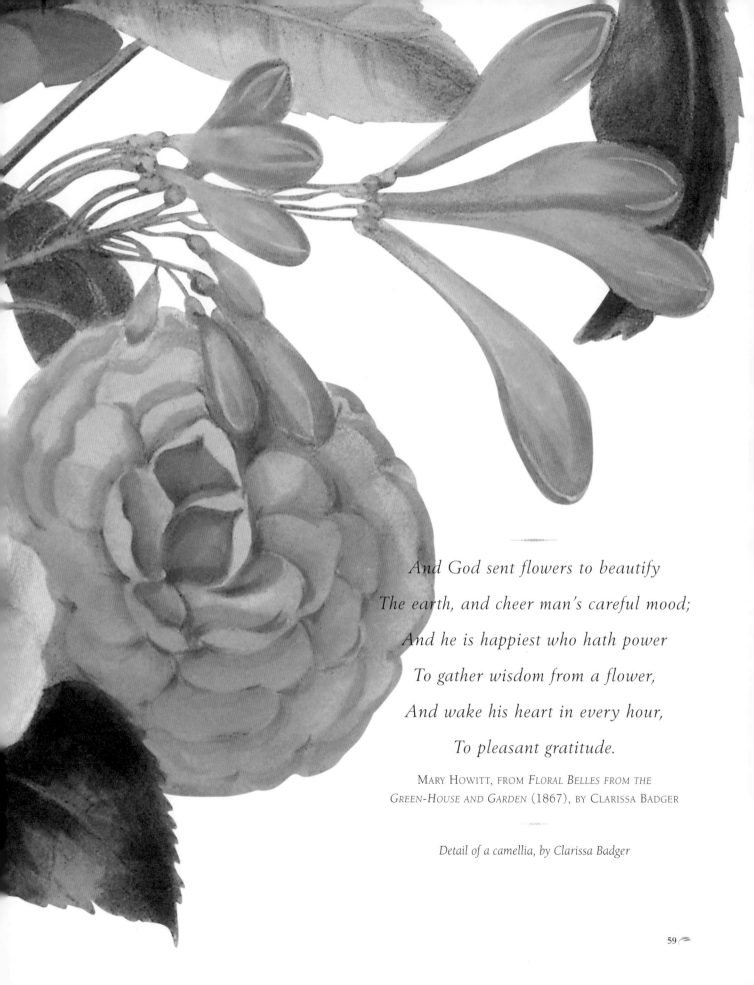

And God sent flowers to beautify

The earth, and cheer man's careful mood;

And he is happiest who hath power

To gather wisdom from a flower,

And wake his heart in every hour,

To pleasant gratitude.

MARY HOWITT, FROM *FLORAL BELLES FROM THE
GREEN-HOUSE AND GARDEN* (1867), BY CLARISSA BADGER

Detail of a camellia, by Clarissa Badger

Rebecca Hey
(fl. 1820s)

Rebecca Hey's *The Moral of Flowers,* published in 1849, depicts the spirit of flowers, poetry, and musings with great flair. Its twenty-three illustrations, drawn and engraved by William Clark, former draftsman and engraver to the London Horticultural Society, were all selected by Hey, drawn from nature, and excellently rendered.

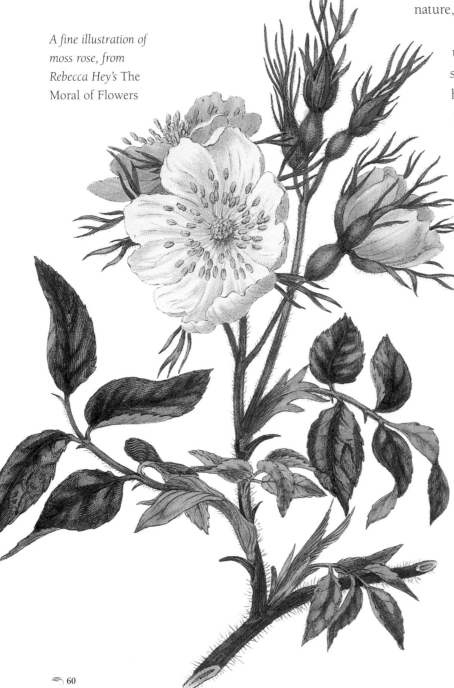

A fine illustration of moss rose, from Rebecca Hey's The Moral of Flowers

The book was a result of the urging of a friend, who wanted some poetic sketches to accompany her drawings. The friend suggested that the work would have worth if it contained moral and religious hints. Hey gladly embarked on the task.

Hey was an ardent researcher and good editor, and *The Moral of Flowers* emerged as a landmark in the language-of-flowers genre. While poetry is the volume's backbone, its discussions of botany and the history of each plant, woven uniquely into the poetry of each floral profile, show considerable research. Hey was especially indebted to Sir F. W. Smith, a prominent botanist and illustrator whose botanical knowledge adds to the interest of the work.

Hey also wrote *The Spirit of the Woods* in 1837, which contained six hand-colored plates of her drawings.

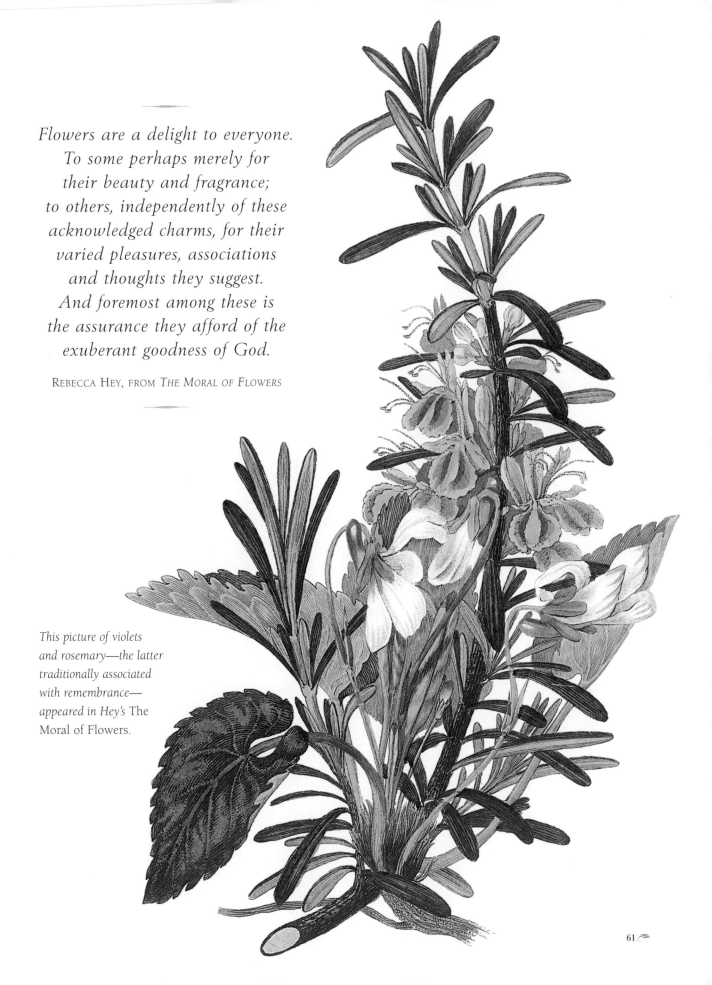

Flowers are a delight to everyone.
To some perhaps merely for
their beauty and fragrance;
to others, independently of these
acknowledged charms, for their
varied pleasures, associations
and thoughts they suggest.
And foremost among these is
the assurance they afford of the
exuberant goodness of God.

REBECCA HEY, FROM *THE MORAL OF FLOWERS*

This picture of violets
and rosemary—the latter
traditionally associated
with remembrance—
appeared in Hey's The
Moral of Flowers.

John Ingram
(1822–1876)

John Ingram was a gardener for the English royalty. Although never very well known, Ingram's drawings are included here as they are typical of those produced by the chromolithographic process and have a flair for the decorative. His work appears in *Flora Symbolica: The Language and Sentiment of Flowers*.

In Eastern lands they talk of flowers

and they tell in their garlands their loves and cares

each blossom that blooms in their garden bowers

on its leaves a mystical language wears.

JOHN INGRAM, FROM *FLORA SYMBOLICA*

RIGHT: *A floral bouquet by John Ingram*

Frances Sargent Locke Osgood
(1811–1850)

The first language-of-flowers book I purchased was Frances Sargent Locke Osgood's *The Poetry of Flowers and Flowers of Poetry,* an edition published in 1851. In the book, we are treated to a delightful marriage of poetry and flowers, the poetry from several authors, including Osgood herself. More importantly, it contains lovely color plates (by an anonymous artist) and is charmingly done with beautiful graphics and design.

Osgood lived most of her life in Hingham, Massachusetts, with her brother and sister, both of whom became authors. She was educated chiefly at home, and by the age of fourteen was being published in the pamphlet *Juvenile Miscellany.*

In 1834, Osgood married a portrait painter and moved with him to London. There, her book *The Floral Offering* became a success, and Osgood was favorably accepted by London society. In 1839 she and her husband returned to New York, where Osgood became editor of *Ladies Companion,* a typical women's journal of the time. She also contributed to several American periodicals and published verse and prose. In 1845, Edgar Allan Poe requested her opinion of his famous poem "The Raven." The two frequently corresponded, and it has been hinted that a romance developed between them. In 1847 Osgood's health failed, yet she continued to write and publish.

The Poetry of Flowers and Flowers of Poetry, first published in 1846, is a beautiful book filled with wonderful poems and eloquently expressed thoughts. It is heavily based on Linnaean nomenclature and was influenced by Robert Tyas's book *The Sentiments of Flowers,* published a decade earlier.

This rendering of fritillaria appeared in Frances Sargent Locke Osgood's The Poetry of Flowers and Flowers of Poetry.

Frederic Shoberl
(1775–1853)

In 1839, Frederic Shoberl penned *The Language of Flowers*, a book that went through many editions and was immensely popular in its time. In it, Shoberl's writing seems to sum up much of the era's sentiment, as in this excerpt from the book's preface:

> *Yes, flowers have their language. Theirs is an oratory, that speaks in perfumed silence, and there is tenderness, and passion, and even the lightheartedness of mirth, in the variegated beauty of their vocabulary. To the poetical mind, they are not mute to each other; to the pious, they are not mute to their Creator; and ours shall be the office, in this little volume, to translate their pleasing language, and to show that no spoken word can approach to the delicacy of sentiment to be inferred from a flower seasonably offered.*

ABOVE: *Frederic Shoberl's depiction of* Dianthus caryophyllus *(carnation)*

OPPOSITE: *A duet of garden flowers by Shoberl that demands attention*

When the attraction of transitory objects are veiled in the gloom of night. . . . When amidst the stillness of nature the voice of God resounds in rustling trees and murmurings of the swelling billows—the soul seems to wing its way toward the realm of eternity and the virtuous mind is impressed with a deeper consciousness of its moral dignity.

FREDERIC SHOBERL, FROM *THE LANGUAGE OF FLOWERS*

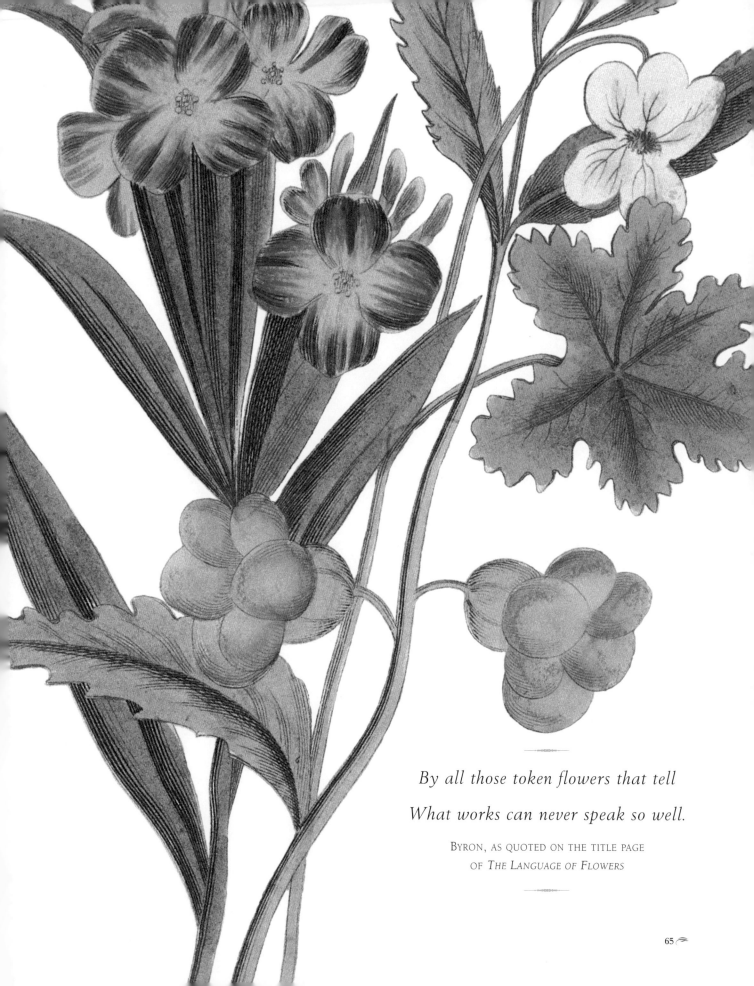

By all those token flowers that tell

What works can never speak so well.

BYRON, AS QUOTED ON THE TITLE PAGE
OF THE LANGUAGE OF FLOWERS

Louisa Anne Meredith Twamley
(1812–1895)

Louisa Anne Meredith Twamley moved as a newlywed to Tasmania from England. In her wonderful book *Some of My Bush Friends in Tasmania,* published in 1860, she celebrates the country's native flowers, berries, and insects:

One volume such as this would but partially suffice to realize my designs, so many more beautiful subjects still remain to be illustrated, among our flowers, trees, and insects; and it is my wish to continue this, my labor of love in their service, if it shall please Him—amidst whose infinite and glorious creation I am but as an ant, busy on her own small mound of earth—to grant me time and power to pursue my pleasant task.

In the preface to *Some of My Bush Friends,* Twamley expounds on her love for flowers. She states that she draws from nature and never minimizes or maximizes a flower for dramatic or decorative effect.

Twamley had both the talent of close observation and a deft drawing hand. Although classified as one of the language-of-flowers artists, she more strictly belongs with artists such as Sarah Anne Drake and Augusta Withers, both considered superb artists of their time.

Louisa Twamley is famous for her books on Tasmania, which are filled with meticulously executed and well-designed drawings, such as this one composed for the title page of Our Wild Flowers.

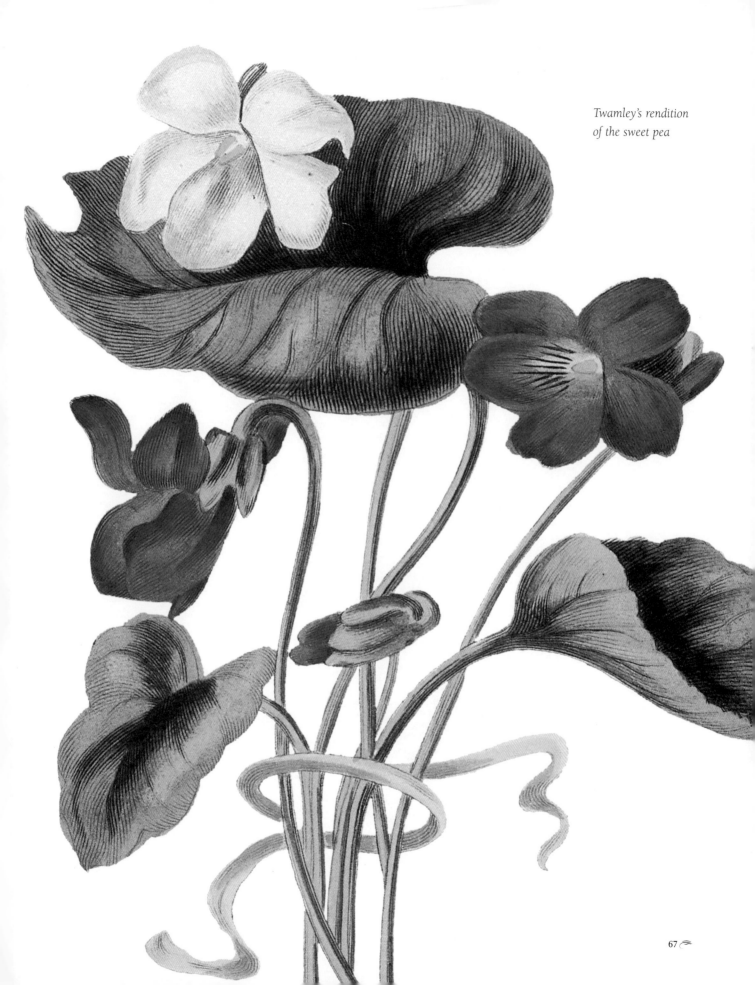

*Twamley's rendition
of the sweet pea*

Robert Tyas
(1811–1879)

In this lovely rendering by Robert Tyas, mirabilis plants contrast with spirea in the background.

If Pierre-Joseph Redouté was the master of florilegia, Robert Tyas was the virtuoso of the sentimental language-of-flowers books. He did innumerable floral illustrations for books, including for his own *Favorite Field Flowers* (1848), *Flowers from the Holy Land* (1850–51), *The Sentiments of Flowers* (1853), and *The Language of Flowers* (1869). He also published *Floral Emblems* (1869) and *The Young Ladies' Book of Botany,* as well as other volumes in the genre. Because of Tyas's stature in the art community of the time, he glamorized floral art, making it a noble industry.

From the hundreds of fine drawings Tyas left behind, one can see that he was a fast worker and that his talent stemmed from innate ability rather than professional training. (In fact, he was trained as a reverend.) His colorful drawings capture the softness of flowers, displaying their beauty in well-designed portraits. Before Tyas turned to the language of flowers, he illustrated many books on garden flowers, which gave him the training to masterfully create the handsome, beautiful bouquets that fill his language-of-flowers books.

OPPOSITE: *This handsome bouquet by Tyas features white violet, small bindweed, red and white rosebuds, and Asiatic ranunculus. Flora's Dictionary defines white violets as "modesty," rosebuds as "admiration" (although white rosebuds are also given the meaning "a heart that is ignorant of love"), and ranunculus as "I am dazzled by your charms."*

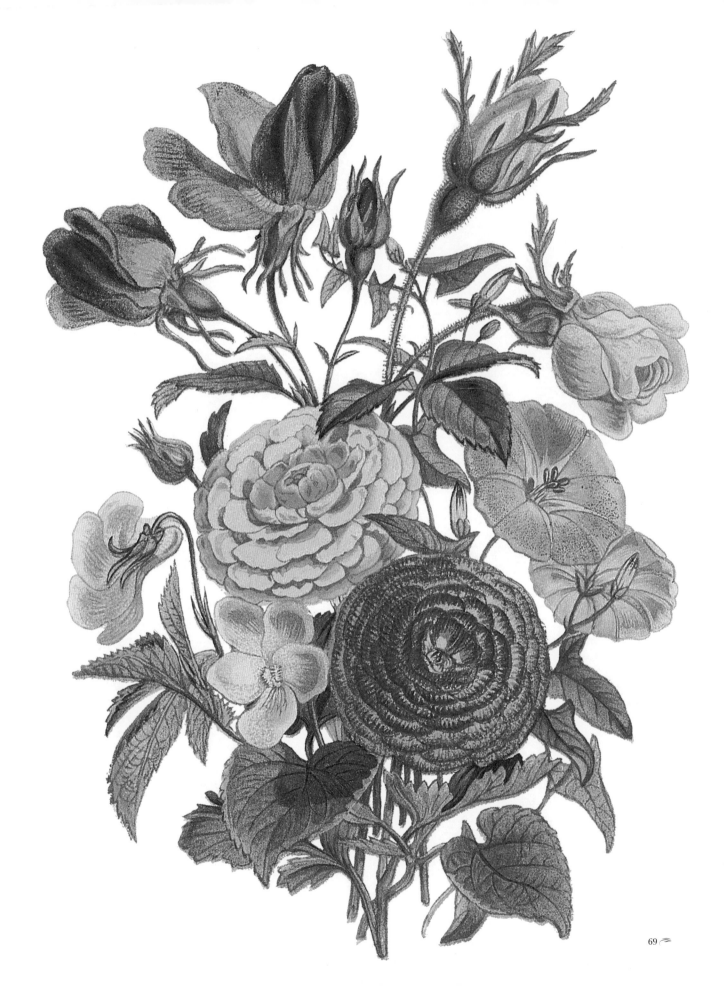

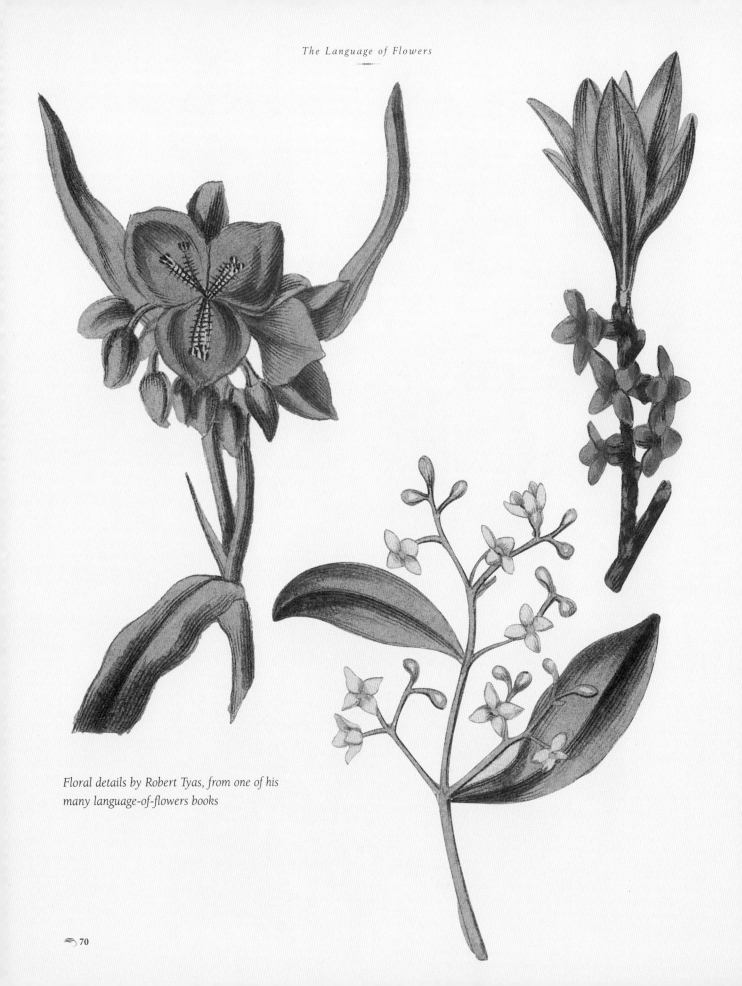

*Floral details by Robert Tyas, from one of his
many language-of-flowers books*

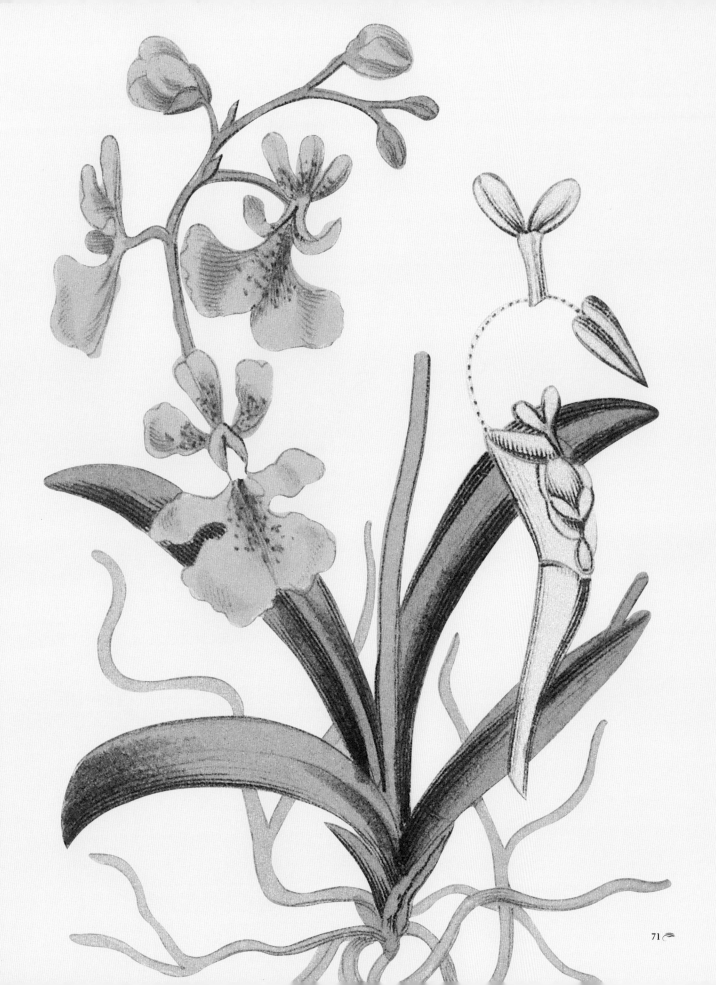

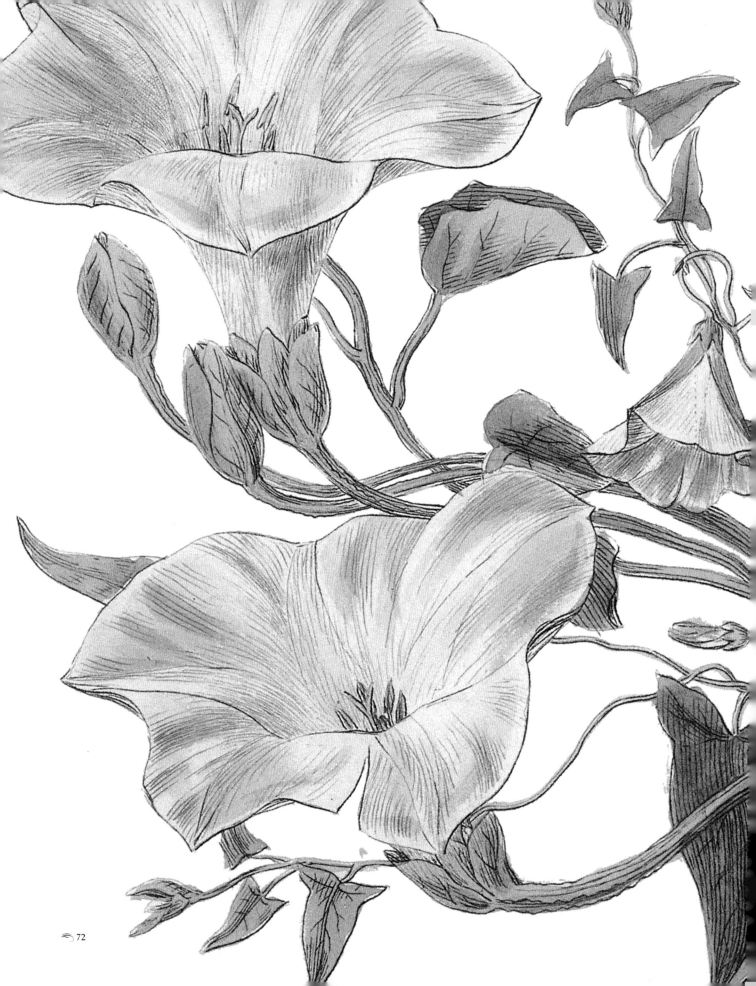

Lady Caroline Catherine Wilkinson
(1822–1881)

Lady Caroline Catherine Wilkinson compiled poems about nature to fill her book *Weeds and Wildflowers: Their Uses, Legends and Literature,* published in 1858. The book is awash with sentimental jargon. Although Lady Wilkinson was a noted botanical illustrator, an artist referred to as "Mrs. Berrington of Woodland Castle" executed the volume's colored drawings.

Weeds and Wildflowers is an important contribution to the language-of-flowers genre, combining sentimental writing with fine botanical illustration. Berrington's depictions of the burnet rose and a crocus, for example, are delicate and beautifully detailed.

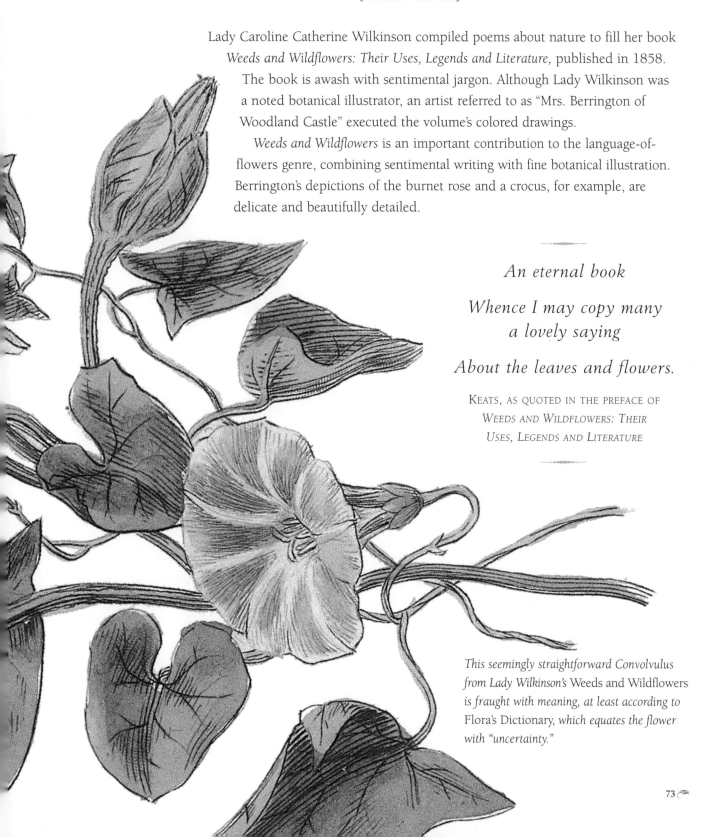

An eternal book

*Whence I may copy many
a lovely saying*

About the leaves and flowers.

KEATS, AS QUOTED IN THE PREFACE OF
*WEEDS AND WILDFLOWERS: THEIR
USES, LEGENDS AND LITERATURE*

This seemingly straightforward Convolvulus from Lady Wilkinson's Weeds and Wildflowers *is fraught with meaning, at least according to* Flora's Dictionary, *which equates the flower with "uncertainty."*

Mrs. Edward W. Wirt
(1784–1857)

Mrs. Edward W. Wirt's book *Flora's Dictionary*, published in Baltimore circa 1855, was so beautifully illustrated that it is difficult to find a volume that still contains the color pictures: Most were removed from the books and framed.

Along with its fine illustrations and many quotations illustrating the meanings of various flowers, the book includes a section on the structure of plants and a sketch of Linnaeus's life. Each page is beautifully defined with floral borders, adding to the volume's charm. In the preface, Wirt explains her goal in writing the book:

Each blossom that blooms in their garden bowers

On its leaves a mystic language bears.

PERCIVAL, AS QUOTED IN THE PREFACE OF *FLORA'S DICTIONARY*

The quotations are designed as poetic translations of the several emblems to which they are respectively applied. They are the language of the emblem rendered in verse: and, from the intrinsic beauty of most of these quotations, may it not be added, that these are the flowers of poetry aptly employed in illustrating the flowers of the earth? Some of the lines are original contributions for this little work, and it is believed that they will be found worthy of this association with established poets. In some instances answers are furnished; these may be tacitly made by returning a part of the same flower which has been presented. And where there are no answers prepared, a similar return of a part of the flower will signify, that the sentiments expressed are reciprocated.

There are few little presents more pleasing to a Lady, than a bouquet of flowers; and, if the donor be disposed to give them greater significance, it will be easy, with this manual before him, to make his selection in such a way as to stamp intelligence and expression on a simple posy.

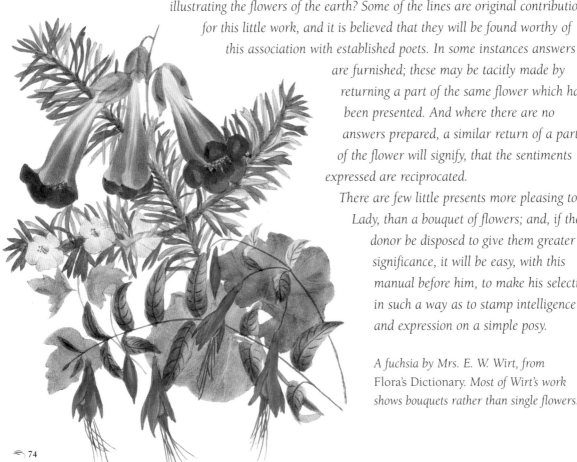

A fuchsia by Mrs. E. W. Wirt, from Flora's Dictionary. Most of Wirt's work shows bouquets rather than single flowers.

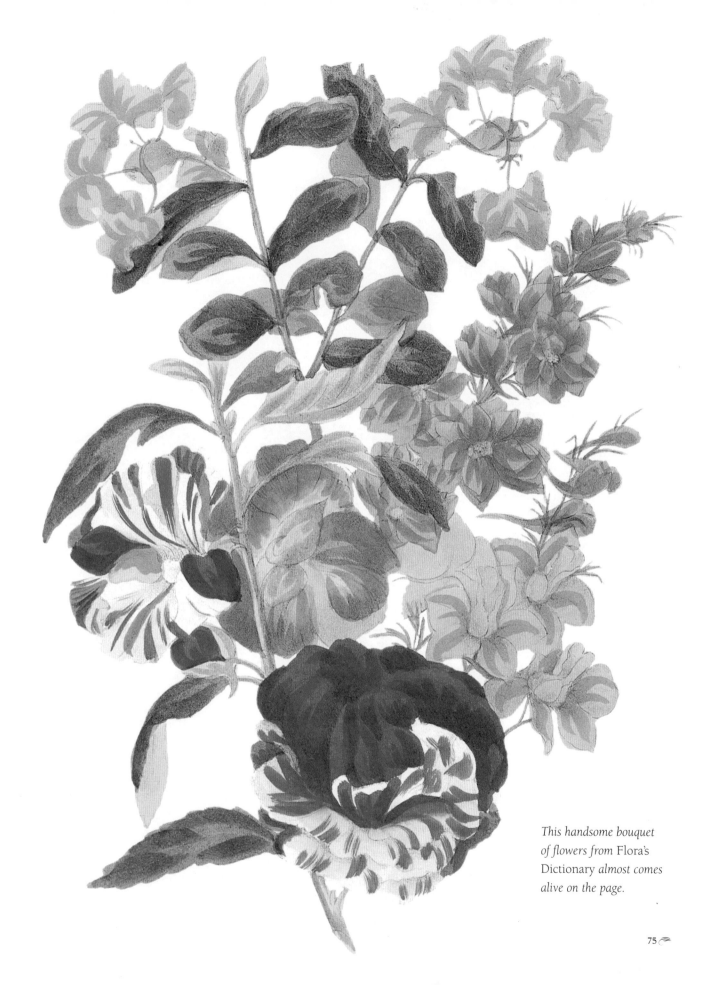

This handsome bouquet of flowers from Flora's Dictionary *almost comes alive on the page.*

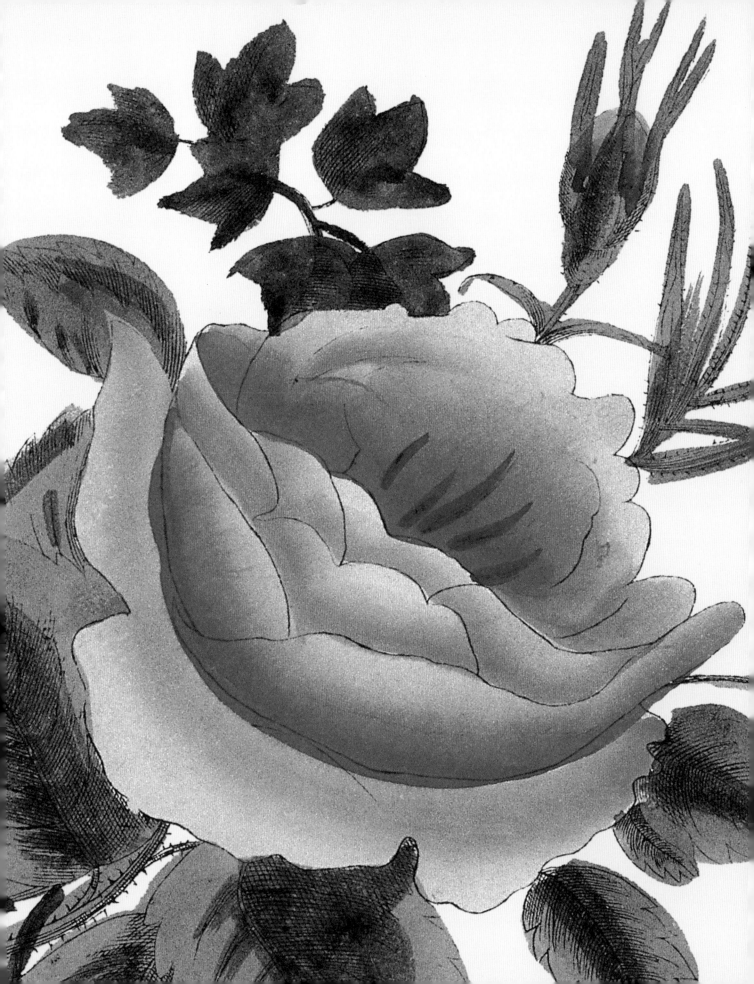

Language-of-Flowers Books from the Author's Collection

Earth's Silent Voices, by Sophina Gordon (n.p., n.d.)

Every Lady Her Own Flower Gardener, by Louisa Johnson (New Haven, 1871)

Every Lady's Guide to Her Own Garden, by "A Lady" (London, 1851)

Every Woman Her Own Flower Gardener, by Mrs. S. O. Johnson (New York, 1871)

The Flora Belle, or Gems from Nature, by J. L. Comstock (New York, n.d.)

Flora Symbolica, or The Language and Sentiment of Flowers, by John Ingram (London, 1887)

The Floral Keepsake, edited by John Keese (New York, n.d.)

The Floral Offering, edited by Frances Sargent Locke Osgood (Philadelphia, 1850)

Flora's Dictionary, by Mrs. E. W. Wirt (Baltimore, 1830)

Flora's Interpreter, and Fortune Flora, by Sarah J. Hale (Boston, *c.* 1860)

The Flower Garden, by Charlotte Elizabeth (New York, 1864)

The Flower Vase, by Sarah C. Edgarton (Boston, 1843)

Flowers from Nature, by Anne Everard (London, 1835)

Gleanings from the Field of Life, by Florence Bailey (Philadelphia, 1882)

Lexicon of Ladies' Names with Their Floral Emblems, by Sarah Carter (Boston, 1865)

The Ladies' Wreath, edited by Mrs. S. T. Martyn (New York, 1851)

The Lady's Book of Flowers and Poetry, edited by Lucy Hooper (New York, 1824)

Language and Poetry of Flowers, by Henry Gardiner Adams (Philadelphia, 1866)

The Language and Poetry of Flowers, author unknown (London, 1875)

Le Langage des Fleurs, by Charlotte de la Tour (Paris, 1819)

The Language of Flowers, by Anne Pratt and Thomas Miller (London, n.d.)

The Language of Flowers, edited by Frederic Shoberl (Philadelphia, 1839)

The Language of Flowers, by Robert Tyas (London, 1869)

Life Among the Flowers, edited by Laura Greenwood (New York, 1880)

The Moral of Flowers, by Rebecca Hey (London, 1849)

The Poetry of Flowers, edited by Frances Sargent Locke Osgood (New York, 1851)

The Voice of Flowers, by Mrs. L. H. Sigourney (Hartford, 1846)

A rose by Mrs. S. T. Martyn,
from The Poetry of Flowers

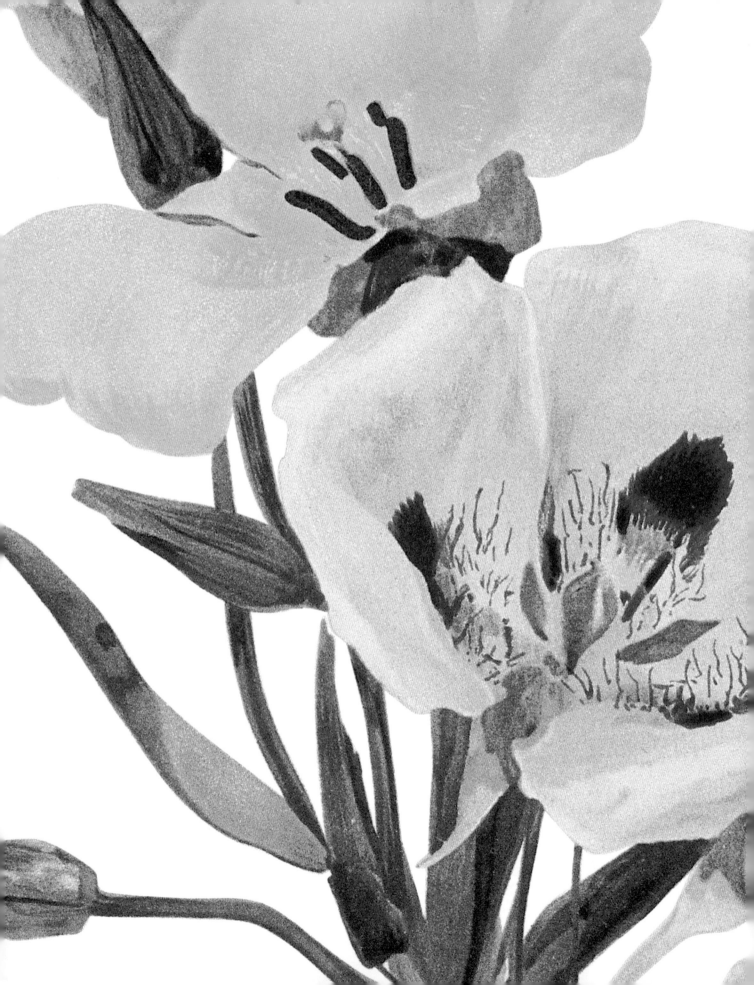

Artists Explain How to Draw Flowers

To all the mechanical trades, drawing is perhaps of more use than either writing or arithmetic. It is of immense use to a gardener; and we hope no young reader will neglect its acquirement. He may do it by copying the cuts in this magazine.

THE GARDENER'S MAGAZINE, 1831

Detail of Calochortus, by George Rosenberg (see also page 130)

Much of the glory of botanical art belongs to talented women of the Victorian era. These women are not well known today, and many are thought to have spent their days doing little but enjoying music or stitching needlepoint. Actually, the plant revolution did more than fill up idle hours. The talents and creativity of these women flourished as they cultivated and then drew flowers.

Publishers quickly realized that there was a market for botanical drawing books, known as "copy" books, with outlines to be copied in uncolored and colored stages. Publishers' catalogs included hundreds of botanical copy books: some small, some large, most inexpensive. Once the flowers had been colored or copied, the books, or simply their illustrations, were given away or discarded. Very few survive today.

Copying and coloring flowers became the rage. It was not only enjoyable, it was also considered educational as it enabled women to learn the scientific names for plants in their gardens. The books were in the right place at the right time, creating a sensational, and fashionable, trend. We know, for example, that in the 1750s a

Augustin Heckle is generally considered the originator of drawings such as these for The Lady's Drawing Book and Compleat Florist, *a fine example of the era's how-to-draw flower books.*

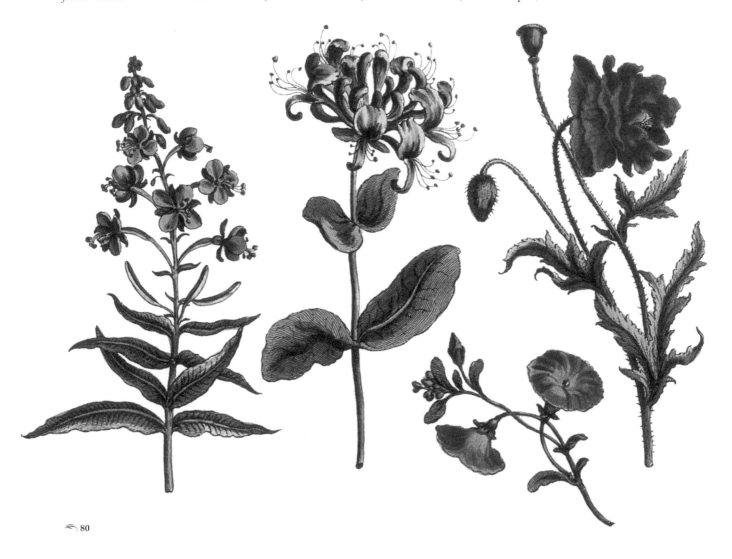

Mrs. Delaney invited guests to flower-drawing parties instead of the accustomed needlepoint gatherings. Queen Charlotte and her daughter, Princess Elizabeth, enjoyed coloring engravings of heather from botanical plates rendered by the great artist Franz Bauer. By the end of the 1800s, the craft of painting flowers in several media, mostly watercolor, had become a necessary talent for any well-bred young lady.

One of the earliest botanical copy books was *The Lady's Drawing Book and Compleat Florist,* published in 1755 by Carington Bowles, although some controversy exists about which publisher actually originated the book. In it were twenty-six plates of flowers, some printed in outline. The book's fine, vividly colored drawings were rendered by Augustin Heckle (also known as Heckel) and engraved by A. H. Dolin. A pioneer of the botanical copy book genre, *The Lady's Drawing Book* is a superb training guide for drawing flowers. Heckle also illustrated *The Florist, or an Extensive and Curious Collection of Flowers for the Initiation of Young Ladies Either in Drawing or in Needlepoint,* published in 1759. Both of these books were immensely popular and were reprinted again and again. Other books followed.

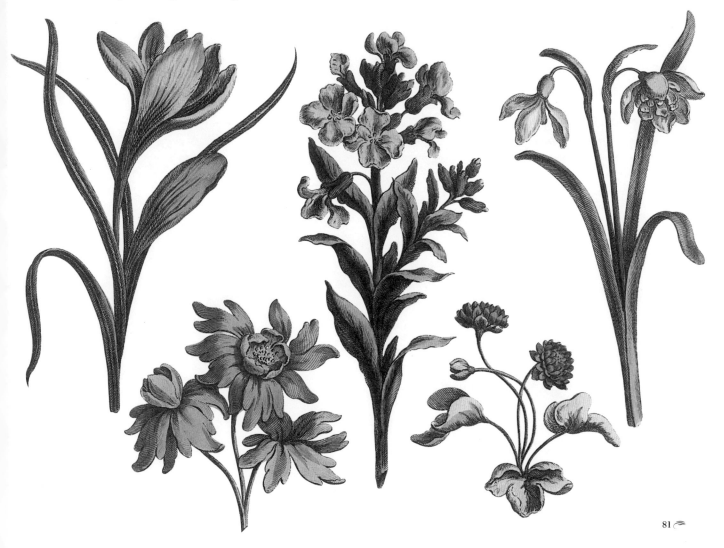

Charts like these, from James Andrews's Lessons in Flower Painting (1836), showed readers how to administer color shading in gradual steps.

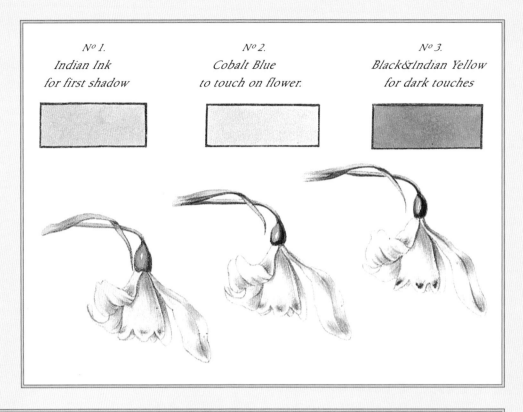

No 1.
Indian Ink
for first shadow

No 2.
Cobalt Blue
to touch on flower.

No 3.
Black&Indian Yellow
for dark touches

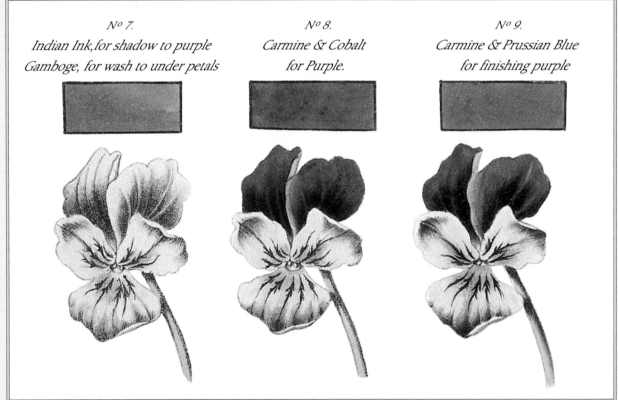

No 7.
Indian Ink, for shadow to purple
Gamboge, for wash to under petals

No 8.
Carmine & Cobalt
for Purple.

No 9.
Carmine & Prussian Blue
for finishing purple

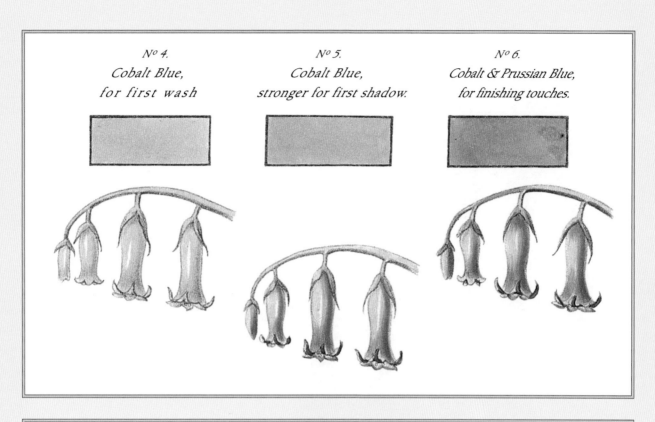

Nº 4.
Cobalt Blue,
for first wash

Nº 5.
Cobalt Blue,
stronger for first shadow.

Nº 6.
Cobalt & Prussian Blue,
for finishing touches.

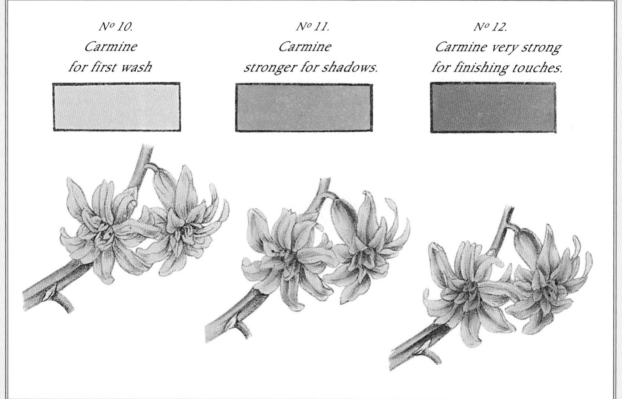

Nº 10.
Carmine
for first wash

Nº 11.
Carmine
stronger for shadows.

Nº 12.
Carmine very strong
for finishing touches.

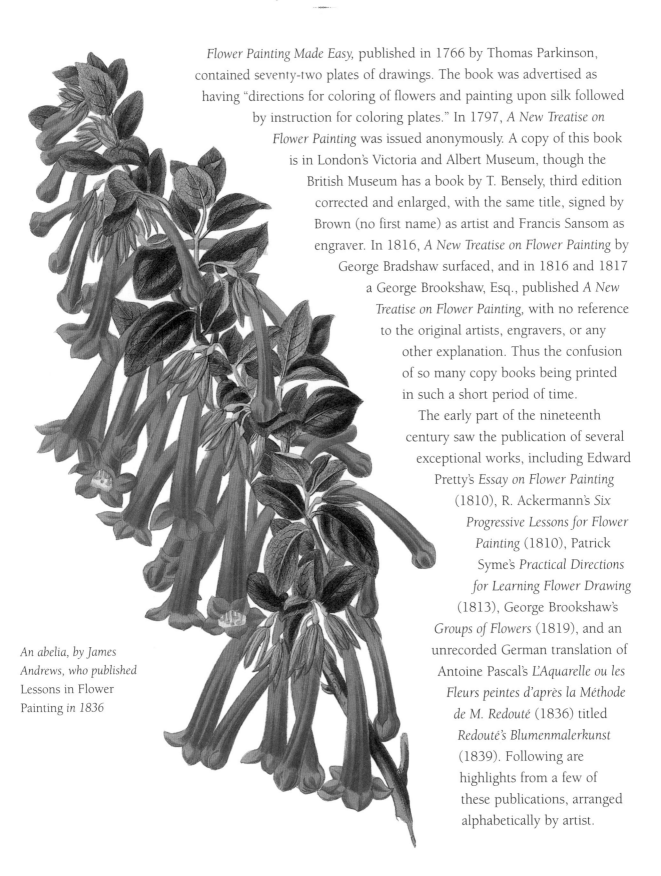

An abelia, by James Andrews, who published Lessons in Flower Painting *in 1836*

Flower Painting Made Easy, published in 1766 by Thomas Parkinson, contained seventy-two plates of drawings. The book was advertised as having "directions for coloring of flowers and painting upon silk followed by instruction for coloring plates." In 1797, *A New Treatise on Flower Painting* was issued anonymously. A copy of this book is in London's Victoria and Albert Museum, though the British Museum has a book by T. Bensely, third edition corrected and enlarged, with the same title, signed by Brown (no first name) as artist and Francis Sansom as engraver. In 1816, *A New Treatise on Flower Painting* by George Bradshaw surfaced, and in 1816 and 1817 a George Brookshaw, Esq., published *A New Treatise on Flower Painting,* with no reference to the original artists, engravers, or any other explanation. Thus the confusion of so many copy books being printed in such a short period of time.

The early part of the nineteenth century saw the publication of several exceptional works, including Edward Pretty's *Essay on Flower Painting* (1810), R. Ackermann's *Six Progressive Lessons for Flower Painting* (1810), Patrick Syme's *Practical Directions for Learning Flower Drawing* (1813), George Brookshaw's *Groups of Flowers* (1819), and an unrecorded German translation of Antoine Pascal's *L'Aquarelle ou les Fleurs peintes d'après la Méthode de M. Redouté* (1836) titled *Redouté's Blumenmalerkunst* (1839). Following are highlights from a few of these publications, arranged alphabetically by artist.

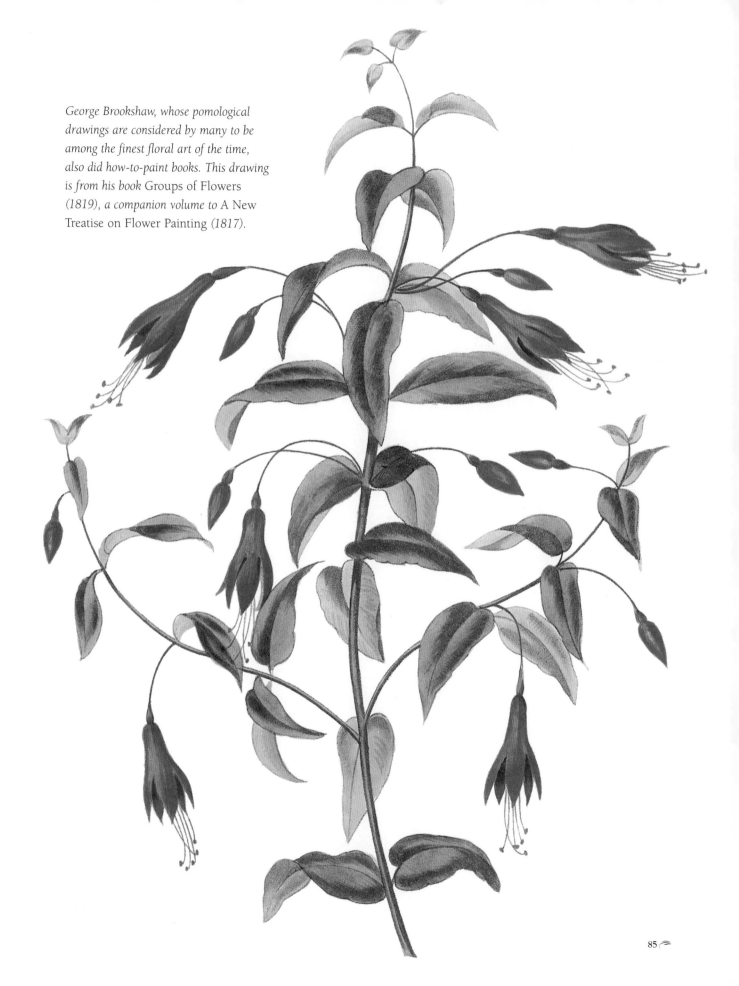

George Brookshaw, whose pomological drawings are considered by many to be among the finest floral art of the time, also did how-to-paint books. This drawing is from his book Groups of Flowers (1819), a companion volume to A New Treatise on Flower Painting (1817).

R. Ackermann
(fl. 1790s)

R. Ackermann is hardly mentioned in any of the books about botanical art, yet he certainly knew how to draw flowers. He had a talent for sketching, drew the parts of a flower to scale, and his color work was adequate, though not striking or dramatic.

First draw your outlines, very faintly, with black lead, then trace them over with a crow-quill or fine camel-hair pencil, your ink more diluted with water than is necessary for bold landscapes; the extreme tenderness of the flower petals making it necessary to draw the outlines very faint; when this is done rub out the black lead.

R. ACKERMANN, FROM *SIX PROGRESSIVE LESSONS FOR FLOWER PAINTING*

Ackermann's book *Six Progressive Lessons for Flower Painting*, published in 1810, includes directions for drawing and coloring flowers based upon botanical principles, with step-by-step color combinations and instructions on how they should be applied. While the first half of the book contains solid technical instruction, the second half contains only outline sketches and one finished color illustration—all Ackermann deemed necessary to complete his teaching on the subject. An excerpt from Ackermann's book follows on pages 88–89.

BELOW AND OPPOSITE:
Uncolored and colored stages of various garden flowers, from Six Progressive Lessons for Flower Painting

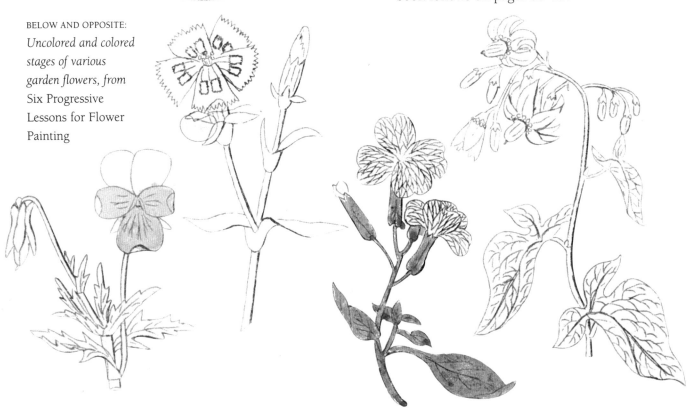

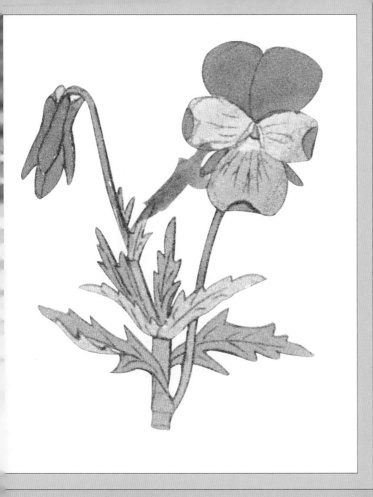
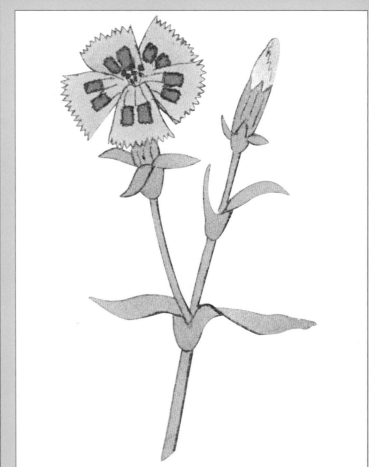
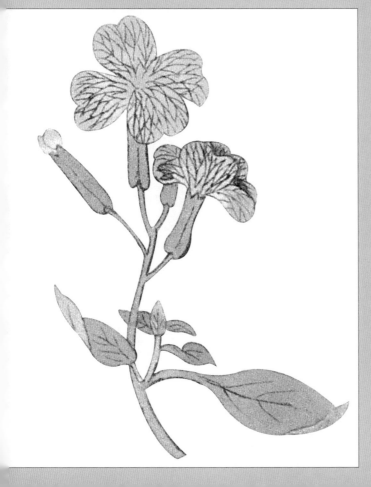
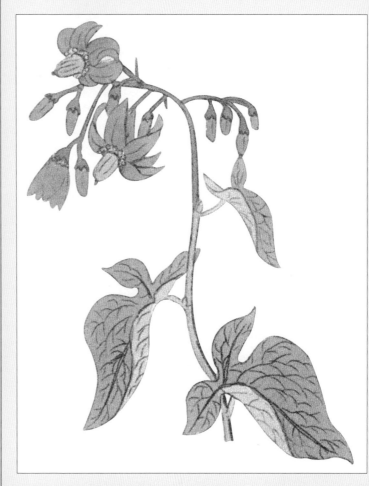

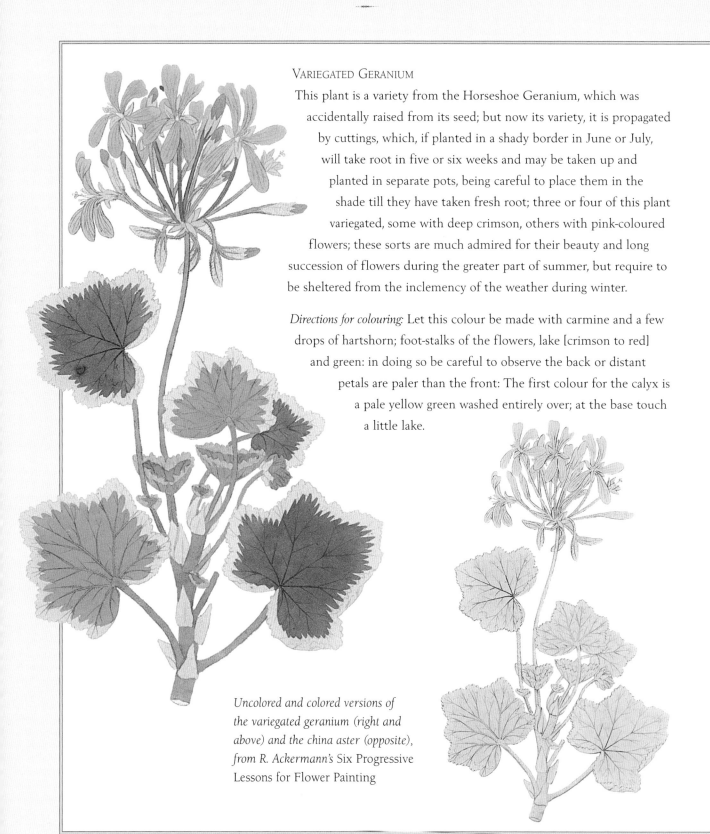

VARIEGATED GERANIUM

This plant is a variety from the Horseshoe Geranium, which was accidentally raised from its seed; but now its variety, it is propagated by cuttings, which, if planted in a shady border in June or July, will take root in five or six weeks and may be taken up and planted in separate pots, being careful to place them in the shade till they have taken fresh root; three or four of this plant variegated, some with deep crimson, others with pink-coloured flowers; these sorts are much admired for their beauty and long succession of flowers during the greater part of summer, but require to be sheltered from the inclemency of the weather during winter.

Directions for colouring: Let this colour be made with carmine and a few drops of hartshorn; foot-stalks of the flowers, lake [crimson to red] and green: in doing so be careful to observe the back or distant petals are paler than the front: The first colour for the calyx is a pale yellow green washed entirely over; at the base touch a little lake.

Uncolored and colored versions of the variegated geranium (right and above) and the china aster (opposite), from R. Ackermann's Six Progressive Lessons for Flower Painting

China Aster

This plant is a native of China, from whence the seeds were introduced into France by their missionaries, where the plants were first raised in Europe; as it is an annual, they are only propagated by seeds, which must be sown in the spring. . . . Flower colour made with Prussian blue and a small tint of lake or carmine; the middle of the flower gamboges [yellow]; the buds or unopen flowers, of the flower colour very pale the inner segments a faint yellow green; leaves the front green with gamboge, king's yellow, and indigo; back green made from the front; decayed leaves much yellower than the others.

Woody Nightshade

The main stalk yellow and pale, the flower stalks and upper part of the main stalk a tingy purple . . . front petals and buds a fine purple, back petal redder than the front.

Jessamine

The leaves darker green with gamboges and yellow, calyx and stalks rather yellow the points of the stalks to be tipped with red. The tubes or cylinder of flowers pale yellow green, the upper side exposed to the bud a pale carmine. Petals may be left to the whiteness of the paper and the effects of shade as in the specimen.

Sweetpea

The front leaves Prussian blue and gamboges, the stalk, calyx, and tendrils much yellower and pale. The flower's upper petal a dark red purple, the inside petals Antwerp blue and a slight tint of carmine.

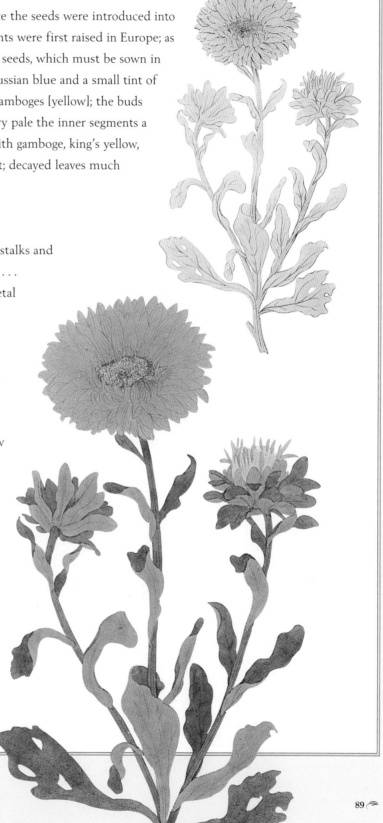

James Andrews
(*c.* 1801–1876)

The outline (below) and finished color version (opposite) of a bouquet by James Andrews

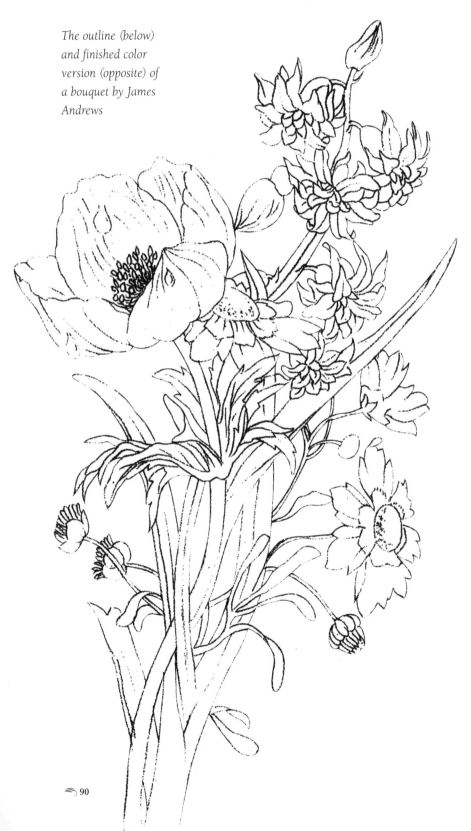

James Andrews was a prolific botanical artist who contributed many plates to *Floral Magazine and Florist.* His book *Lessons in Flower Painting,* published in 1836, was one of the better how-to manuals of the time, with fine floral illustrations. He also produced a great number of illustrations for Robert Tyas's many language-of-flower books (see page 68).

Although later described by Wilfred Blunt in *The Art of Botanical Illustration* as one who might have been a great artist had he not frittered his time away doing sentimental books, Andrews is now considered an excellent botanical artist. Looking at his many floral illustrations, it is apparent that he perhaps did too much too fast, though he was obviously quite familiar with the subject, and his habit of working quickly should hardly have received negative comments at the time. Andrews was good at what he did—that much is documented by the many different authors he worked for: He produced thousands of illustrations and helped inspire a generation of floral artists.

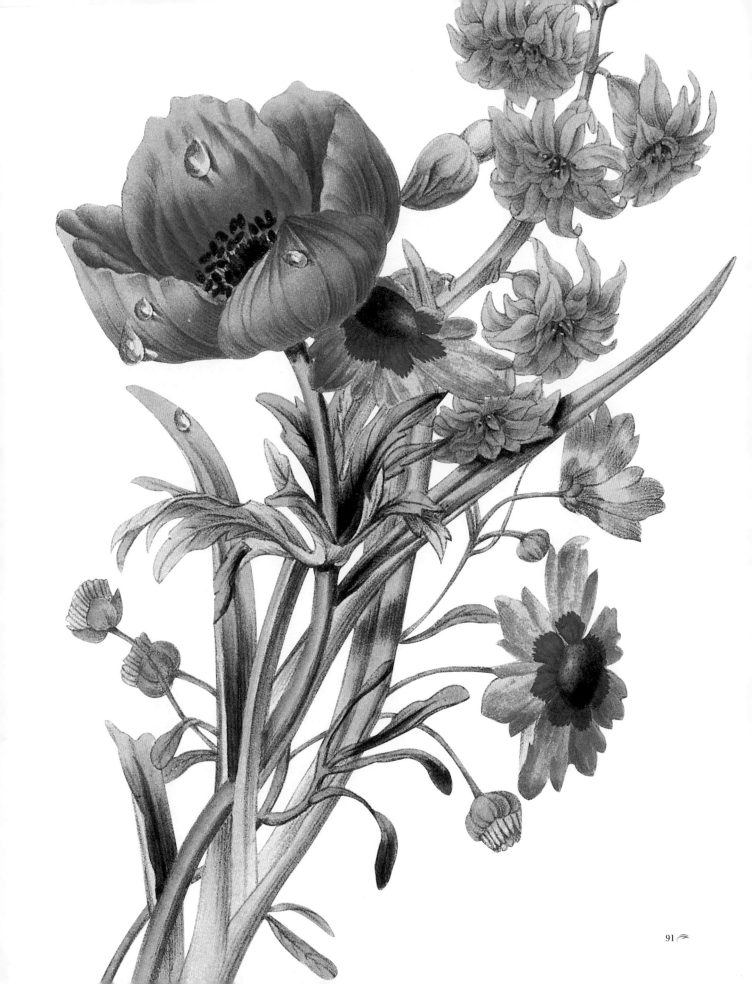

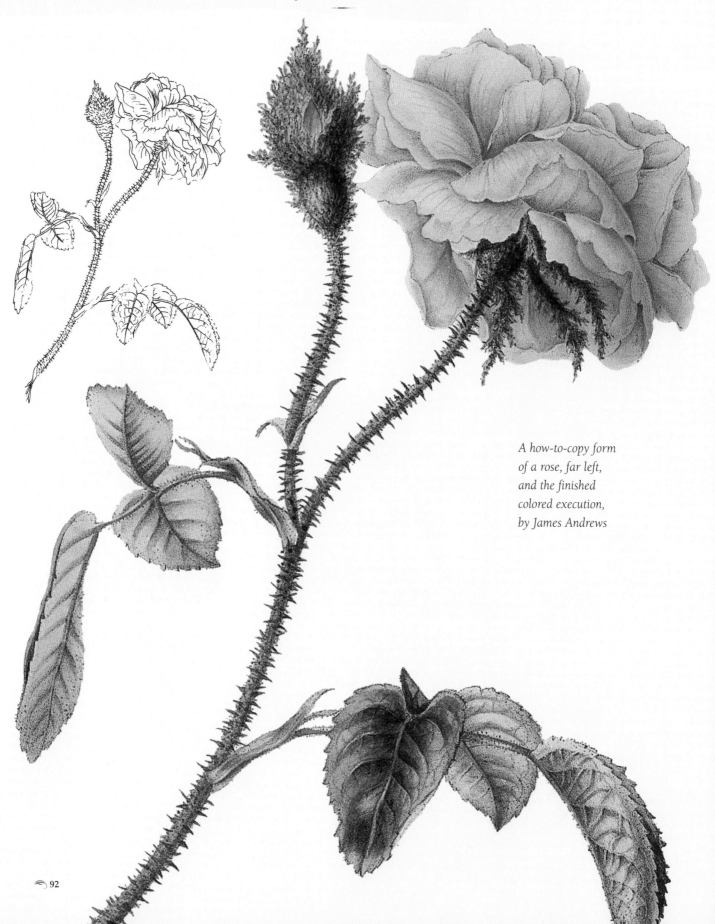

*A how-to-copy form
of a rose, far left,
and the finished
colored execution,
by James Andrews*

Andrews's how-to-draw leaf forms, left, and the finished color renditions, below

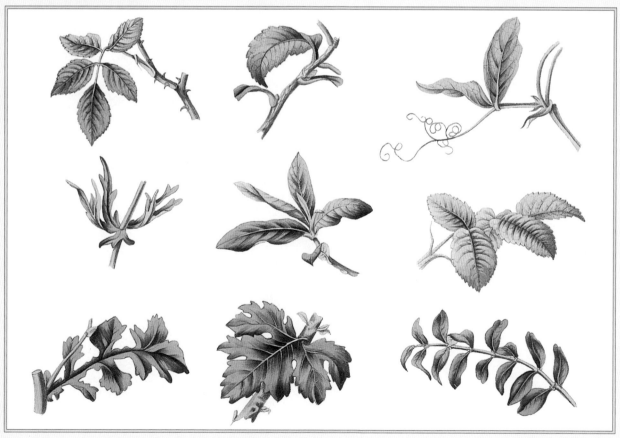

George Brookshaw
(1751–1823)

In his books *A New Treatise on Flower Painting*, published in 1816, and its companion volume, *Groups of Flowers*, published in 1819, George Brookshaw stated that his work was intended essentially for young aspiring artists. And while he suggested that floral art was most suitable for ladies and did not require any knowledge of perspective, he also stated that floral painting was not a lesser genre of art but was as important as any other. An excerpt from *Groups of Flowers* follows on pages 96–7.

*To Ladies, flower painting
is peculiarly appropriate:
It is an easy introduction
to general painting, and does
not require a previous
knowledge of perspective.
It may be attained without
the expense of a Master, a few
elementary instructions and
good copies being sufficient.
Ladies who have reared a
fine specimen of a favorite
plant, by being enabled
to copy it, convert a
fleeting and transitory
pleasure into a permanent
source of satisfaction.*

GEORGE BROOKSHAW, FROM
GROUPS OF FLOWERS

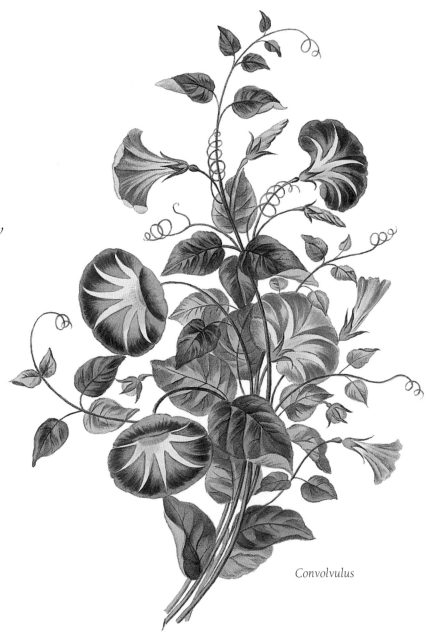

Convolvulus

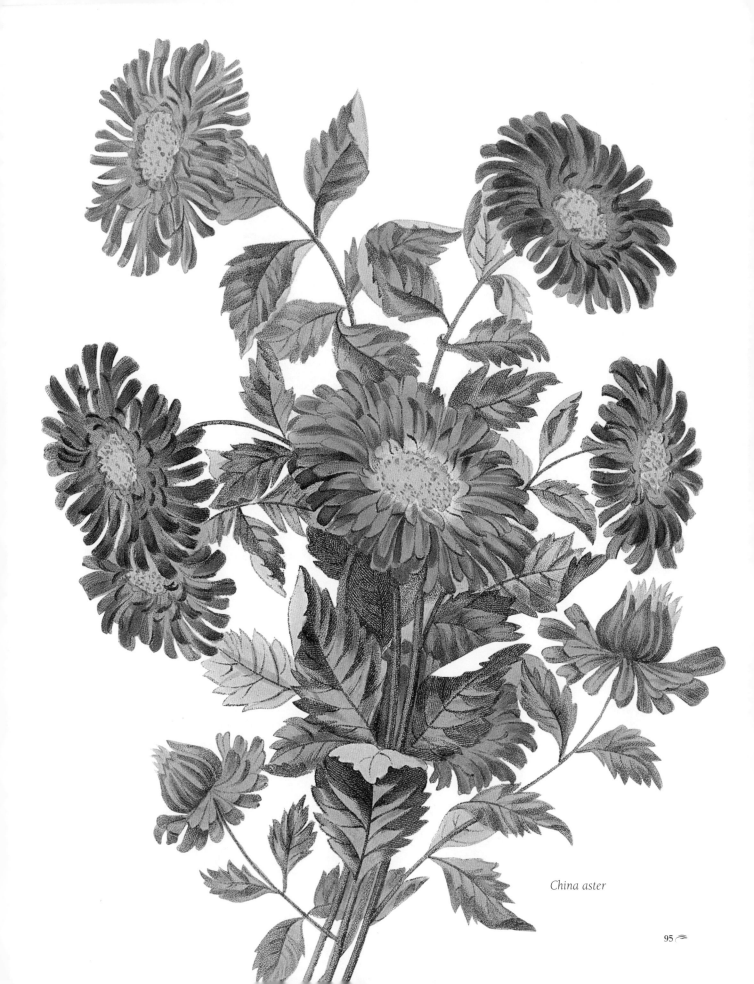

China aster

In the supplement to my *Treatise on Flower Painting,* I promised to give some studies of groups of flowers in the style of higher finishing: The following six plates are of that description, and have been drawn with a view to lead the young artist onward in a progressive line of improvement.

I must here observe that I propose continuing, in the works similar to the present, a series of instructions for painting flowers, fruits, birds, and other interesting subjects; and as the whole will be taken from Nature, and executed in an elegant taste, I cannot avoid indulging the hope, that those who honor my undertaking by using it as their guide, will acquire a natural, free, and graceful manner of drawing.

I may perhaps be accused of too great a partiality for my favorite art, but I frequently wish that drawing was always made an essential part of education, there being so many situations in life in which the use of the pencil is not only a pleasing, but useful accomplishment.

It is, however, of the greatest importance for the young student to avoid copying from ill-designed or badly coloured patterns; this observation is rendered necessary from the number of drawings which are continually presented to the eye, of groups of flowers gaudily coloured but apparently all pressed together, and without either grace or correctness in the design and manner of grouping: Indeed, I am sorry to add, there are few others to be obtained, even at our best repositories of the elegancies of art, which with all their excellence in other subjects, do not appear.

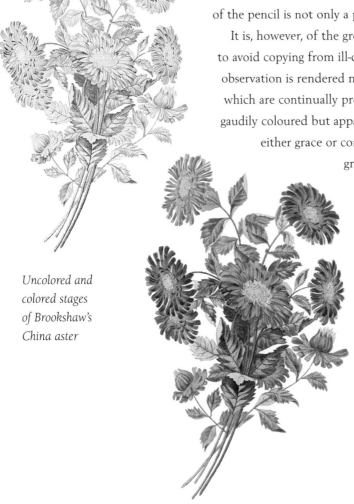

Uncolored and colored stages of Brookshaw's China aster

THE CHINA ASTER

This plate represents a group of China asters, which will be found easy to colour after they are sketched, that very few instructions are required to enable the student to do them. I must however recommend a very correct sketch to be made: Observing that the leaves have their proper turns, it will also be advisable to mark in the petals

with a fine pencil, with lake for the pink flowers, and purple for the purple flowers; then with a pencil that will spread the point, put in each petal with one broad stroke, if possible. As all the different tints are the effect of light and shade, you must heighten the dark parts with deeper tints; and observe, the more tints you can introduce, the richer your drawing will appear.

THE MAJOR CONVOLVULUS

This plate represents a group of Convolvulus. It must be observed that in this plant the pink and purple flowers grow upon the same stem; and being one of the tribe of creepers it has a number of tendrils.

In colouring from the flowers I should recommend the learner not only to draw them but to study them . . . and observe how each particular flower or leaf turns, the different tints or colours of the different flowers, how one is relieved by the other, and in what manner the leaves are relieved by the different tints given them; for example how the blue green tint of the back of the leaves gives effect and force to the front leaves, by making them appear more forward.

After an attentive examination the whole should be sketched in with a black lead pencil; then holding the sketch at a distance observe whether you have got all the principal stems correct. . . . Then observe how the leaves lay against or over each other and whether they are in their proper places, also the flowers and buds. . . . Rub out your black lead sketches, til they appear so pale you can correct the drawing if necessary.

Now as to the methods of colouring I should recommend you put in the first and second tints of all the parts . . . you can then proceed to a more finished drawing by heightening all the parts with one or two more dark tints. . . . Now to make these flowers appear more highly finished, I will make use of a tint between the first and second, and another tint between the second and third, making together five tints which will cause the gradation from the darker to the light parts to appear more gradual and soft.

Uncolored and colored stages of Convolvulus

Mrs. William Duffield (née Rosenberg)
(1819–1914)

Mrs. William Duffield considered the advent of watercolor the reason why flower painting became a vogue. In her book *The Art of Flower Painting,* published in 1856, her instructions were general, concentrating on drawing single flowers, such as primroses, yellow crocus, geraniums, or roses. A brief study of her work indicates that she was concerned with composition, arrangement, light and shade, and color.

Pansies were popular flowers in the nineteenth century. This rendition is attributed to Mrs. William Duffield, but is likely by an anonymous artist.

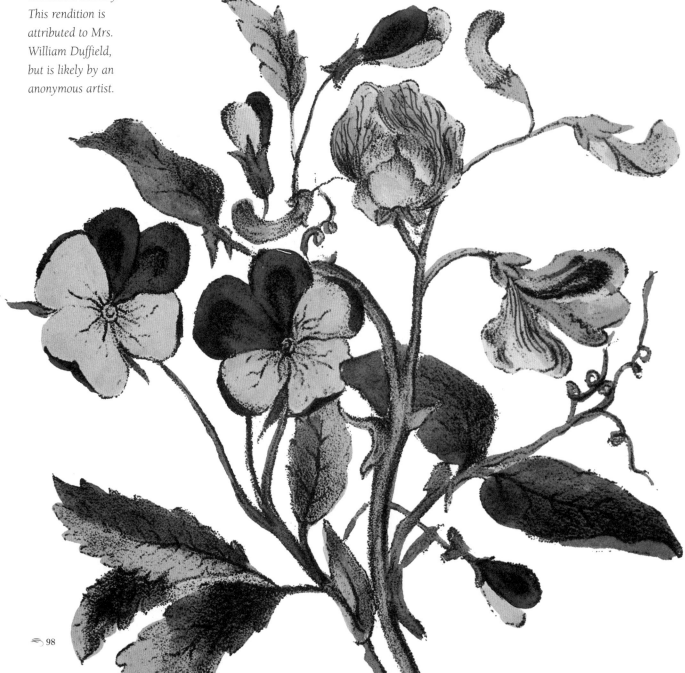

Walter Hood Fitch
(1817–1892)

It is impossible to write anything about botanical art without a discussion of Walter Hood Fitch, who produced thousands of drawings for *Curtis's Botanical Magazine* between 1834 and 1878. In 1869, eight articles by Fitch appeared in the periodical *Gardeners' Chronicle*; this lengthy and fine exposition included a premier course in botanical drawing, with elaborations on each part of the flower. Following on pages 100–103 is an excerpt from one such article, as reprinted in 1950 in Wilfred Blunt's *The Art of Botanical Illustration*.

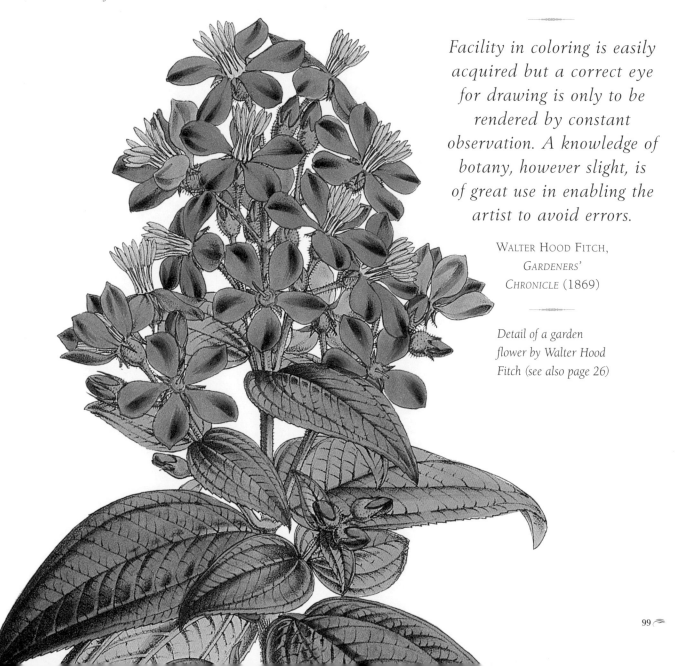

Facility in coloring is easily acquired but a correct eye for drawing is only to be rendered by constant observation. A knowledge of botany, however slight, is of great use in enabling the artist to avoid errors.

WALTER HOOD FITCH,
GARDENERS'
CHRONICLE (1869)

Detail of a garden flower by Walter Hood Fitch (see also page 26)

I may premise that a knowledge of botany, however slight, is of great use in enabling the artist to avoid the errors which are occasionally perpetrated in respectable drawings and publications, such as introducing an abnormal number of stamens in a flower, giving it an inferior ovary when it should have been a superior one, and vice versa. I have frequently seen such negatively instructive illustrations of ignorance—quite inexcusable, for a little knowledge would enable them to be avoided. It is more creditable that one's works should furnish an example than a warning.

STEMS

In the straight stem there is always some degree of curve, therefore, the ruler should never be used; it is the last resort of those unable to make "straight strokes" and only worthy of schoolboys. It is more difficult to draw parallel lines, and the best practice is to sketch grasses or long-leaved plants. Leafy stems or branches should be first faintly outlined their whole length, of their proper thickness, so that the drawing may occupy a well-balanced position on the paper. Then mark whence the leaves spring. It is also desirable to note the shape of the stem, whether square, round, winged, *etc.*

LEAVES

If the leaves are more or less erect in relation to the stem, sketch the lower ones first, as a guide for those above, as in the left-hand cut in the following sketch.

If reflexed, commence with the upper leaves, for the same reason. If done thus systematically, there will be a great saving of time and India-rubber.

Opposite leaves are best shown slightly askew, but if the stem is branched, the leaves on some of the branches should be more or less foreshortened, for the sake of variety.

Outline large leaves faintly before sketching them decidedly, and that should be done with one stroke of the pencil, and not with repeated touches, unless the leaves are woolly, when an indefinite outline is advisable. It is better to put in the midrib first, and it should always have some degree of curve, however stiff the leaves may be—leaves are very seldom so rigid as to have none; then mark whence the veins springs.

In serrated leaves it is safer to put in the serrated outline before doing the veins; and, in cases where the latter terminate in the points of the serratures, commence the veins at the points, and they are sure to terminate properly.

In lobed leaves, after faintly indicating the lobes, put in the ribs and veins first, and the outline of the lobes, particularly if they be toothed, will be found much easier. In digitate leaves, indicate the petiole and midribs first, the relative position of the leaflets can be kept with greater certainty. In pinnate leaves, when large, after faintly sketching the rachis and the points whence the leaflets spring, put in the midribs first, and define the leaflets last; if the pinnate leaf is small, this is unnecessary.

FLOWERS

Flowers are often considered the most difficult parts of a plant to sketch; but such, I think, is not really the case, their perspective being more evident and less varied than that of leaves whose positions are almost infinite.

The most common error perpetrated is that of not placing the flower correctly on its stalk or peduncle, but with its neck dislocated as it were, thus imparting to the sufferer an air of conscious comicality. To avoid this infliction, in making the first sketch prolong the stalk or axis through the flower to the centre, whence the petals or divisions may be made to radiate correctly beyond a doubt. Another common fault is to represent them all pointing in one direction; sometimes this may occur in Nature, but it is not artistic to copy it in every case.

For scientific purposes it is desirable that positions should be as varied as possible. For the front view a faint circle should be penciled, the centre and the divisions of the corolla indicated, and then sketched in as firmly as is desirable. If the drawing is to be coloured, the outline and veins, if any, should be strong enough not to be quite obliterated by dark color.

In a side view the tube should be properly adjusted to correspond with the throat or eye; the simplest way to do so is to carry the outline of the tube faintly through to the centre of the flower, as in the foregoing cut.

Composite flowers, such as the Daisy, after being faintly defined, should be subdivided by lines radiating from the centre, as a guide for the direction of the outer florets. Inattention to this precaution is apt to result in the said florets being all endowed with a twist or curve to one side or the other, an arrangement unknown, I believe, to botanists, in this natural order.

In drawings for scientific purposes, it is proper to mark the number of outer florets, also the number of teeth at the tips, as in some plants they are more or less numerous. The direction the florets assume, whether spreading or reflexed, should be noted.

Uncolored details of an iris (below) and a colored iris (opposite)

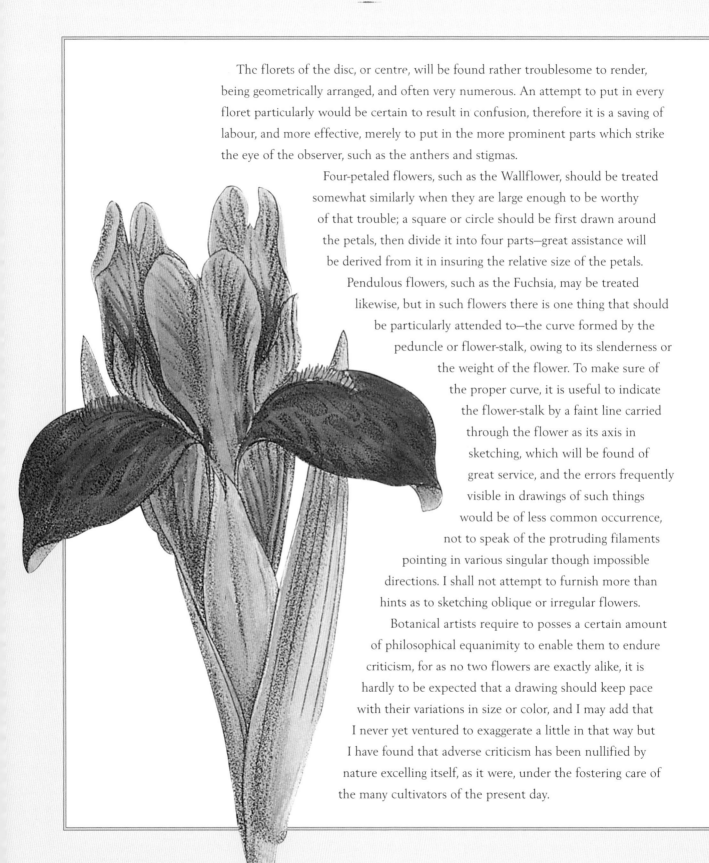

The florets of the disc, or centre, will be found rather troublesome to render, being geometrically arranged, and often very numerous. An attempt to put in every floret particularly would be certain to result in confusion, therefore it is a saving of labour, and more effective, merely to put in the more prominent parts which strike the eye of the observer, such as the anthers and stigmas.

Four-petaled flowers, such as the Wallflower, should be treated somewhat similarly when they are large enough to be worthy of that trouble; a square or circle should be first drawn around the petals, then divide it into four parts—great assistance will be derived from it in insuring the relative size of the petals. Pendulous flowers, such as the Fuchsia, may be treated likewise, but in such flowers there is one thing that should be particularly attended to—the curve formed by the peduncle or flower-stalk, owing to its slenderness or the weight of the flower. To make sure of the proper curve, it is useful to indicate the flower-stalk by a faint line carried through the flower as its axis in sketching, which will be found of great service, and the errors frequently visible in drawings of such things would be of less common occurrence, not to speak of the protruding filaments pointing in various singular though impossible directions. I shall not attempt to furnish more than hints as to sketching oblique or irregular flowers. Botanical artists require to posses a certain amount of philosophical equanimity to enable them to endure criticism, for as no two flowers are exactly alike, it is hardly to be expected that a drawing should keep pace with their variations in size or color, and I may add that I never yet ventured to exaggerate a little in that way but I have found that adverse criticism has been nullified by nature excelling itself, as it were, under the fostering care of the many cultivators of the present day.

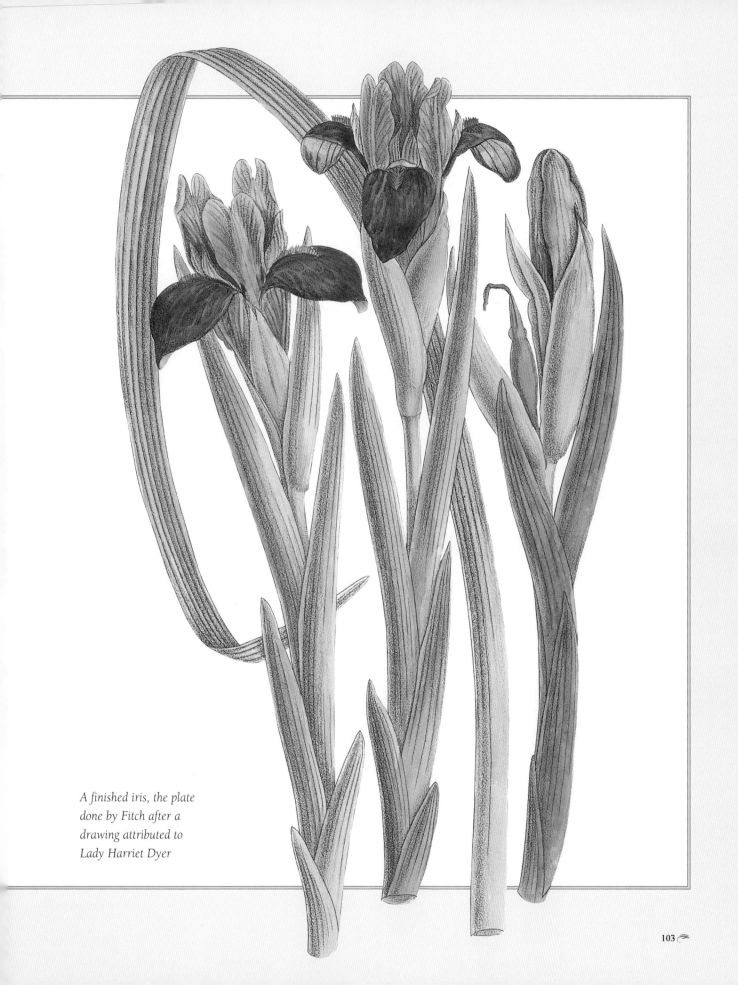

A finished iris, the plate
done by Fitch after a
drawing attributed to
Lady Harriet Dyer

Ada Hanbury
(fl. 1870–1880)

BELOW: *An iris by an anonymous artist, from* Advanced Studies of Flower Painting in Water Colors

OPPOSITE: *Azaleas by Ada Hanbury*

Like many books intended to teach young women how to render plants, *Advanced Studies of Flower Painting in Water Colors,* published in 1885 and credited to Ada Hanbury "and other artists," explains the rudiments of botany and then offers specific instructions for drawing roses, carnations, marigolds, irises, anemones, and other flowers. One unusual feature of this copy book is that the colored drawings are tipped-in photographs that correspond to original outline drawings.

The following excerpt gives detailed instructions for painting flowers:

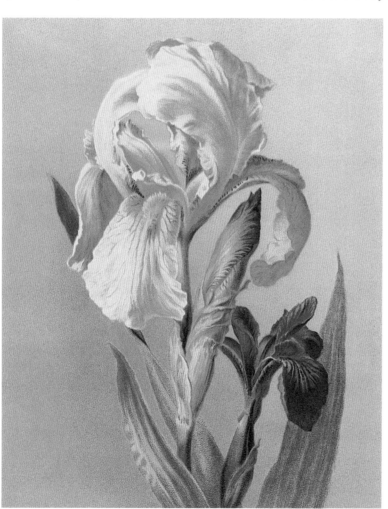

A flower consists of four distinct parts, which are arranged in four circles or whorls. The outside whorl is called the calyx or cup; it is generally of green color and contains the other parts of the flower. The subdivisions of the calyx are called sepals. The second whorl is the corolla whose subdivisions are the petals, and these being the colored and generally the largest features of the blossom.

Inside the corolla lies the stamens which consists of little stalks with a sort of knob at the outer end of each; the little stalk is the filament . . . and the knob is called the anthers. . . . The center of the flower is occupied by the pistil which varies in shape.

Amongst other features of the plant . . . are the peduncle, or long stalk upon which the blossom rests.

Begin with a simple flower . . . Flowers should be drawn as nearly as possible to their natural size.

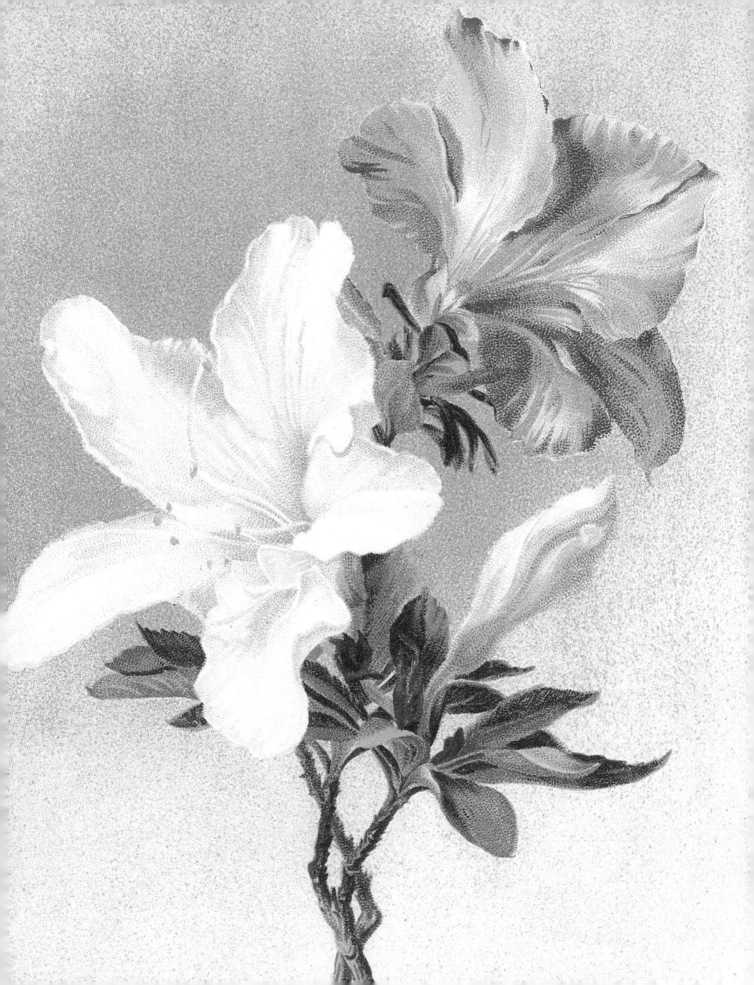

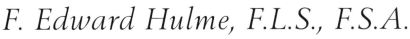

F. Edward Hulme, F.L.S., F.S.A.
(1841–1909)

F. Edward Hulme was a giant in the field of floral drawing. His distinguished pedigree includes a master's degree in art from Marlborough College in 1870, and a tenure as professor of drawing at Kings College in 1885. Publications include *Plants: Their Natural Growth* (1874), a gem of a book that covers everything you would want to know about the decorative and ornamental treatment of plants, as well as *Suggestions in Floral Design* (1878); *Familiar Wild Flowers*, eight volumes (1875–84); and *Flower Painting in Water Colours* (1883).

Hulme was an excellent teacher, and his own work shows a strict confirmation to rules rather than decorative effect. His flower portraits are just that—portraits, accurate but without drama.

The flower painter need fear no glaring sun, no fatiguing walks, no burden of the necessary impedimenta, but in the quiet of his or her own room may strive with more or less success to depict beautiful forms and tints before them. . . . While it is always painful to point out to young individuals that come before one how imperfect their work is, we may render good service if we here indicate that the delineation of plant form requires practice, knowledge, and study.

F. EDWARD HULME, FROM *FLOWER PAINTING IN WATER COLOURS*

Detail of a flower (left) and leaf patterns (opposite), from F. Edward Hulme's Plants: Their Natural Growth

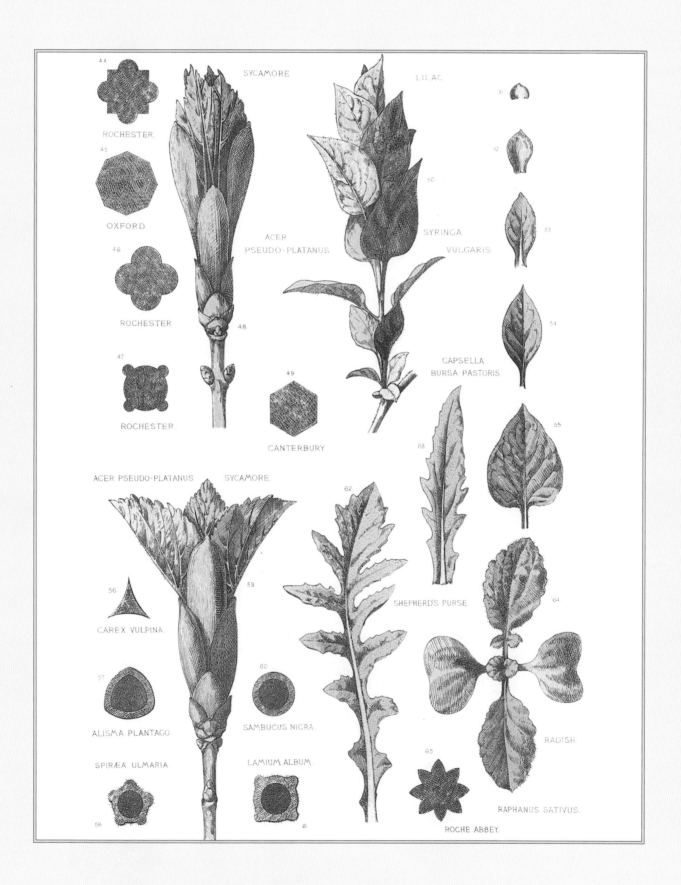

44

ROCHESTER.

45

OXFORD

46

ROCHESTER

47

ROCHESTER

SYCAMORE

ACER
PSEUDO-PLATANUS

48

49

CANTERBURY

LILAC

SYRINGA
VULGARIS

CAPSELLA
BURSA-PASTORIS

51

52

53

54

55

ACER PSEUDO-PLATANUS SYCAMORE.

56

CAREX VULPINA.

57

ALISMA PLANTAGO

SPIRÆA ULMARIA

58

59

60

SAMBUCUS NIGRA

LAMIUM ALBUM.

61

62

63

SHEPHERD'S PURSE.

64

65

RADISH.

RAPHANUS SATIVUS.

ROCHE ABBEY.

Jane Webb Loudon
(1807–1858)

Jane Loudon began as the amanuensis of her famous husband, John Claudius Loudon, but went on to become an accomplished artist in her day. Loudon's great talent is evident in her wonderful four-volume series *The Ladies Ornamental Flower Garden,* published between 1840 and 1844. The book's flowers—brilliantly designed and colored, and botanically accurate—almost jump off the page. (For more on Jane Loudon, see page 156.)

Loudon's work is so significant because she covered the gamut of garden flowers as well as greenhouse indoor plants. In *My Own Garden* (1855), Loudon showed she was a competent gardener with a great affinity for plants, which no doubt accounted for her deft understanding of how they grow and mature.

RIGHT AND OPPOSITE:
Bouquets by Jane Loudon

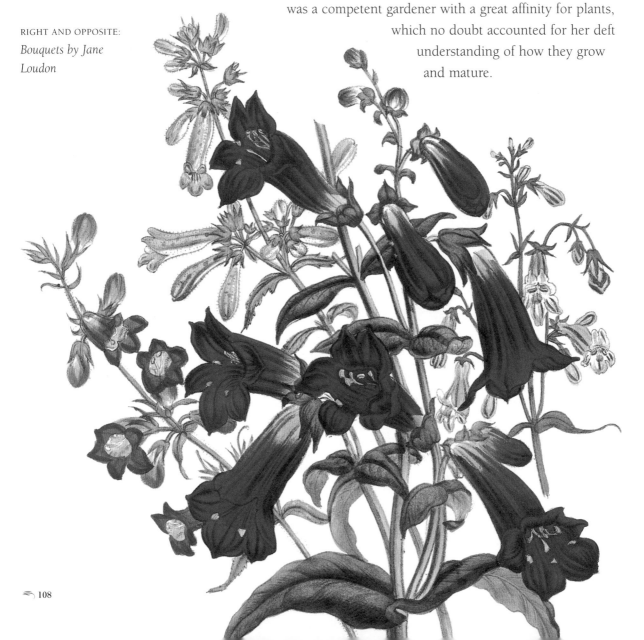

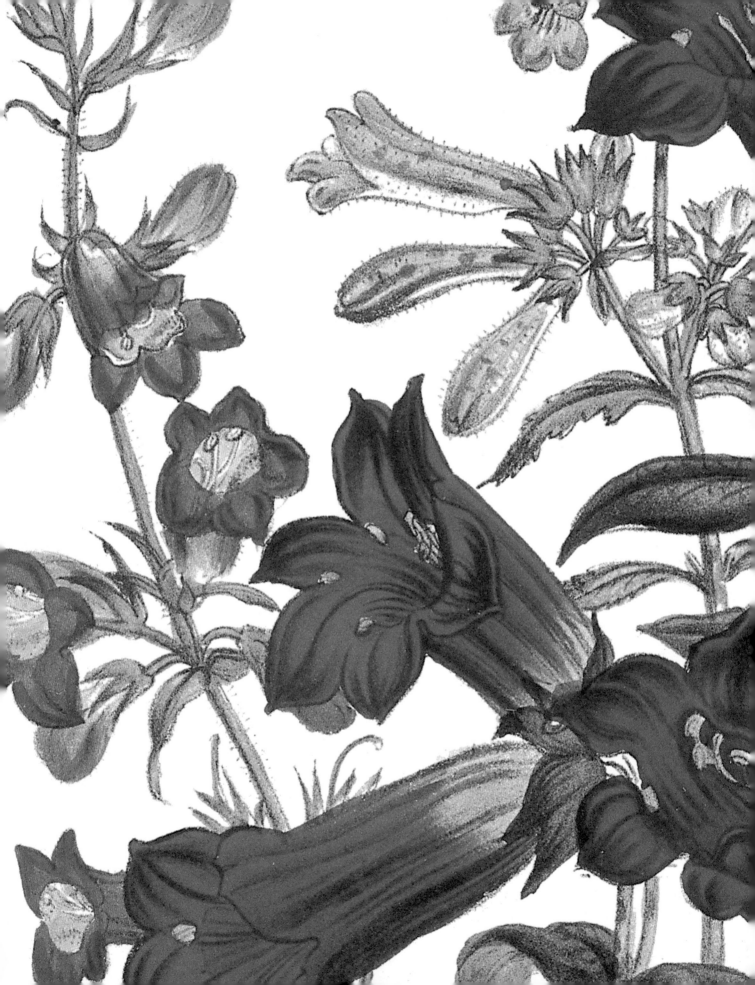

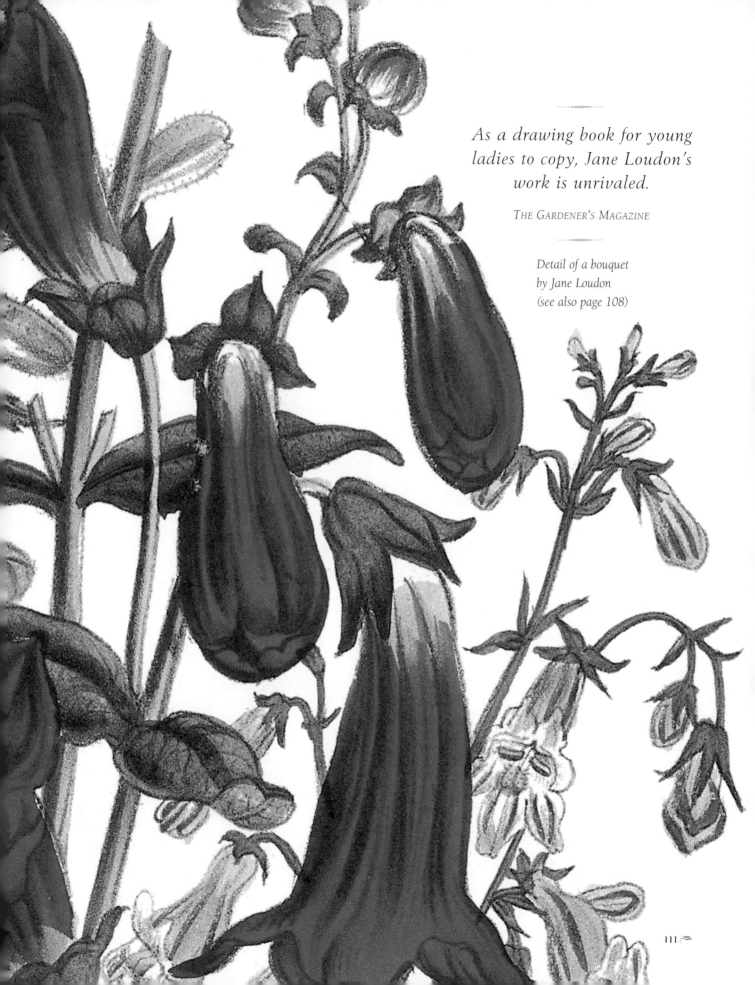

As a drawing book for young ladies to copy, Jane Loudon's work is unrivaled.

THE GARDENER'S MAGAZINE

*Detail of a bouquet
by Jane Loudon
(see also page 108)*

Henrietta Maria Moriarty
(fl. 1800s)

Henrietta Maria Moriarty espoused a fairly common moral position of her day, praising flowers for their religious and moral significance. Her book *Fifty Plates of Greenhouse Plants Drawn and Colored from Nature,* printed in 1807 (second edition), was primarily a botany book, but it also tried to teach young ladies who wanted to draw. In it, there was a series of fine floral watercolors, though no uncolored copy images.

Some controversy exists about Moriarty's drawings. Experts of her time argued that the drawings were too good for a woman's hand and weren't her own work, though the accusations were never proven. Perhaps Moriarty was a governess to wealthy families and had access to their grand flower gardens.

Detail of a Protea, by Henrietta Moriarity

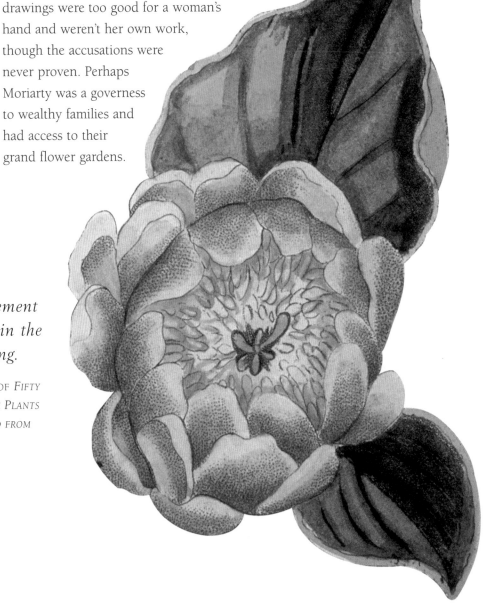

For the improvement of young ladies in the art of drawing.

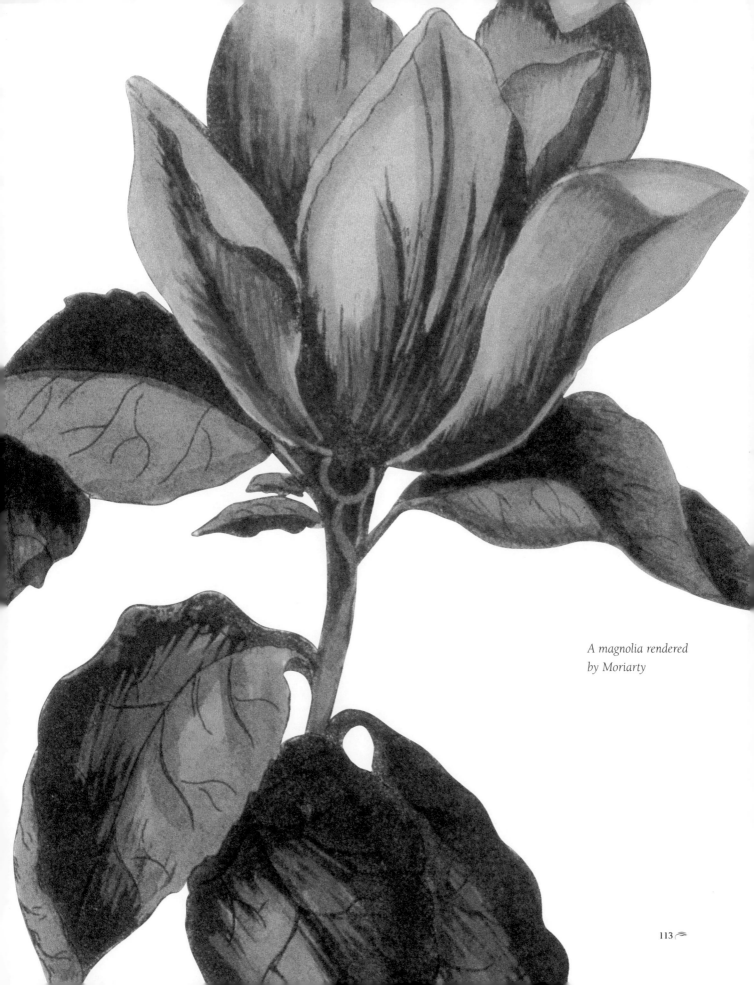

A magnolia rendered by Moriarty

Ethel Nisbet
(fl. 1890)

Little is known about Ethel Nisbet but that she exhibited flower paintings at the Royal Academy, the Society of British Artists, and the New Water-Color Society in the 1880s and 1890s. The following brief excerpt from her book *Flower Painting for Beginners* (no date available) shows how she approached drawing flowers:

BELOW: Uncolored and colored render-ings of poppies, from Ethel Nisbet's Flower Painting for Beginners

OPPOSITE: A dahlia by Nisbet

> *First mark the center of the flowers, placing them accurately with reference to each other. Draw in their stalks, making them point to the flower centers, and noticing the exact curve of each stalk as well as the general direction. . . . After marking the points at which the leaves start and sketching in the central veins, the general form of the flower may be drawn . . . then the separate petals added afterwards. . . . It might be well in dealing with many petals . . . to divide the petals into groups. The petals must be drawn well. The flower should look irregular, but not ragged. The petals should radiate from the center, starlike.*

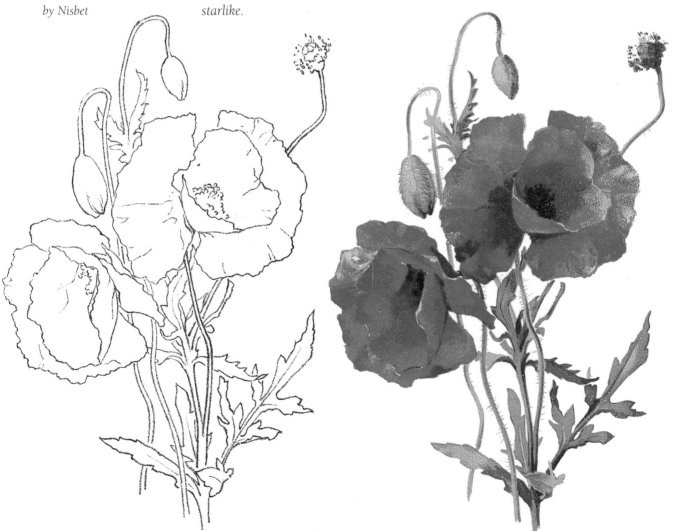

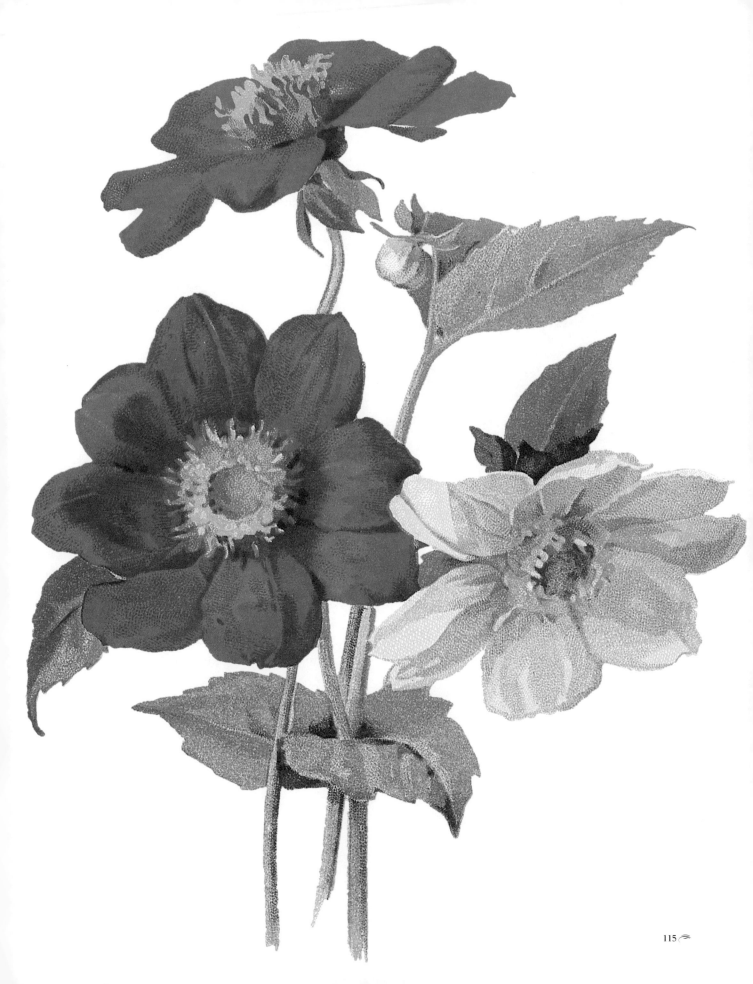

Mrs. E. E. Perkins
(fl. 1830s)

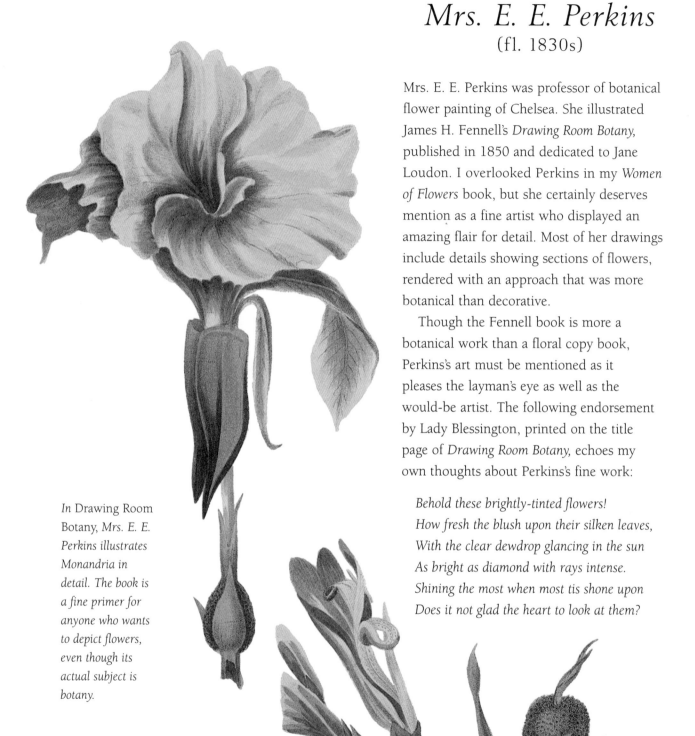

In Drawing Room Botany, *Mrs. E. E. Perkins illustrates Monandria in detail. The book is a fine primer for anyone who wants to depict flowers, even though its actual subject is botany.*

Mrs. E. E. Perkins was professor of botanical flower painting of Chelsea. She illustrated James H. Fennell's *Drawing Room Botany,* published in 1850 and dedicated to Jane Loudon. I overlooked Perkins in my *Women of Flowers* book, but she certainly deserves mention as a fine artist who displayed an amazing flair for detail. Most of her drawings include details showing sections of flowers, rendered with an approach that was more botanical than decorative.

Though the Fennell book is more a botanical work than a floral copy book, Perkins's art must be mentioned as it pleases the layman's eye as well as the would-be artist. The following endorsement by Lady Blessington, printed on the title page of *Drawing Room Botany,* echoes my own thoughts about Perkins's fine work:

Behold these brightly-tinted flowers!
How fresh the blush upon their silken leaves,
With the clear dewdrop glancing in the sun
As bright as diamond with rays intense.
Shining the most when most tis shone upon
Does it not glad the heart to look at them?

Edward Pretty

(fl. 1810)

Not much is known of Edward Pretty, but he is mentioned in Wilfred Blunt's *The Art of Botanical Illustration* along with other great names in the flower-painting arena, such as G. Testolini and Patrick Symes. Pretty was certainly an exceptional artist, as the examples of his work shown here attest. In 1810, he published *A Practical Essay on Flower Painting*, excerpted on pages 118–21.

A Practical Essay on Flower Painting by Edward Pretty appeared in 1810 and was perhaps the most useful and beautiful copy book of the period. The drawings, such as those shown here, are finely detailed and exquisite.

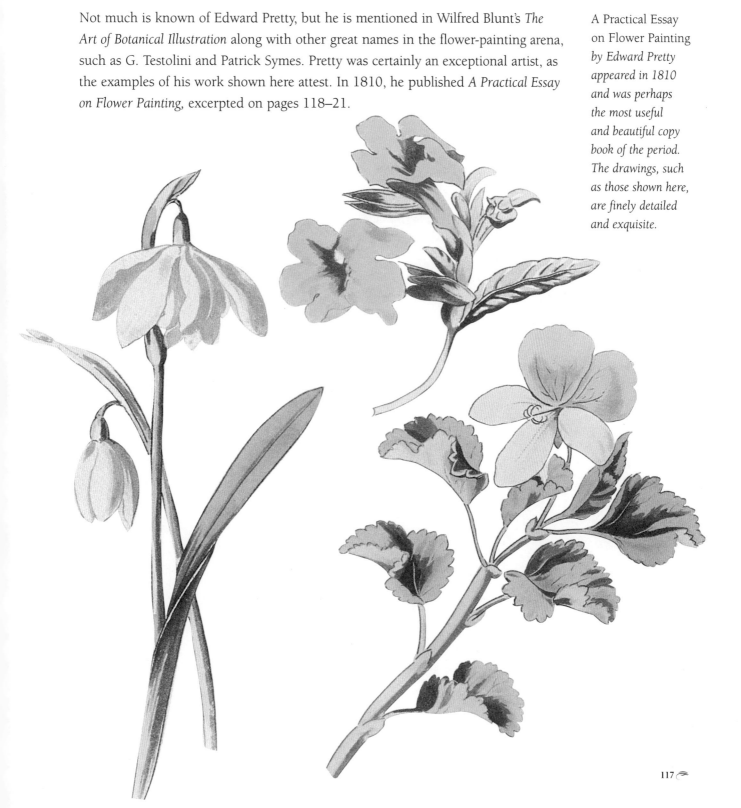

Outline is the first thing to be attempted; and some practice must be made before any attempt is made on Indian ink or colours. The first plate may be copied several times; also the third. Strict attention must be paid not to get a harshness of outline, but to have it as light and clear as possible. As light and shadow is the grand object in every branch of painting, I shall explain it as far as it is connected with art. In drawing the shadows are generally laid in first with neutral or Indian ink. As shadows are occasioned by the absence of light, darkness, its primitive colour is black; in studying from Nature it therefore requires the strictest attention in observing the strength of shadow you have on the natural object, and shading your drawing accordingly.

Uncolored versions of (left to right) a York rose, rosebud, and Austrian rose

The book includes a color chart and twenty-four drawings with full color renditions of geraniums, snowdrops, flax, hawthorn, selsis, hyacinth, polyanthus, wallflower, and several roses—all of the highest quality.

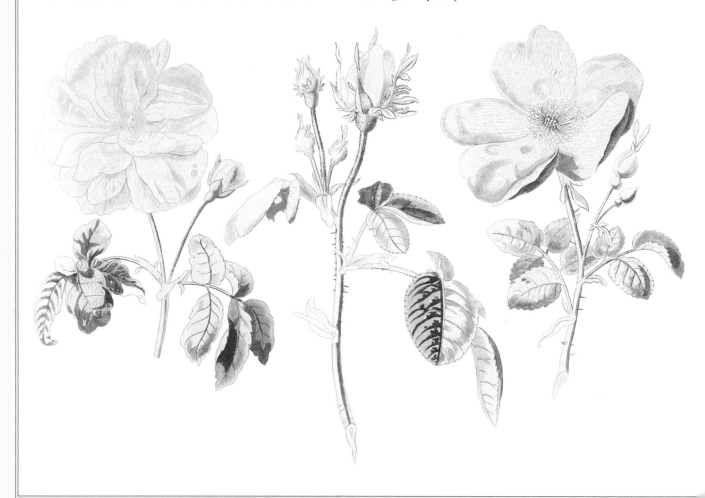

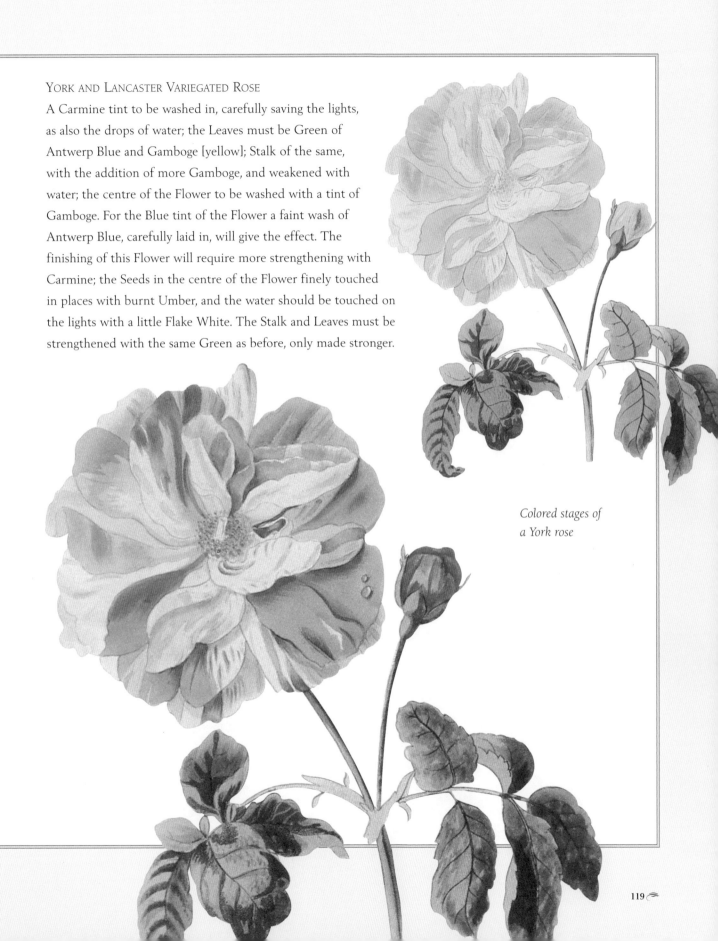

York and Lancaster Variegated Rose

A Carmine tint to be washed in, carefully saving the lights, as also the drops of water; the Leaves must be Green of Antwerp Blue and Gamboge [yellow]; Stalk of the same, with the addition of more Gamboge, and weakened with water; the centre of the Flower to be washed with a tint of Gamboge. For the Blue tint of the Flower a faint wash of Antwerp Blue, carefully laid in, will give the effect. The finishing of this Flower will require more strengthening with Carmine; the Seeds in the centre of the Flower finely touched in places with burnt Umber, and the water should be touched on the lights with a little Flake White. The Stalk and Leaves must be strengthened with the same Green as before, only made stronger.

*Colored stages of
a York rose*

ROSE-BUD

The finishing of this Lesson will require great labour and care. The Flower, a tint of Carmine, with a faint tinge of Blue on the reflected lights; the first Ground, or tint for the Stalk and Leaves, is prepared from Gamboge and White, with the addition of a little Antwerp Blue, just to take off the glare of the Gamboge; and for the Greens, Antwerp Blue, Gamboge, and White, varying them according to the tint required. It will be adviseable in this and every other Lesson to be particularly careful in trying your Tints several times on a piece of paper, as more must depend on the judgment of the Student than on written directions. The Stalk must be tinged in parts with a wash of Lake; the fine touches on the Buds, Stalk, Leaves, and must be burnt Sienna, finishing with the same in the most careful manner possible. On the principal Leaf, a few light touches of the Veins are discernible, which is done with White and a little Gamboge.

*Colored stages of
a rosebud*

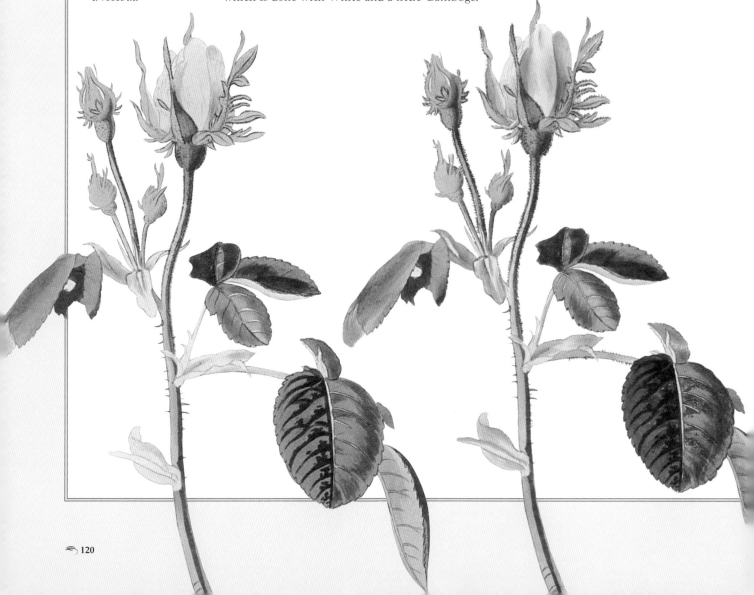

Austrian Rose

This Flower must be entirely laid in with a ground tint of Indian Yellow and afterwards glazed with Red Lead; the Leaves should be washed in with a Green of Antwerp Blue and Gamboge; the Stalk, a tint of Lake [red/Carmine], mixed with a little Green. For the finishing of the Flower, Carmine should be used, which must be chiefly done by hatching; afterwards the Veins of the Corollae should be cut up, and the water touched in, finishing with a touch of light on the drops: the spots on the Stamina are Carmine very strong; the Stalk should now be brightened with Carmine, and the thorns touched in with the same; the Leaves must be finished with a stronger Green of Prussian Blue and Gamboge, adding a little Sap Green.

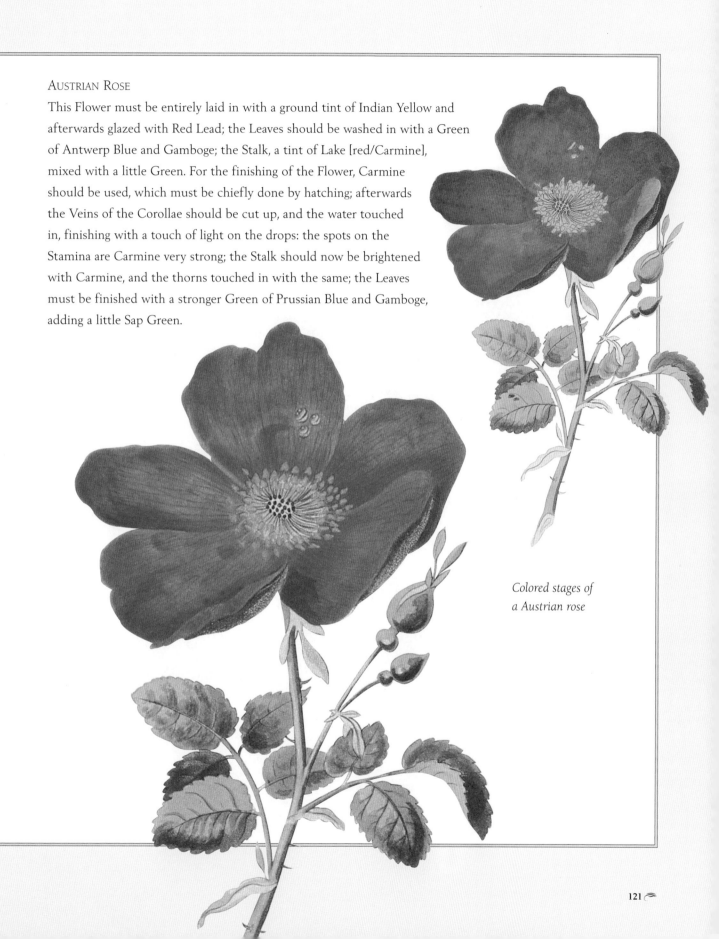

*Colored stages of
a Austrian rose*

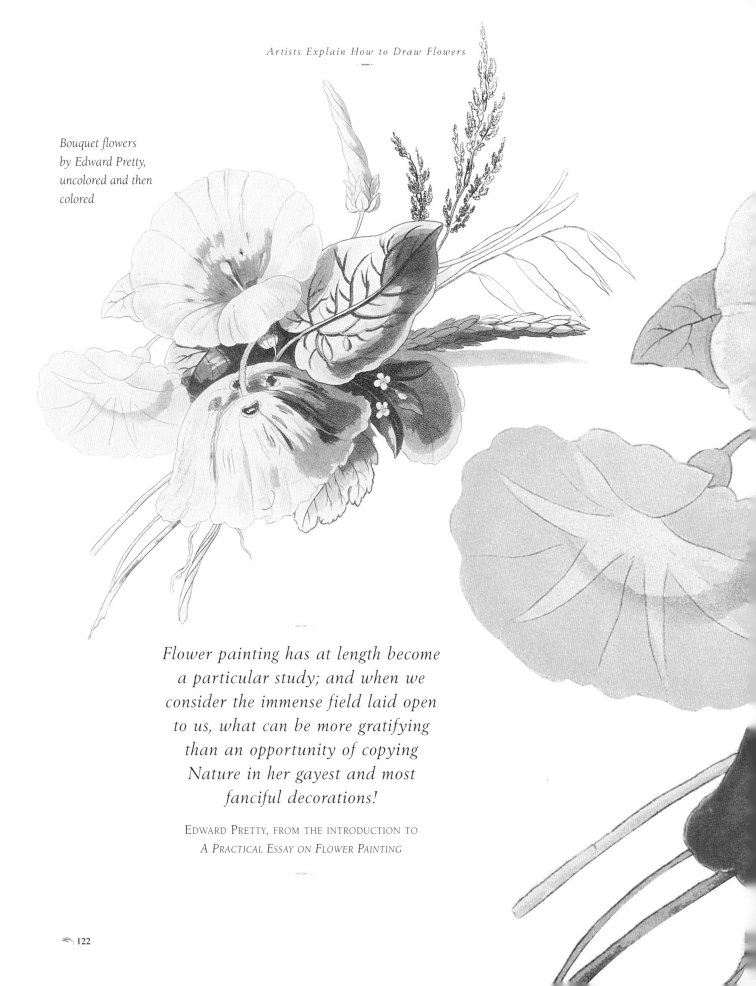

Bouquet flowers by Edward Pretty, uncolored and then colored

Flower painting has at length become a particular study; and when we consider the immense field laid open to us, what can be more gratifying than an opportunity of copying Nature in her gayest and most fanciful decorations!

EDWARD PRETTY, FROM THE INTRODUCTION TO *A PRACTICAL ESSAY ON FLOWER PAINTING*

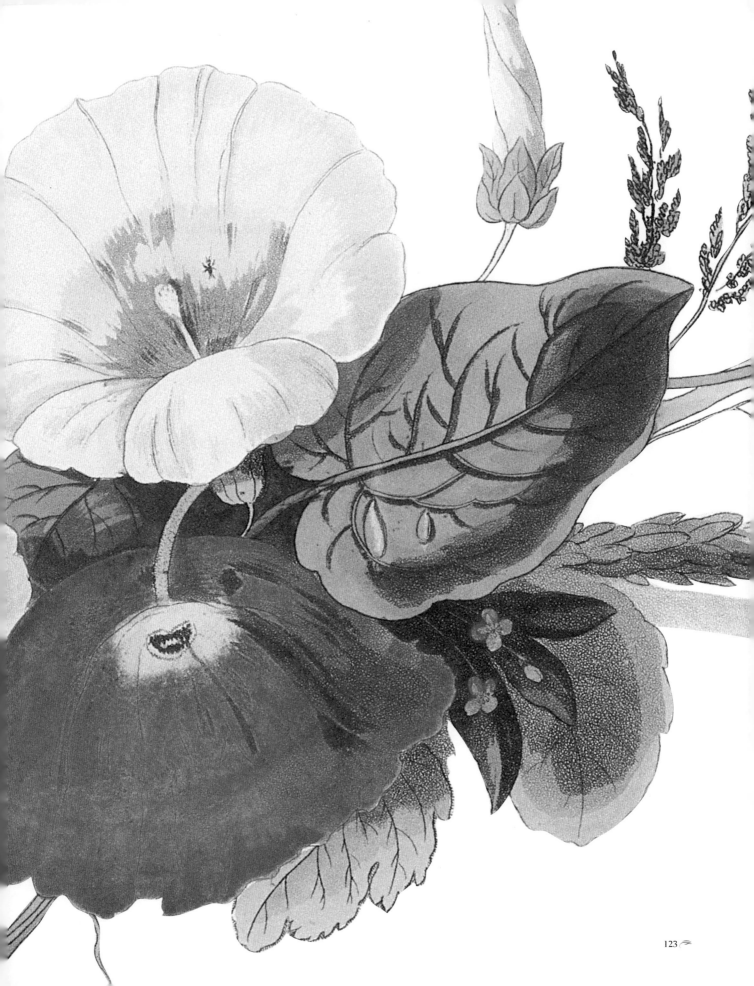

Pierre-Joseph Redouté
(1759–1840)

Redouté's Blumenmalerkunst, although neither written nor illustrated by Pierre-Joseph Redouté, is a German translation of Antoine Pascal's *L'Aquarelle ou les Fleurs peintes d'après la Methode de M. Redouté*, which was supposedly a guide to how Redouté painted his flowers.

Pascal was one of Redouté's few male students; questions remain, however, about whether Redouté authorized the content of *L'Aquarelle*, or even whether the book actually existed. We do find support of the work with its inclusion in the catalog for a 1975 Sotheby's auction of the magnificent botanical library of collector Arpad Plesch, which is listed as including a copy of *L'Aquarelle ou les Fleurs peintes d'après la Methode de M. Redouté* (lot 588).

> *Drawing is the basis of everything. Someone who knows how to draw will not have any difficulty painting. This is a principle that cannot be said enough to those who want to become a watercolor painter and consider drawing to be a boring and useless task.*
>
> FROM *REDOUTÉ'S BLUMENMALERKUNST*

Additional support for *L'Aquarelle*'s existence comes from Wildred Blunt's *The Art of Botanical Illustration* (1950), in which Blunt states, "Dunthorne describes *L'Album des Dames* (1830) as 'the only French book of note' of this kind; but he does not seem to know of Antoine Pascal's *L'Aquarelle ou les Fleurs peintes d'après la Methode de M. Redouté* (1836). Nor have I seen this, for what was perhaps the only copy in this country, that at the British Museum, was destroyed by bombs during the second World War; but it might be a work of some importance." Redouté was quite secretive about his painting techniques, but since Pascal was one of his students, the French version is probably quite satisfactory.

Redouté's Blumenmalerkunst, published in 1839 and credited only to "an admirer of flower painting art," is a German translation of *L'Aquarelle*, though it cannot be established definitively as an authentic translation because it is unrecorded. The book explains how to paint with nature and gives an introduction to plant knowledge, flower painting techniques, and composition. Its plates are attributed to Bernard et Frey.

Because Redouté is considered the epitome of botanical artists, a label certainly justified by his renderings of roses and irises, I am including on pages 128–29 an excerpt from *Blumenmalerkunst*, translated into English.

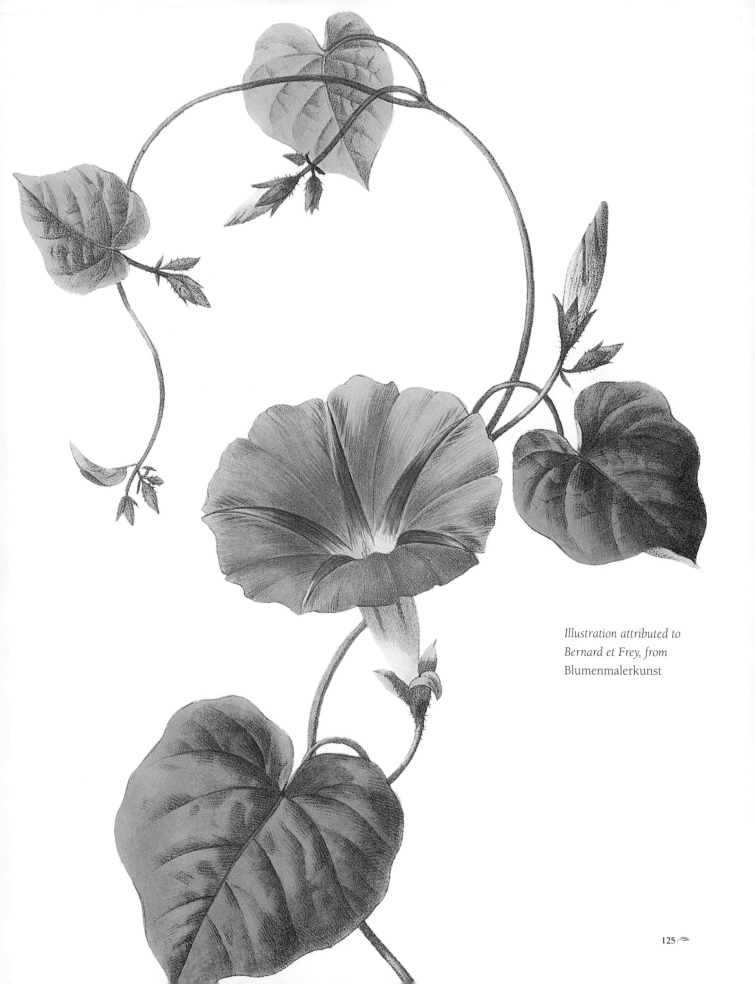

Illustration attributed to
Bernard et Frey, from
Blumenmalerkunst

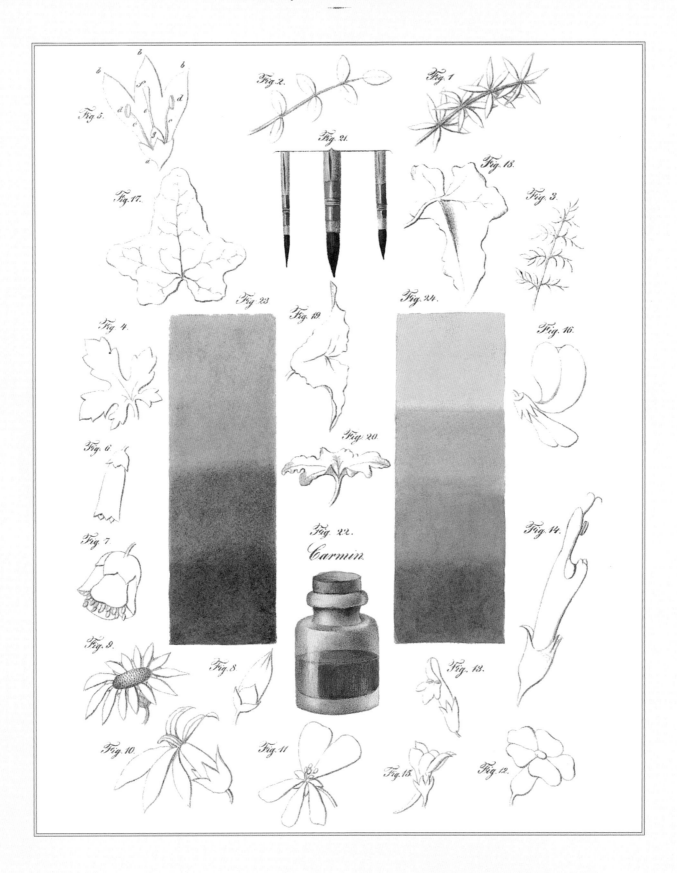

OPPOSITE: *A paint chart attributed to Bernard et Frey, from* Blumenmalerkunst. *The plants here and in the illustrations on pages 127–29 are from the garden of Jacques Martin Cel.*

LEFT: *Outline drawing attributed to Bernard et Frey, from* Blumenmalerkunst

First you have to be familiar with the basics of painting, followed by the rules of perspective. For our purposes, aerial perspective is indispensable, much more important than linear, since it demonstrates how to move objects to the back or foreground by strengthening or weakening color. Correctly used, aerial perspective allows you to give a curve to an object. In contrast, linear perspective centers on correct drawing, which can tend to make an artist render all leaves the same way.

The flower painter concerned with the strongest standards of science must also have some knowledge about botany or important details will be missed. Although we are mostly concerned with what we see above the ground, in certain groups, like the onions, roots are important. Therefore it is no subject for a flower painter. There are even air plants, which shoot their roots in the air. In this case the roots, also belong to the characteristic impression of the plant, which has to be studied closely by the flower painter because certain flowers are only distinguishable this way.

The shape of leaves and their positions are also important. They may be lily, sword, spear, heart, violin, barrel, organ, shield, or club shaped. There are also triangular, three-sided, and wedge-shaped leaves. Leaves may be positioned face-to-face, crossed, in an arrangement of three, four, or five, in two rows or lines, by turns, in no pattern, or in a bunch. Additionally there are sometimes also side leaves, which can be bound up with the main leaf, stand free, or form a sheath around the stalk.

The part of a plant that is the most important one for the flower painter is the blossom. Since it is a more complex structure than the leaves we have to study it more carefully and should use a magnifying glass.

Drawing is the basis of everything. Someone who knows how to draw will not have any difficulty painting. This is a principle that cannot be said enough to those who want to become watercolor painters and consider drawing a boring and useless task. The start is very hard but a good will paired with endurance will succeed all difficulties. Here are some guiding words for the one who is his own teacher.

When drawing a plant or parts of it with just a slight suggestion of the shadows, catching merely a moment, it is called a sketch; it is only an impression of what will result when you paint the same item with time

An uncolored narcissus (right) and the same narcissus, colored (opposite), attributed to Bernard et Frey, from Blumenmalerkunst

and leisure. When there is an indication of color it is called a colored sketch; an example would be the drawing of a six-leafed crown with one leaf colored, or one of a stalk with only one green leaf. You might consider this to be imperfect but very often it is not possible to work any other way.

The sketch is followed by the design, which contains further detail and shows the object more finely. You can also hatch it with a dry brush but the result appears hard compared with the one made using watercolor.

When using dry colors you are not always in need of hatching but by using it a little, by painting a couple of times over the same spot, or by moving the pencil or chalk in little circles, you are able to create an image which is similar to one in wash.

To make it easier to learn to draw, practice copying until your hand knows how to draw different types of lines effortlessly. When this is accomplished try using a brush; at the beginning you should only paint thin lines, which improves guiding a brush because you are forced to hold it as effortlessly as possible, which is very hard at the beginning. You need a relaxed hand, which may be relaxed but can also draw strong lines. A common mistake among beginners is the fact that they push too hard, which brakes the chalk or pencil tip and creates brush lines with different widths.

When drawing a plant the most important things are the choice of the subject and the way it is shown. They indicate the talent of the artist.

When we look at two roses we will see very soon which one is the more perfect. Next, we must find the optimal position for it. Probably it is best painted in its entirety and when you can see its flower leaves from the front or from the side. Taste must make this decision; you have to choose a position that shows the harmony of the lines as well as the beauty of the item. Additionally you have to take care of the lights and shadows in order to make it perfectly clear what your drawing is supposed to be.

Begin with simple objects, then advance to more complicated ones.

George F. Rosenberg
(1825–1869)

In his book *A Guide to Flower Painting in Water Colours*, published in 1853, George Rosenberg concentrated on the structural arrangement of the flower's calyx, corolla, organs of germination, and leaves. The balance of this small book mentions materials to purchase and then includes forty pages from a catalog of George Downey & Co., a supplier of artists' materials. Herewith are a few details from Rosenberg's book:

In flower painting, as in all other branches of the fine arts, form is the first thing to be studied. Flowers [like every other class of objects in nature] have their own peculiarities of structure, and without some acquaintance of their anatomy, it is hardly to be expected that the most careful draughtsman will avoid committing gross errors.

The leaves of plants . . . are as wondrously beautiful in themselves as the flowers. . . .

Pictured are some of the most unusual and varied forms of the leaves. . . . There are ribs and veins . . . the skeleton of frame that supports the substance of material which the leaf is composed. There is usually but not always a central rib, from either side of which others of lesser size branch, alternately or in pairs, these again having supplementary veins crossing from one to the other until the whole leaf is one mass of network.

Calochortus by George Rosenberg

James Sowerby
(1757–1822)

James Sowerby was known more for his multi-volume *English Botany*, published over a twenty-four-year period and to which he contributed some twenty-five thousand plates, than he was for his book *An Easy Introduction to Drawing Flowers*, published in 1788.

Sowerby was a student at the Royal Academy and was first made an apprentice to a marine painter. He then tried his hand at portrait painting and started to teach. He probably published *An Easy Introduction to Drawing Flowers*, originally intended for beginners as well as for his own pupils, just as the mania for how-to-draw flower books began.

The key to Sowerby's philosophy and work was botanical detail. Though his art was not decorative, it was always botanically accurate. Sowerby was a strict disciplinarian who perfectly delineated every leaf and flower, and he emphasized that young beginners who wanted to paint flowers must understand botany.

This [book] is to blend amusement with improvement and provide color plates of botanical details.

JAMES SOWERBY, FROM *AN EASY INTRODUCTION TO DRAWING FLOWERS*

Hypericum by James Sowerby

Patrick Syme
(1774–1845)

Patrick Syme's book *Practical Directions for Learning Flower Drawing*, published in 1813, is unique because it includes step-by-step instructions and outlines of flowers that take the reader from pencil sketch to first coloring, and, finally, completed illustration. Syme's line work was delicate and lacked boldness, but his step-by-step method of coloring worked. He was adamant about making accurate outline sketches and studying the final sketch from all angles, as is evident in the following excerpt:

> *The outline ought to be clean and delicate, and every line drawn with firmness and decision. In making the outline the pupil should examine the flower at first as a whole, and conceive an idea of its general form, and of the shape of the principle parts of which it is composed. A general outline of the different parts is to be sketched with a pencil, in a very light manner, comparing them with one another, and examining their proportions. . . . But it is of material consequence that the greatest exactness be observed in making the outline of every part of the plant; for in a flower that has lateral leaves growing out from the stem, exactly opposite to each other, if these are placed a little above or below where they should be, the character of the plant is changed. Nature indeed is so fond of variety, that one plant of the same species is scarcely to be found exactly like another, in size and color; yet she is uniform with respect to their characteristics; for if these be altered in the smallest degree, a botanist will be at a loss in what class, order, or genus the plant should be arranged.*

The author hopes that this work will be a useful guide to ladies in the country, who wish to learn flower-drawing; and particularly those who have not had the opportunity of receiving instructions from a master.

PATRICK SYME, FROM THE PREFACE TO *PRACTICAL DIRECTIONS FOR LEARNING FLOWER DRAWING*

Syme was, without a doubt, a perfectionist. Many of his drawings are on display in the National Gallery in Edinburgh, Scotland. Following on pages 134–35 are his instructions for depicting the cinquefoil, or wild tansy.

OPPOSITE: *Patrick Syme's* Practical Directions for Learning Flower Drawing, *published in 1813, contained general instruction as well as step by steps for painting flowers.*

This plant, which represents a specimen of the wild-tansy (*Potentilla anserine*), is intended to illustrate the drawing, shading, and colouring of yellow flowers, being particularly adapted for those learning flower-drawing. It is of a clear yellow colour, inclining a little to a straw tint. This will be found easier to copy than a deep yellow flower, bordering upon orange.

For the first shades of this flower, use a mixture of light red, gamboges [yellow], and Prussian blue; and in making this tint, take more gamboge than of the other two colours, and less blue than red, trying the tint upon a piece of paper before beginning to shade. Repeat this tint two or three times very pale and soften every shade. After having done the partial shades, go over the whole flower with pale gamboge, as is done in the two uppermost petals of the half-finished flower. Do the stamina over with gamboge and orpiment [orange to lemon-yellow]; afterwards take a tint of gamboge, with a small quantity of orpiment in it, to do the middle parts of the five petals of the flower; then finish the partial shades with light red, Prussian blue, and gamboge mixed, in fine touches, without softening. Do the veins in the middle of the petals with orpiment and gamboge; draw them with a fine pointed small brush, taking great care to make them ramify regularly on each side. Finish the stamina with burnt sienna, mixed with a very small quantity of orpiment and blue. Do the first shades of the green leaves with a pale tint of gamboge and Prussian blue, taking nearly equal parts of each colour. Do the calyx or flower-cup of the bud in the same manner, but for the calyx of the large flower head, use a little burnt umber along with the blue and yellow. After the partial shades of the green leaves are done, as represented by the leaf attached to the joint from which the bud springs, do them all over with the same tint. The calyx of the bud is to be done with the same colours. Repeat with a deeper tint of the same colours, two or three times, as in the partial shades of the green leaves. The touches are so small in these leaves, they require no softening. Keep the points of the green leaves very sharp, and finish the calyx of the bud with a little umber, mixed with the other colours. The calyx of the large flower-head may be lightly touched with the same. With this tint finish also the olive-green parts about the joints, and the stems of the bud, and green leaves; and take it a little lighter and more on the gamboge for the two ends of the main stem.

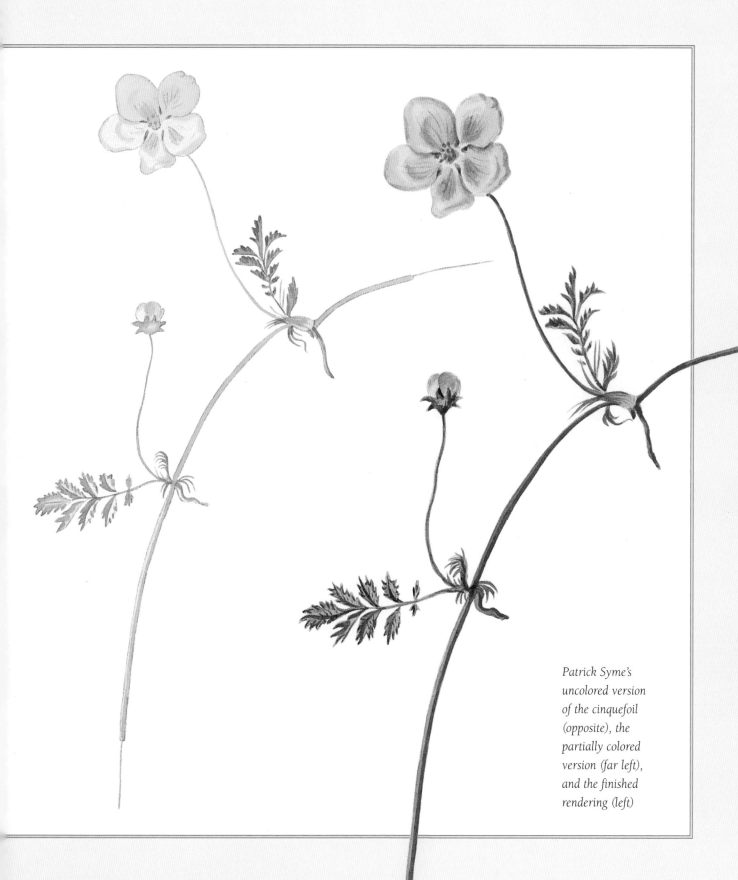

*Patrick Syme's
uncolored version
of the cinquefoil
(opposite), the
partially colored
version (far left),
and the finished
rendering (left)*

A Gallery
of Artists

The artists featured alphabetically on the following pages are among those whom I especially admire. Like most in this book, the illustrations have been taken from my personal collection. The notes about each artist's works are my own commentary; you may be the judge of the illustrations' beauty for yourselves.

If your favorite artist is missing, it is simply a result of limited space. Further, I have only included works that I have personally viewed. I have omitted contemporary floral artists and landscape floral painters, concentrating instead on botanical artists of the eighteenth and nineteenth centuries.

Detail of foxgloves and snapdragons,
by Anne Pratt (see also page 163)

Pancrace Bessa
(1772–1835)

Pancrace Bessa was considered a printer of fine talent, yet was always overshadowed by his famous teacher, Pierre-Joseph Redouté. Born in Paris, Bessa was one of Redouté's few male students; he was also a student of Gerard van Spaendonck. It was said that, along with Redouté, Bessa contributed plates for the botanist Aimé Bonpland's *Description des Plantes rares cultivées à Malmaison et à Navarre* (1812–17).

Bessa's technique of stipple engraving, similar to that used by Redouté, was prominently used in his book *Fleurs et Fruites*, published in 1808. He was also proficient at fruit portraiture. Ultimately, Bessa was appointed flower painter to the Duchess of Berry, becoming her drawing master in 1820. He also exhibited at the Paris Salon.

Bessa drew more than five hundred illustrations for Mordant de Launay's periodical *Herbier Général de l'Amateur,* published from 1810 to 1837. He was also responsible for the charming, petite drawings that illustrate Charlotte de la Tour's well-known *Le Langage des Fleurs,* published in 1819 (see page 49). Along with Redouté, Bessa was appointed painter of vellums at the Museé d'Histoire Naturelle in Paris in 1823 after Gerard van Spaendonck left. Bessa retired around 1830.

Pancrace Bessa is responsible for the impressive illustrations in Charlotte de la Tour's Le Langage des Fleurs, *perhaps the vanguard of the language-of-flowers books. Here is a fine rendering of marguerites and violets from the book.*

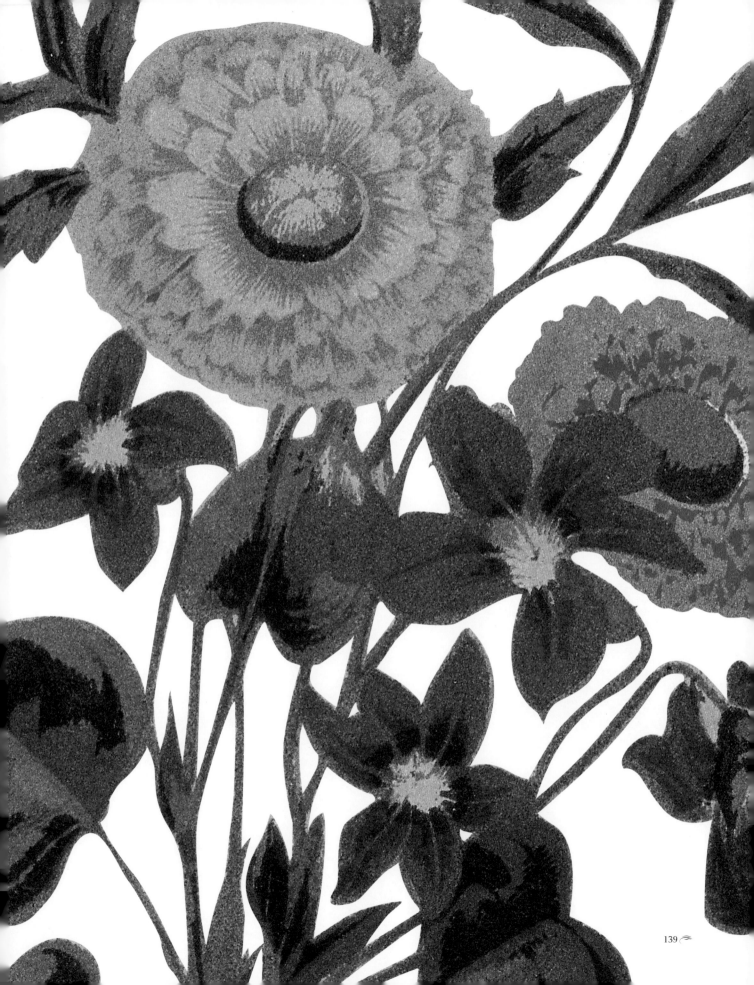

Elizabeth Blackwell
(1700–1758)

The story of Elizabeth Blackwell is full of intrigue and industry—and devotion. Her husband, Dr. Alexander Blackwell, opened a print shop in London without having completed the apprenticeship required by law, and was thereby arrested and imprisoned. Elizabeth Blackwell was devastated; she faced a bleak future without him. A woman of resources and intelligence, however, she learned that doctors needed an illustrated herbal guide. Sir Hans Sloane of the Botanical Garden at Chelsea encouraged Blackwell repeatedly to produce such a book until she set to work near the Physic Gardens, industriously studying and drawing plants.

Elizabeth Blackwell's rendition of a peony from the Physic Gardens

Blackwell knew that as a woman she would find it difficult to obtain the help necessary to produce such a work, so she decided to sketch her own drawings, engrave them on copperplates, and hand-color them herself. This was an unusual and monumental task, but succeed she did, and on a grand scale.

Blackwell's magnificent two-volume work, titled *A Curious Herbal,* stands as one of the earliest English herbal reference books. The volumes contain five hundred hand-colored plates; four plates were done with each leaf for more than 125 weeks, starting in 1737 and ending in 1739. Blackwell's drawings may lack the elegance and style of some later botanical works, but they were done to aid in the identification of plants rather than for decorative appeal.

Blackwell's heroic efforts paid off, and the money she earned helped get her husband out of debtor's prison—but he could not keep out of trouble. Dr. Blackwell traveled on his own to Sweden in the 1740s, where he allegedly became involved in a conspiracy to alter the Swedish succession and was convicted of high treason. He was executed in 1747. Elizabeth Blackwell did no more illustrations. She died in 1758.

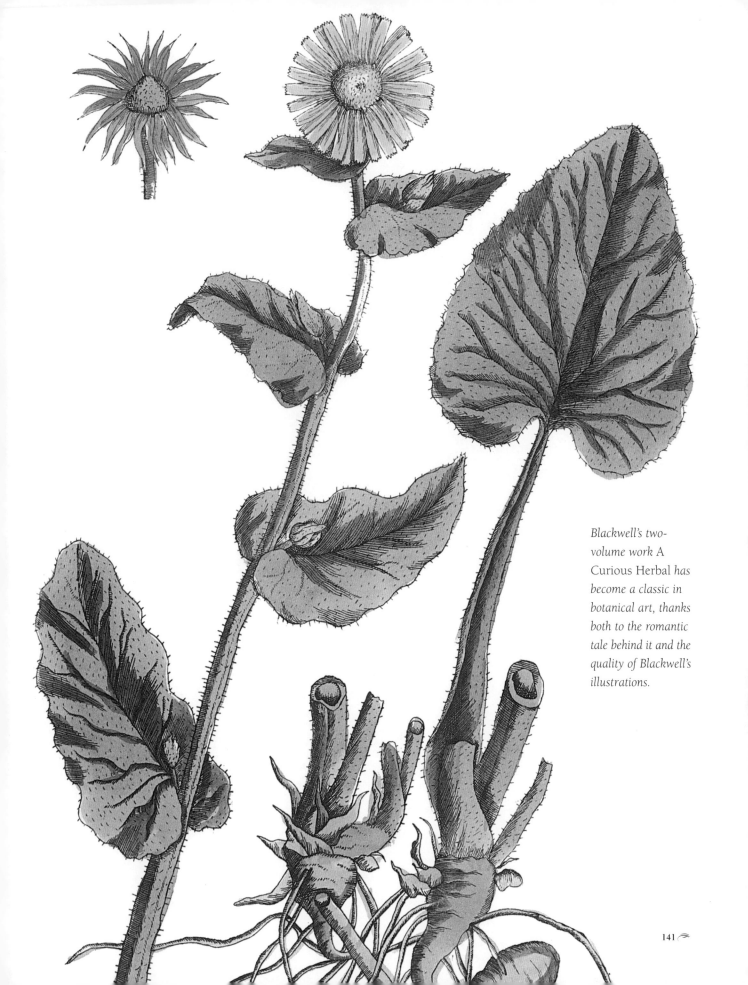

Blackwell's two-volume work A Curious Herbal has become a classic in botanical art, thanks both to the romantic tale behind it and the quality of Blackwell's illustrations.

Sarah Anne Drake
(1803–1857)

Sarah Anne Drake was a prolific botanical artist whose work appeared in scores of botanical publications, yet she is most known for her portraits of orchids in James Bateman's mammoth *Orchidaceae of Mexico and Guatemala* (1837–43). She also did illustrations for Sydenham Edwards's magazine *The Botanical Register,* and in fact it was her excellent illustrations of exotic plants that made that magazine so popular.

Drake was a friend of John Lindley, a professor of botany, which explains her association with Edwards and Bateman. She did detailed drawings for Lindley's very popular book *Ladies Botany,* which went through several printings between 1834 and 1837, though she was never credited on the title page. Her orchid drawings for Lindley's *Sertum Orchidaceae* (1837) were magnificent and continue to be highly revered by collectors. Drake also contributed to the esteemed periodical *Transactions of the Royal Horticultural Society.* With such a volume of work, Drake is now considered one of the finest botanical artists of her time.

Drake also knew John Lindley's sister, Anne, and had a long association with the family. She lived in the family's household while studying in Paris in 1830, and Lindley was obviously responsible for her great interest in orchids. In 1847, Drake lived with an uncle, Daniel Drake, and in 1852 married a farmer, John Sutton Hastings. She died in 1857, supposedly from diabetes.[1]

> *To be able to draw flowers botanically—with the characteristics by which varieties and subvarieties are distinguished—is one of the most useful accomplishments of your ladies of leisure living in the country. It is due to Miss Drake of Turham Green to state that her talents for teaching these objects are of the highest order.*
>
> THE GARDENER'S MAGAZINE, 1831

RIGHT: *Detail of a sweet orange, by Sarah Anne Drake*

[1] Material paraphrased from *John Lindley,* edited by William Stearn (Antique Collectors Club, 1999).

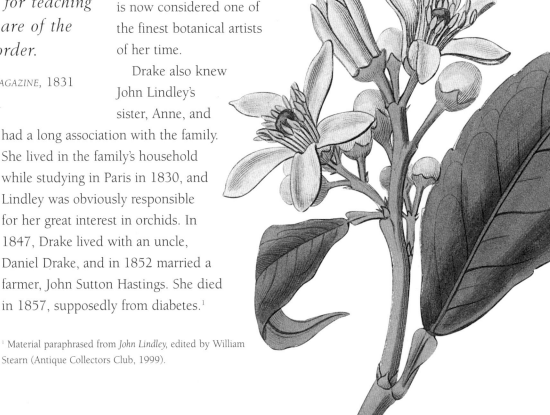

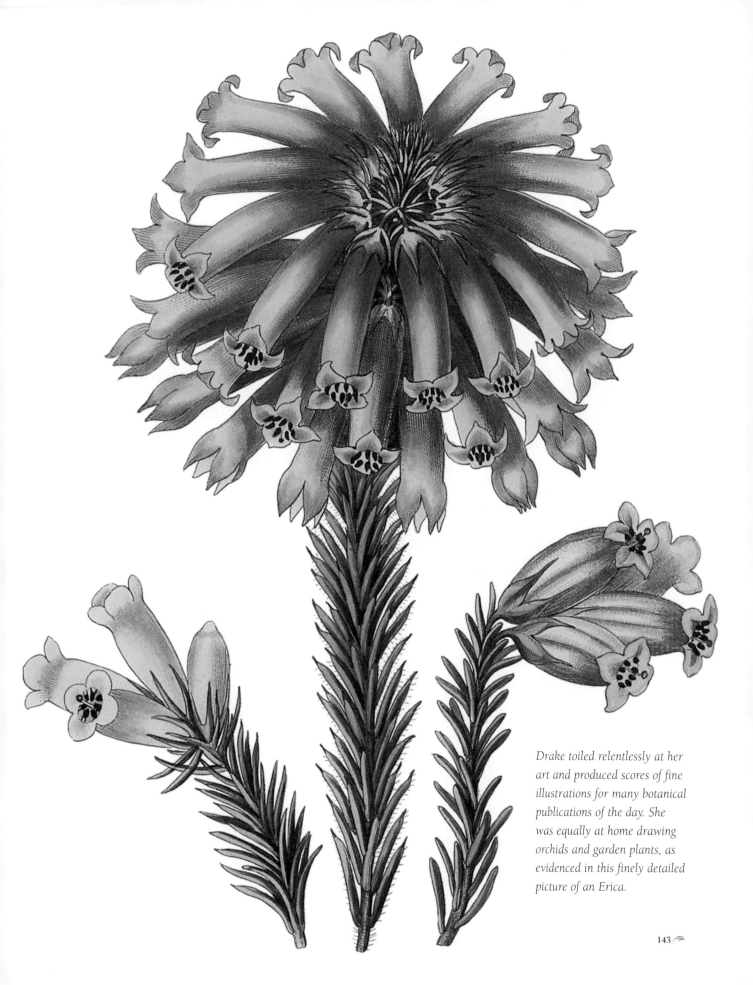

Drake toiled relentlessly at her art and produced scores of fine illustrations for many botanical publications of the day. She was equally at home drawing orchids and garden plants, as evidenced in this finely detailed picture of an Erica.

143

Lady Harriet Anne Thiselton Dyer (née Hooker)
(1854–1945)

Harriet Anne Hooker was the eldest daughter of Sir Joseph Dalton Hooker, who took over *Curtis's Botanical Magazine* when his father, Sir William Jackson Hooker, stepped aside. She married W. T. Thiselton Dyer, the director assistant, and later director, of Kew Gardens. Having grown up steeped in botany, Lady Dyer had a love of gardening as well as an appreciation of art. Blessed with the master botanical artist Walter Hood Fitch as a teacher, it was easy for her to develop her natural drawing talent.

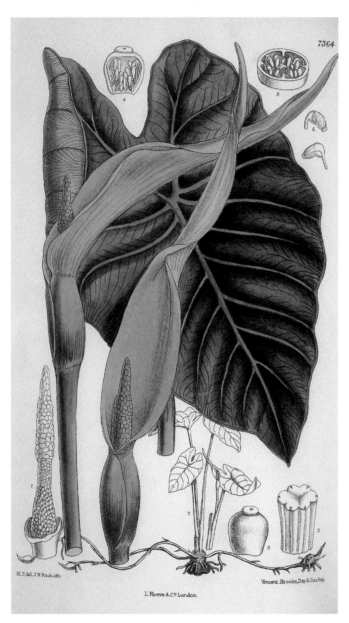

When Fitch resigned his position with *Curtis's Botanical Magazine*, someone had to take over his drawing duties. At her father's urging, Lady Dyer stepped into the role and went on to create lovely, accurate drawings. In only two years, between 1878 and 1880, she rendered almost one hundred illustrations. It is also said that she contributed drawings to Charles McIntosh's horticultural books.

At the age of 74, Lady Dyer, by then a widow, moved to Devonshire and created a fabulous garden, an amazing feat at that age. With the proverbial green thumb, anything she put into the ground flourished. As *Nature Magazine* said of her in its February 1946 issue, "She was a très grande dame."

Dyer's work contains great detail; she created fine compositions and possessed a well-honed sense of coloring, no doubt assisted by observation of her own gardens.

The eldest daughter of Sir Joseph Dalton Hooker, Lady Harriet Dyer was known for her green thumb as well as for her art, such as this fabulous Aroid illustration for Curtis's Botanical Magazine.

Elsie Katherine Dykes (née Kaye)
(d. 1933)

William Rickatson Dykes was a giant among horticulturists, but one doubts if he could have achieved such fame without the aid of his wife, Katherine. William died before completing his famous tulip book, *Notes on Tulip Species,* and it was Katherine who edited and completed the work, using watercolors she had done from living specimens.

William Dykes was secretary of the Royal Horticultural Society in London and an astute observer of irises and tulips. Katherine shared his enthusiasm in the garden; at one time she was known as the "Lady of the Irises." Her beautiful drawings for *Notes on Tulip Species,* finally published in 1930, displayed a thorough knowledge of tulip anatomy as well as an affinity with nature. Katherine Dykes knew her subject well and executed the drawings with great botanical accuracy. Unfortunately, her career in botanical art was shortened by her untimely death.

OPPOSITE: *Devoted to her husband and his work with tulips and irises, Katherine Dykes was an excellent artist with a keen eye for detail—no doubt enhanced because she herself was an ardent grower of tulips.*

THE NEWS OF THE SUDDEN AND TRAGIC DEATH OF MRS. W. R. DYKES ON THURSDAY, MAY 25, CAME AS A TERRIBLE SHOCK TO THOSE WHO KNOW HER, AND ESPECIALLY TO THOSE WHO WERE AT THE CHELSEA SHOW, AND HAD SEEN HER IN THE MORNING OF THAT DAY. SHE WAS RETURNING TO HER HOME, BOBBINGCOURT, PYHE HILL, MAYFORD, WOKING, WHEN THE TRAIN IN WHICH SHE JOURNEYED FROM WATERLOO WAS INVOLVED IN AN ACCIDENT THAT RESULTED IN HER DEATH. SHE WAS ONE OF FIVE WHO LOST THEIR LIVES, AND TWO OF THE OTHERS BESIDES MRS. DYKES HAD VISITED THE CHELSEA SHOW. THE WIDOW OF THE LATE MR. W. R. DYKES, WHO WAS FOR SEVERAL YEARS SECRETARY OF THE ROYAL HORTICULTURAL SOCIETY—AND WHO LOST HIS LIFE IN EQUALLY TRAGIC CIRCUMSTANCES, FOLLOWING INJURIES RECEIVED IN A MOTOR ACCIDENT—MRS. DYKES WAS AS INTERESTED IN THE CULTIVATION AND THE NOMENCLATURE OF TULIPS AND IRISES AS HER HUSBAND. MANY SEEDLINGS SHE HAD RAISED WERE BROUGHT BY HER TO THE FLOWERING STAGE, AND SHE VERY SUCCESSFULLY CONTINUED THE WORK HE HAD BEGUN UNTIL ALL KEEN LOVERS OF TULIPS AND IRISES FOUND THEIR WAY TO BOBBINGCOURT WHILE THOSE PLANTS WERE IN FLOWER. A HANDSOME AND GIFTED LADY, SHE EDITED THE BOOK ENTITLED *NOTES ON TULIP SPECIES* THAT HER HUSBAND HAD IN PREPARATION AT THE TIME OF HIS DEATH. NOT ONLY SO, BUT SHE ILLUSTRATED THE BOOK WITH FIFTY-FOUR COLOURED PLATES, ALL DRAWN AND COLOURED BY HERSELF. MANY IRIS LOVERS RECEIVED INVITATIONS TO VISIT BOBBINGCOURT DURING THE EARLY DAYS OF THE PRESENT WEEK, BUT ALAS "THE LADY OF THE IRISES" HAD PASSED FROM HER GARDEN, NEVER TO RETURN.

FROM KATHERINE DYKES'S OBITUARY IN *GARDENERS' CHRONICLE,* 3 JUNE 1933

And flowers—the fairy
peopled world of flowers,

Though now the dust has
set that glory free;

Coloring the cowslip with
the sunny hours,

And penciling the wood
anemones:

Silent they seem—yet each
to thoughtful eye

Glow with mute poesy!

FELICIA HEMANS

Sydenham Edwards
(1769–1819)

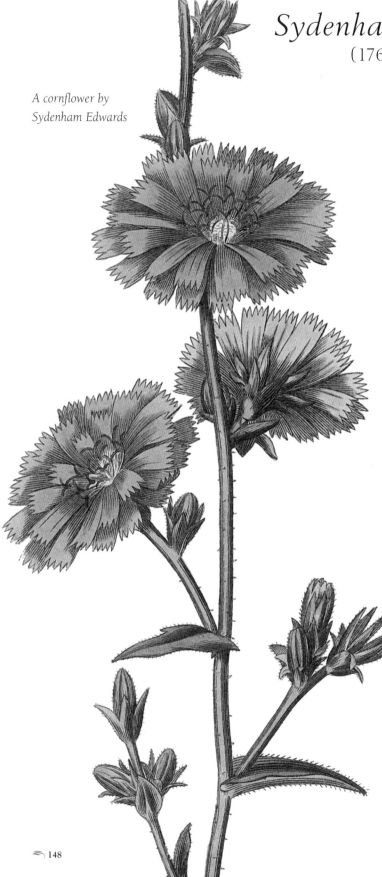

A cornflower by Sydenham Edwards

Sydenham Edwards was born in Monmouthshire, England, the son of a schoolmaster. In his early years he copied floral pictures from books. By chance, a friend of William Curtis (recorded only as "Mr. Denman") saw Edwards's sketches and was so impressed that he had the boy brought to London, where he was instructed in botanical art.

In 1788, Edwards executed his first drawing for *Curtis's Botanical Magazine;* for the next twenty-seven years, he rendered color-plate drawings for the periodical. In 1815, after a misunderstanding with Curtis, Edwards left the magazine and started a rival publication, *The Botanical Register.*

Edwards's greatest contribution was the seventeen hundred plates he did for *Curtis's Botanical Magazine.* He also did a single plate for Robert John Thornton's famous book *Temple of Flora,* published in 1799, and did drawings of animals for countless publications.

Edwards was a respected and quite competent illustrator, with a keen knowledge of plants. Though never blessed with the brush of genius, his work became increasingly skilled over the years. Some of his later drawings for the book *Flora Londinensis* (1817–28) show a winning combination of decorative and botanical art, enhanced by a talented use of color. (For more about Sydenham Edwards, see pages 36–38.)

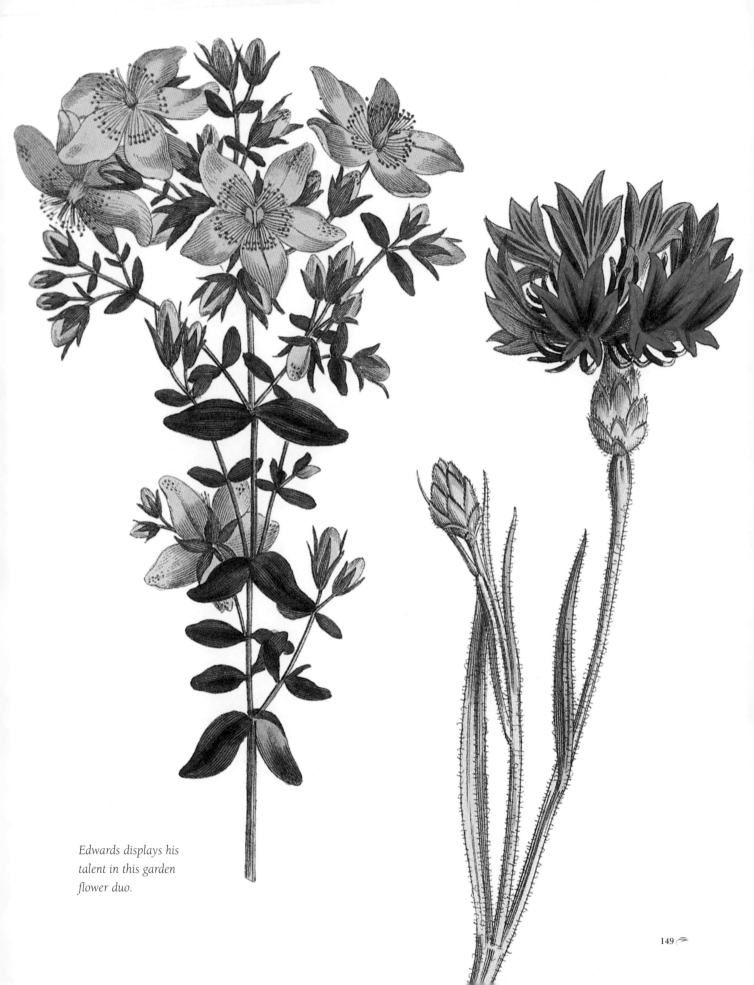

Edwards displays his talent in this garden flower duo.

Georg Ehret
(1708–1770)

Born in Heidelberg, Germany, Georg Ehret grew up surrounded by gardeners, including his father, who also taught him how to draw. When his father died, Ehret was apprenticed to an uncle, also a gardener; his mother remarried another gardener.

Ehret went into service for the Margrave Karl III Wilhelm of Baden, a great patron of plants who had established extensive gardens around his palace. Ehret excelled as an apprentice gardener, attracting the jealousy of fellow workers. The resulting dissension led Ehret to leave in 1726. He then worked for Johann Wilhelm Weinmann, an apothecary who engaged Ehret to do one thousand plant paintings in one year's time. By year's end, however, Ehret had only five hundred paintings completed; he and Weinmann argued, and Ehret broke the agreement.

Ehret then worked for a banker named Loeschenkohl, drawing plants in his garden and coloring about eight hundred engravings from *Hortus Indicus Malabaricus,* a twelve-part compendium of plants of Indian origin published in Holland. Ehret spent five years working on the first three parts of the work. He eventually went to London, armed with many letters of introduction, including one to Sir Hans Sloane, president of the Royal Society, and another to Philip Miller, one of the greatest gardeners of his time.

Ehret met the famous Swedish botanist Carl Linnaeus, and was commissioned to do the drawings for Linnaeus's description of the many exotic plants in the garden of George Clifford, a rich banker from Amsterdam. This publication, *Hortus Cliffortianus,* was published in 1737.

In 1736, Ehret returned to England, where he spent the rest of his life. The Duchess of Portland became his patroness, and he did several drawings for Sir Hans Sloane for the periodical *Transactions of the Royal Horticultural Society.* He also gave drawing lessons to the wealthy. In 1750 he was appointed curator of the Oxford Botanic Gardens, though the vagaries of institutional politics disgusted him and he quickly resigned the post. In 1757 he was made a fellow of the Royal Society.

In his later years, Ehret's eyes started to fail, but he was still able to execute incredible drawings. With a sure hand, he put great vigor into his paintings. He was excellent at designing plates, which he made bolder by his use of cross-line hatching, and was proficient at sketching. Although Ehret lacked Redouté's grace and delicacy, he was still one of the greatest botanical artists of his time.

Ehret's most important engraved works were for his own *Plantae et Papiliones Rariores* (1748–59) and for Dr. Trew's *Plantae Selectae* (1750–73).

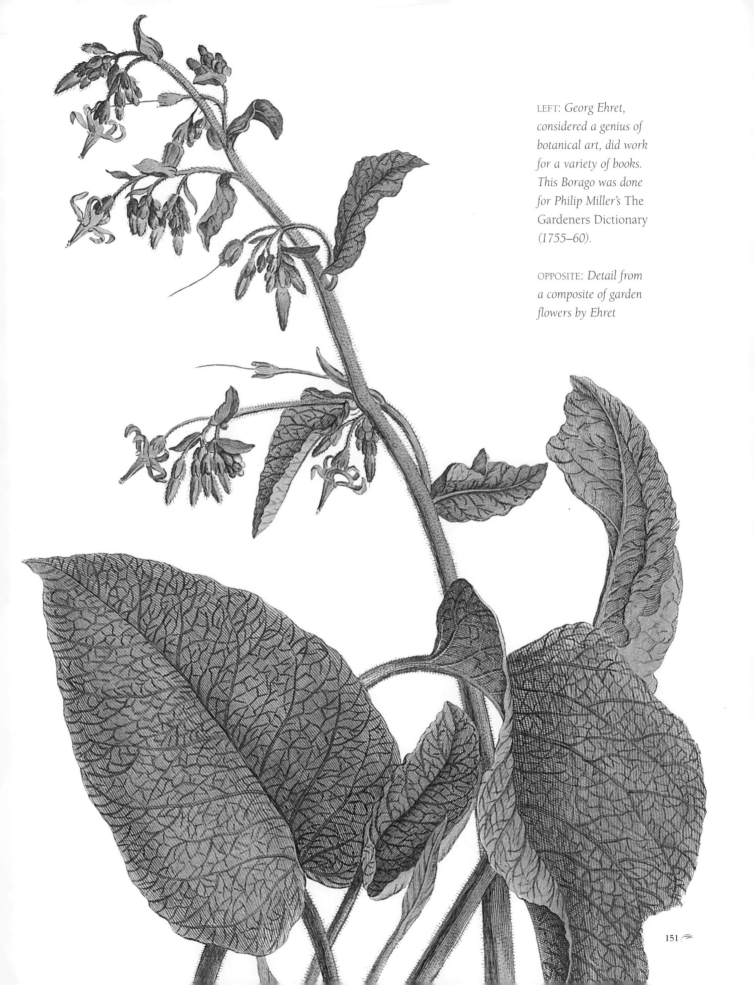

Walter Hood Fitch
(1817–1892)

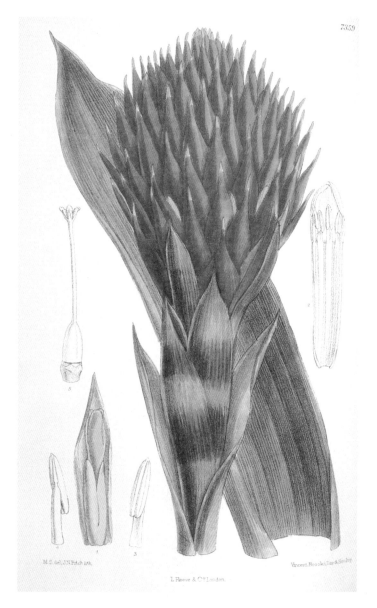

Much has been written about Walter Hood Fitch, the outstanding botanical artist of his era. Some have criticized his work, saying that it is overcrowded and filled with garish colors. To me, his drawings are miraculous for their form, design, and color. And although he may have occasionally sacrificed botanical accuracy for beauty, Fitch was for the most part true to his subjects.

Though originally an apprentice to a textile pattern drawer and a landscape painter, Fitch's heart was always with flowers. He was a fast sketch artist with an amazing ability to memorize the structure of a plant.

After Sydenham Edwards left *Curtis's Botanical Magazine,* Sir William Jackson Hooker did the magazine's illustrations until he met Fitch, who rendered its illustrations from 1834 until 1877. Fitch also illustrated a score of books.

Fitch was a lithographer who drew on stone in fine detail. His illustrations were mainly small in format, to fit the size of the magazine. Like many great artists, he was a master of sketching and used the negative space on the plate to emphasize certain parts of his subjects: The flower, rather than any other part of the plant, was always dominant.

By the time Fitch died in 1892, his reputation and fame were universal. His nephew John Nugent Fitch began executing the illustrations for *Curtis's Botanical Magazine,* and in many cases it is difficult to distinguish the work of the two artists. (For more about Walter Hood Fitch, see pages 99–103.)

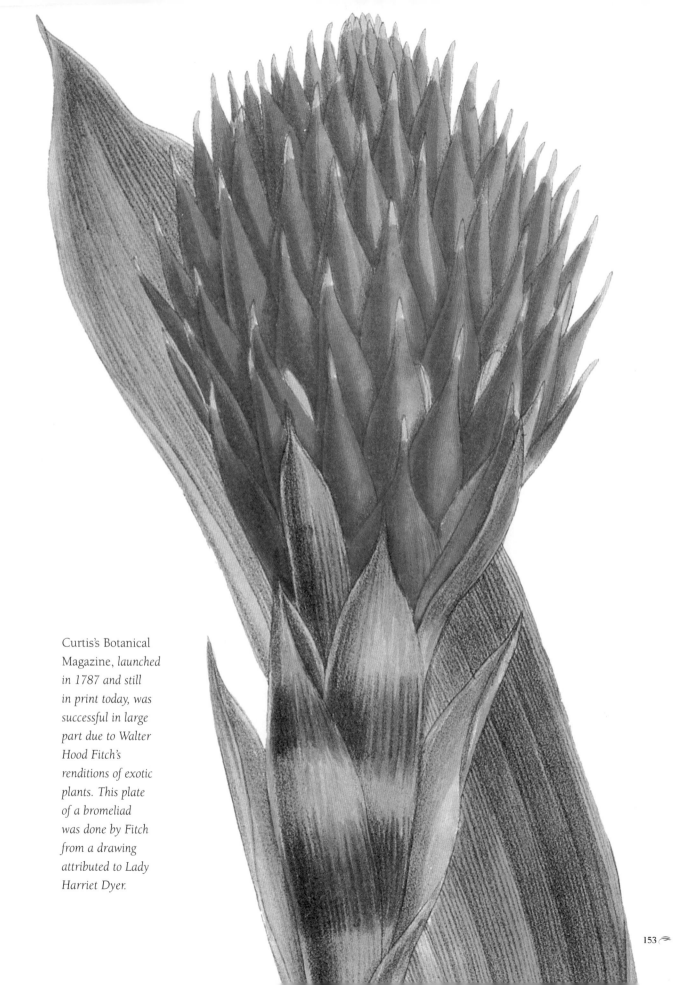

Curtis's Botanical Magazine, *launched in 1787 and still in print today, was successful in large part due to Walter Hood Fitch's renditions of exotic plants. This plate of a bromeliad was done by Fitch from a drawing attributed to Lady Harriet Dyer.*

Sir William Jackson Hooker
(1785–1865)

Sir William Jackson Hooker was born in Norfolk, England, the son of a clothmaker's clerk whose hobby was collecting succulents and exotics. When Hooker turned twenty-one, he took nominal possession of a sizable estate at Kent, but continued his botanical work and was elected a fellow of the Linnaean Society of London. In 1812, he was married to Maria Turner.

In 1816 Hooker published *British Jungermanniae,* which was illustrated with his own drawings and was a great success. In 1820 he secured the position of professor of botany at the University of Glasgow, where he associated with botanists and explorers and published many works. In 1827 Hooker became editor of *Curtis's Botanical Magazine,* where several of his illustrations appeared, and in 1841 he became the first director of the Royal Botanic Gardens at Kew.

As director of Kew Gardens, Hooker's first moves were to open the gardens to the public and to establish an arboretum, museum, and library. More greenhouses were added and the magnificent Palm House was completed in 1848. Some years later, Hooker started the Temperate House; in 1848 he began the Museum of Botany, and another museum was built in 1857. When the King of Hanover's house became available in 1851, Hooker opened a library and herbarium there.

Hooker's published works include *Flora Scotica* (1821), a new edition of William Curtis's *Flora Mondinesis* (with G. Grave; no date available), four editions of *British Flora* (1830–38), and *Flora Boreali-Americana* (with R. K. Greville, 1827–31). His interest in ferns led to an additional five volumes published between 1838 and 1862. It is estimated that, in total, Hooker published more than eight thousand plates of plants, eighteen hundred or more from his own drawings. When he died in 1865, Hooker's youngest son, Sir Joseph Dalton Hooker, succeeded him at the Royal Botanic Gardens. (For more about Sir William Jackson Hooker, see page 33.)

Sir William Jackson Hooker was responsible for many floral publications, and furnished more than six hundred plates to Curtis's Botanical Magazine. *Here are two details from his rendition of Aquilegia.*

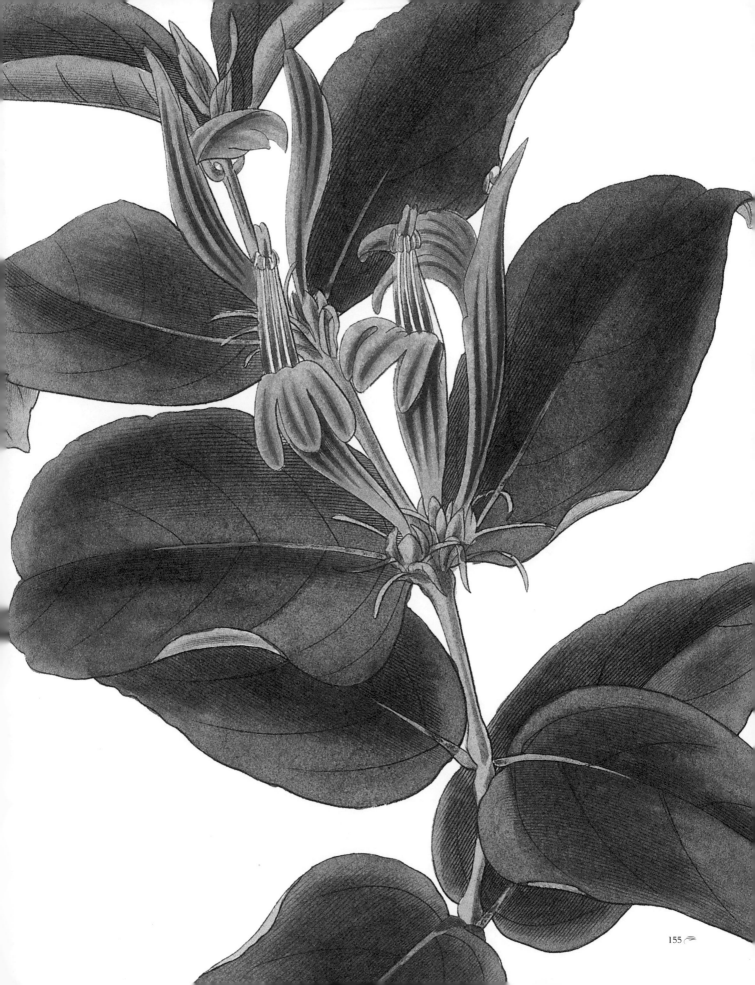

Jane Webb Loudon
(1807–1858)

Jane Loudon was a woman's garden writer; her books directly targeted women of her time, a niche almost completely empty until she came along. Loudon believed that clear instructions would enable any lady to master gardening, and indeed, her easy-to-understand style and sound knowledge of the subject made her writings instantly popular. Loudon's publications included *Young Ladies Book of Botany* (1838), *Gardening for Ladies* (1840), *Botany for Ladies* (1842), *The Ladies Magazine of Gardening* (1842), and *The Ladies Companion to the Flower Garden* (1840–44). In 1855 she published *My Own Garden*, a small book for young adults that was a masterpiece of gardening know-how:

Children should have their gardens in an open airy situation, with plenty of light and air; partly because few plants will grow under the drip of trees, and consequently the difficulty of keeping the garden nice is greatly increased, and partly because it is unhealthy for children to work in a garden in a close damp situation. The garden should also be in a good light soil, to lessen the labour of digging. Another point to be considered is to contrive the garden so as to have it contain as many different things as possible. Children like to have their gardens constantly producing something to keep up their interest, and to realize that feeling of ownership so delightful to everyone, and particularly so to a child. I once heard a little boy say: "Those lettuces are my own, out of my own garden, and I grew them for mamma," with an expression of intense enjoyment that I have never forgotten, though many years have since rolled over my head, and the boy has become a man.

Prior to being a published artist, Loudon had spent many hours with her husband, John Claudius Loudon, a famous horticulturist, working in their garden and learning flower structure and form. She became a superior gardener as well as her husband's amanuensis, helping him with his great *Encyclopedia of Gardening* (1834).

When her husband died at the age of sixty, Loudon was only thirty-five years old and needed to support herself. The result was her brilliant four-volume work, *The Ladies Companion to the Flower Garden*, which covered perennials, annuals, bulbous plants, and greenhouse plants.

Loudon's unique gift was portraying mixed garden flowers; her brilliant sense of composition, and her use of light and color, are what make her illustrations special.

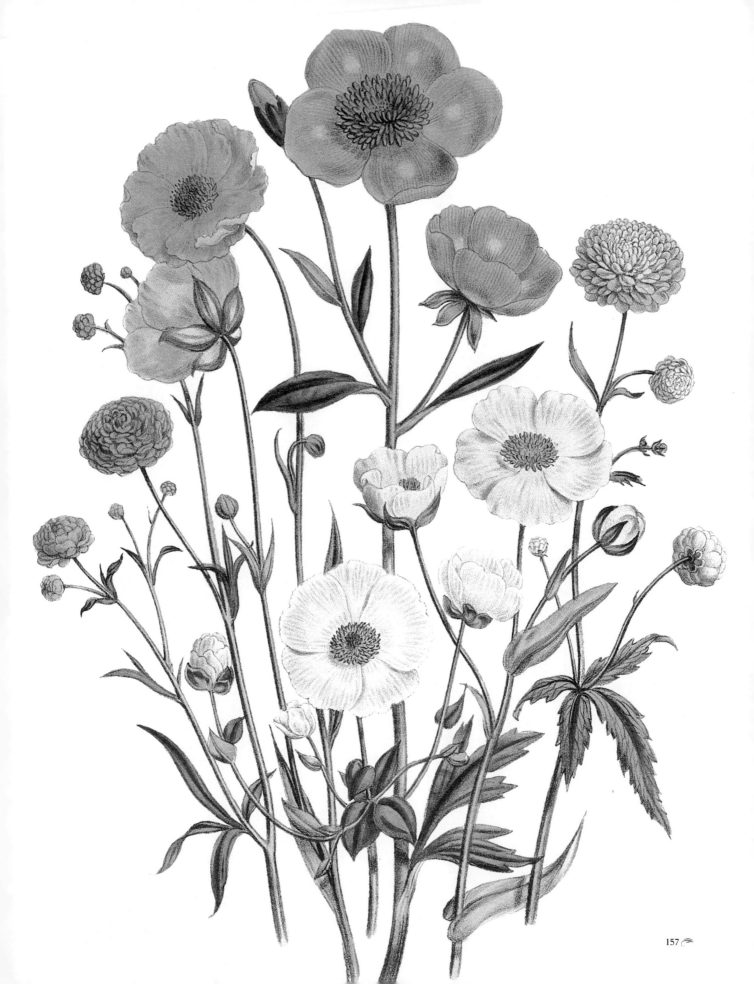

The Misses Maund
(fl. 1800s)

Benjamin Maund, a druggist and bookseller by trade, was also the author of the thirteen-volume *Botanic Garden* and the five-volume *The Botanist*, both published during the 1820s and 1830s. These periodicals owed their popularity to the exquisite and charming drawings done by his daughters, Eliza Maund and Miss S. Maund (no first name available). The sisters' styles were amazingly similar; one almost wonders if they were one and the same person.

Little is known of Maund's daughters other than that they were educated in botany. Both had a fine eye for floral detail and an inherent talent for color. Although the Misses Maund were never given credit for their work, they can now be acknowledged for the glorious beauty of their drawings.

Other women worked for Benjamin Maund as well. For *The Botanist*, for example, he employed Mrs. Edward Bury, Miss Mintern, Miss Nicholson, Miss Hall, and Augusta Withers. The five-volume set is chock-full of brilliant botanical illustrations, making it a collector's item today.

Miss S. Maund did these charming portraits of garden flowers: Sphenogyne speciosa (below left), Solanum etuberosum (below right), *and* Paeonia Russi (opposite).

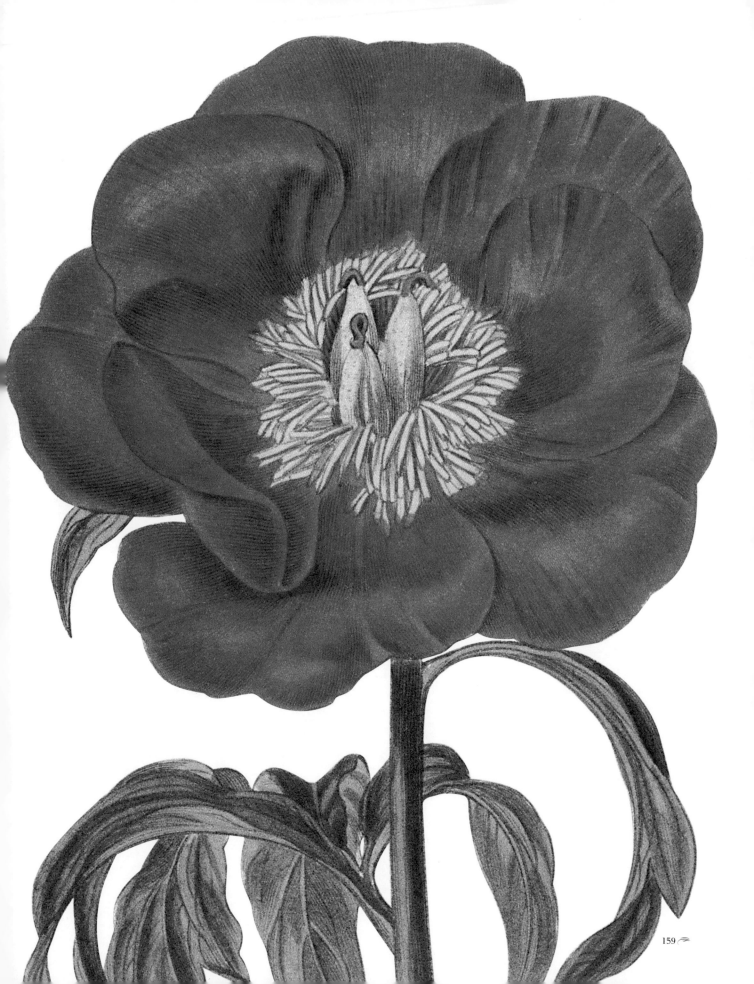

Frederick Polydore Nodder
(d. 1800)

Frederick Polydore Nodder was the botanical painter to Queen Charlotte and exhibited at the Royal Academy. Although a competent botanical artist, he is little known and his work remains underrated. He drew or engraved plates for Erasmus Darwin's *Botanic Garden* (1789) and Thomas Martyn's *Flora Rustica* (1791–95), and worked on *Letters on the Elements of Botany Addressed to a Lady* by J. J. Rousseau, translated by Thomas Martyn (third edition, 1812). Nodder also did his own *Vivarium Naturae* (1790–1813), with George Shaw.

In about 1772, Nodder was commissioned by Sir Joseph Banks to produce drawings from sketches made by Sydney Parkinson, a brilliant artist known for his travels with Captain Cook on the round-the-world voyage of the *Endeavour,* who had died the year prior. Nodder was no Parkinson, but his drawings are botanically accurate, and his plates for Martyn's *Flora Rustica* are quite handsome, drawn more for identification purposes than for decorative beauty.

RIGHT: *Frederick Nodder shows fine detail work in this picture of a shrub.*

OPPOSITE: *Although generally overlooked as a botanical artist in his time, Nodder was highly skilled, as shown by this illustration of a dictamus garden flower.*

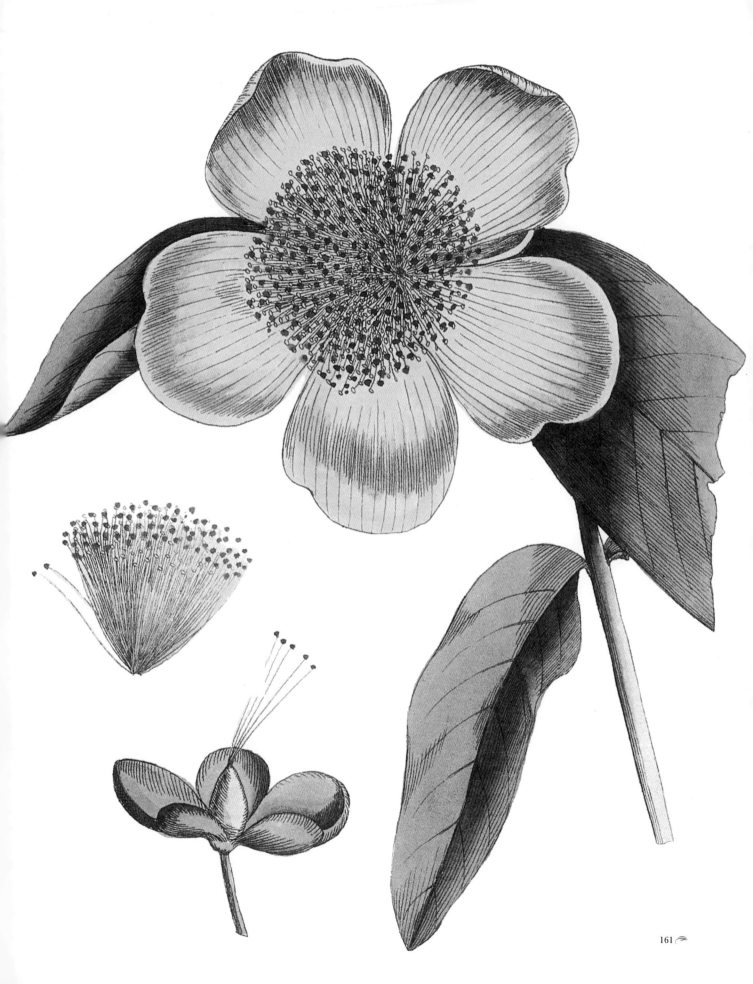

Anne Pratt (née Peerless)
(1806–1893)

Anne Pratt was not only a fine botanical illustrator, but also a fine writer who expressed her floral thoughts and gardening wisdom in homespun style. A frail girl, she had devoted her time from childhood to study; a Scottish friend of the family, Dr. Dodds, helped teach her botany and she took to it instantly. One of Pratt's sisters collected woodland flowers, as many young ladies of the time did, and these helped sharpen her botanical knowledge, later proving valuable in her botanical drawings.

Pratt worked diligently to have her books published; in 1828 she saw her first book, *Flowers and Their Associations*, printed to moderate success. But it was her book *Wild Flowers of the Year*, published in 1857, that turned Pratt into a household name when it garnered praise from Queen Victoria. The book's title page proclaimed that it was intended to promote Christian knowledge, as becomes evident in the following excerpt:

OPPOSITE: *Anne Pratt was well known in her day as a talented artist, and is still regarded as such today. This drawing shows foxgloves and snapdragons.*

> *Never was there a time when the direction of our Saviour to "Consider the lilies" was more willingly followed than now; and knowing well that the love of Nature is a great means alike of mental improvement and of happiness, the Author rejoices in contributing in any way to its diffusion. In endeavouring to illustrate, both by pen and pencil, some of our commonest Wild Flowers, she has had much to render the occupation agreeable. It is in itself a pleasant toil; and while she has been cheered, on the one hand, by the approval of the highest Lady of the land—our beloved and revered Queen—it has been no small gratification to know, that some in lowliest life have read these simple details with profit. More than one case has been made known to her, in which some have gone forth into the fields at the close of the day of toil, with this book in hand, and taught to their wives and little ones the names and uses of many of those flowers which hitherto they had, perhaps, classed under the general name of weeds. If they have gained one new idea of grace and beauty, or have learned one lesson of the great truth, that "God is love," this little book will not have been written in vain.*
> *—Dover, April 1857.*

Although Pratt was a prolific writer, producing several books, it wasn't until 1849 that she began one of her most extensive and well-known works, *The Flowering Plants and Ferns of Great Britain* (1850–57), a monumental and hugely successful five-volume compendium of knowledge that remains as useful today as when it was first published.

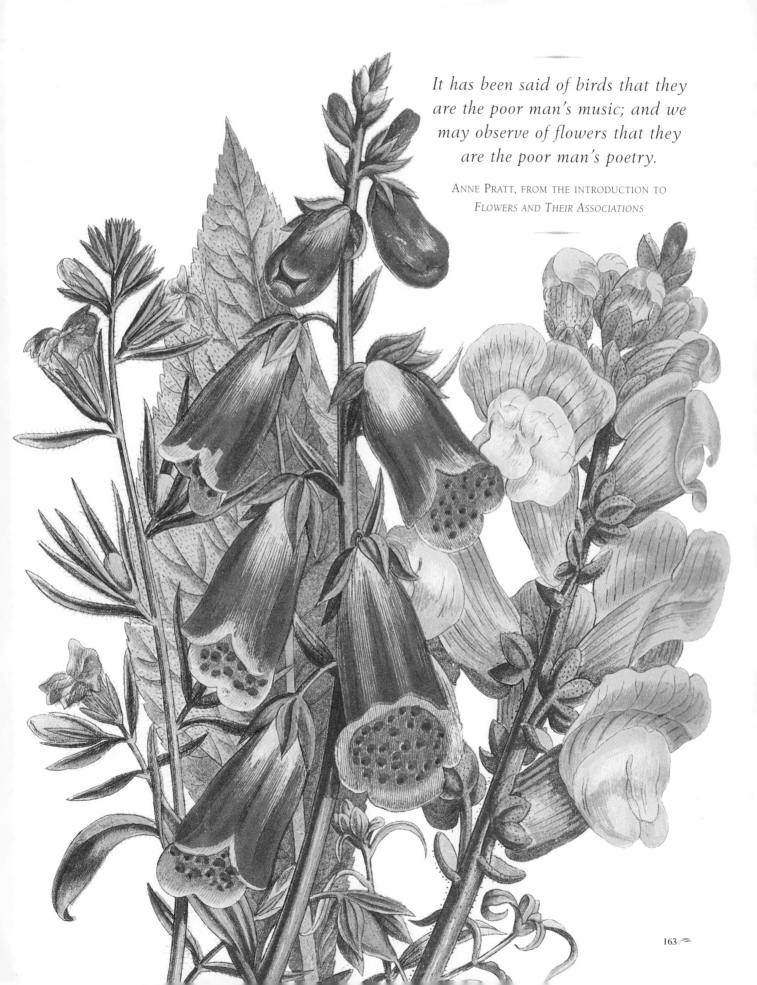

It has been said of birds that they are the poor man's music; and we may observe of flowers that they are the poor man's poetry.

ANNE PRATT, FROM THE INTRODUCTION TO
FLOWERS AND THEIR ASSOCIATIONS

Pierre-Joseph Redouté
(1759–1840)

Born in St. Hubert, Belgium, Pierre-Joseph Redouté came from a long line of painters, including his father, the famous Charles Joseph Redouté. At thirteen, he began traveling through Belgium and Holland, and studied painting for one year.

In 1782, Redouté joined his brother in Paris, where he began frequenting the Jardin du Roi to study its exotic flowers. He also attended lectures by the Dutch artist Gerard van Spaendonck, the respected professor of floral painting at the Louvre. Redouté became van Spaendonck's pupil, learning his craft as well as how to deal diplomatically with royalty. In 1787, the botanist Charles Louis L'Héritier persuaded Redouté to join him in Spain; later, in London, L'Héritier and Redouté collaborated on *Sertum Anglicum* (1788), which explored the rare plants at Kew.

In London, Redouté met some of the great engravers of the time and learned to print in different colors from the same plates, quickly recognizing how the process could enliven floral art. He then returned to Paris, where he was appointed drawing master to the cabinet of Marie Antoinette and flower painter of the Trianon gardens. Redouté's reputation grew as he added watercolors to his collection of work on vellum. From 1798 on, Redouté was involved mainly with books printed in color.

Through L'Héritier, Redouté met Jacques Martin Cels, the owner of a famous garden of exotic plants in Paris. Cels wanted the plants illustrated for his book *Description de plantes Nouvelles et peu connues, cultivees dans de Jardin J. J. Cels*; the book was published with Redouté's illustrations in 1800. Redouté also did illustrations for Cel's *Choix de Plantes . . . dans le Jardin de Cels*.

Detail of Mesembryanthemum (aloe), by Pierre-Joseph Redouté (see also page 24)

In 1798, Joséphine Bonaparte, an admirer of Redouté's work, hired the naturalist Bonpland to re-create in the gardens of Malmaison the environment she had enjoyed during her childhood in the French West Indies. These gardens' large display of roses would inspire Redouté's drawings in Étienne-Pierre Ventenat's *Jardin de Malmaison* (1803). When Napoleon made Joséphine empress in 1804, she bestowed on Redouté the title of Official Painter to the Empress. Redouté reached the pinnacle of his fame with his great multi-volume *Les Liliacées* (1802–16) and *Les Roses* (1817–24). He was now known as the "Raphael of flowers."

When van Spaendonck died in 1822, Redouté was appointed successor to his chair at the Jardin du Roi; students flocked to him. But though Redouté's fame continued, his financial affairs faltered and he eventually had to sell off most of his possessions. At eighty-one, while working on a floral masterpiece, he suffered a stroke. Redouté died June 19, 1840. (For more about Redouté, see pages 124–29.)

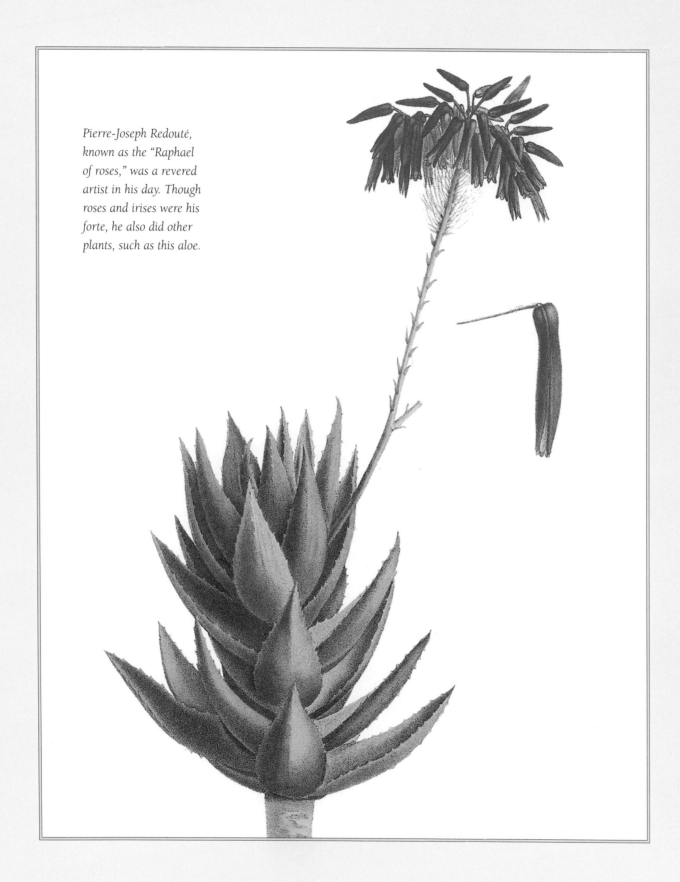

Pierre-Joseph Redouté, known as the "Raphael of roses," was a revered artist in his day. Though roses and irises were his forte, he also did other plants, such as this aloe.

James Sowerby
(1757–1822)

James Sowerby came from a family of artists, growing to become perhaps the best known of the clan. He studied at the Royal Academy and was apprenticed to the marine painter Richard Wright. After exploring that genre and others, he finally chose floral illustration as his artistic vehicle.

In 1787, Sowerby came to the attention of William Curtis, who hired him to do drawings for *Curtis's Botanical Magazine;* many plates in the magazine's first four volumes are Sowerby's. With the publication of the book *English Botany* in 1790, Sowerby's fame spread, mainly because Sir James Edward Smith, who had provided the text, gave Sowerby sole credit for the publication. Sowerby went on to illustrate Smith's *Exotic Botany,* published in 1804.

While Sowerby was working on *English Botany,* he was also producing fine drawings for Smith's *Icones Pictae Plantarum Rariorum Illustratae* (1790–93), William Aiton's *Hortus Kewensis* (1789), and two of his own works, *An Easy Introduction to Drawing Flowers According to Nature* (1788) and *Flora Luxurians* (1789–91). Along with Redouté, Sowerby also contributed to L'Héritier's *Geraniologia,* published in 1792. This massive amount of work proved too much to manage in addition to his work for *Curtis's Botanical Magazine,* and Sowerby curtailed his association with Curtis.

In addition to his botanical pursuits, Sowerby was an ardent student of zoology, shells, and mineralogy. He raised a large family; two of his three sons became artists, and two of his four grandsons and a great-grandson became botanical draftsmen. (For more about James Sowerby, see page 131.)

James Sowerby's illustrations for Exotic Botany, *by Sir James Edward Smith, include superior plant portraits, such as this one of a common red poppy.*

Pierre Jean François Turpin
(1775–1840)

Pierre Jean François Turpin came from a humble background, yet today is considered one of the finest French botanical illustrators of his time. It is said that he attended a good art school in his hometown of Vire; other sources claim he was generally self-taught. At an early age, Turpin met an accomplished botanist, Pierre-Antoine Poiteau. Together, Turpin and Poiteau would collaborate on many works. In 1801, through Poiteau, Turpin became acquainted with the German explorer and naturalist Baron Friedrich Alexander von Humboldt.

Turpin also worked with other great botanical artists of his time, though most of these efforts remain unheralded. Turpin himself is mostly known for François-Pierre Chaumeton's thirteen-volume *Flore Medicale,* to which he contributed hundreds of especially fine botanical prints. He also worked with Poiteau and Redouté on Carl Kunth's *Nova Genera et species Plantarum* (1815–25), Jacques J. H. de la Billardière's *Nova Hollandiae* (1801–7), and Pierre-Étienne Ventenat's *Choix de Plantes* (1803–8)—all exquisite volumes.

Turpin's work shows the influence of both Redouté and the famous botanical artist Gerard van Spaendonck. Turpin's gift was his ability to convey the grace and beauty of a plant with accurate botanical detail. He had an amazing facility to remember what he'd seen in his studies of Redouté's drawings and van Spaendonck's techniques. When Turpin died in 1840, well respected and revered, the world mourned the passing of a great talent.

Here, François Turpin illustrates the bromeliad ananas.

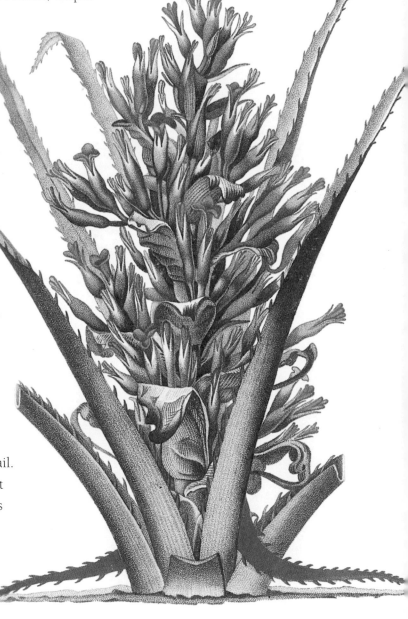

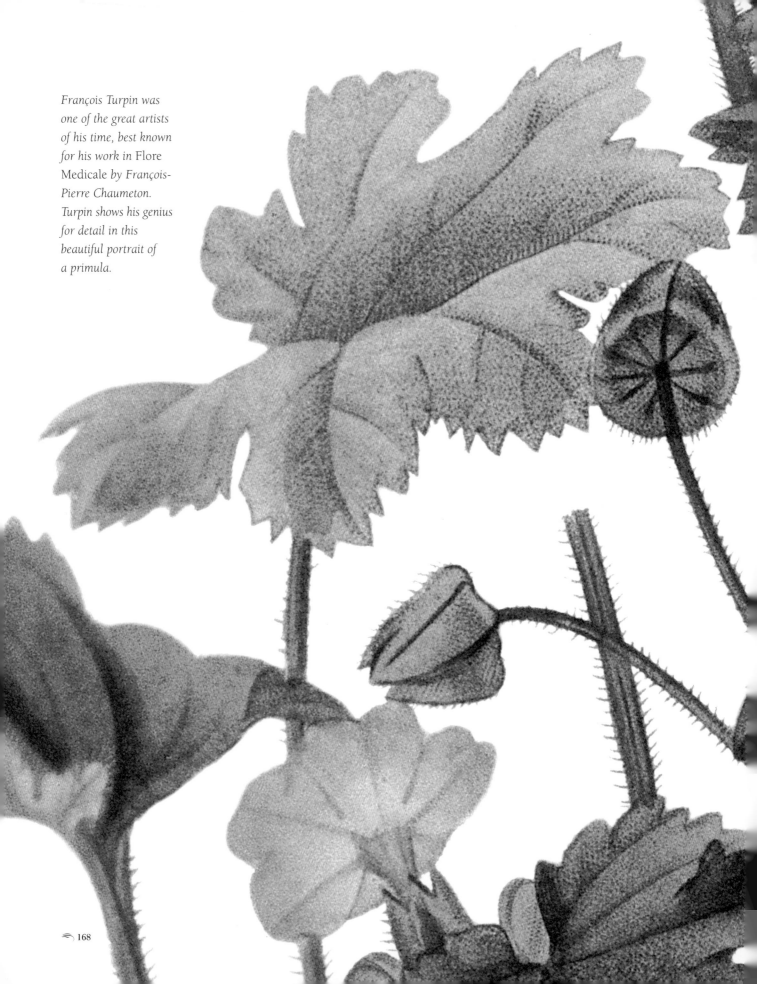

François Turpin was one of the great artists of his time, best known for his work in Flore Medicale by François-Pierre Chaumeton. Turpin shows his genius for detail in this beautiful portrait of a primula.

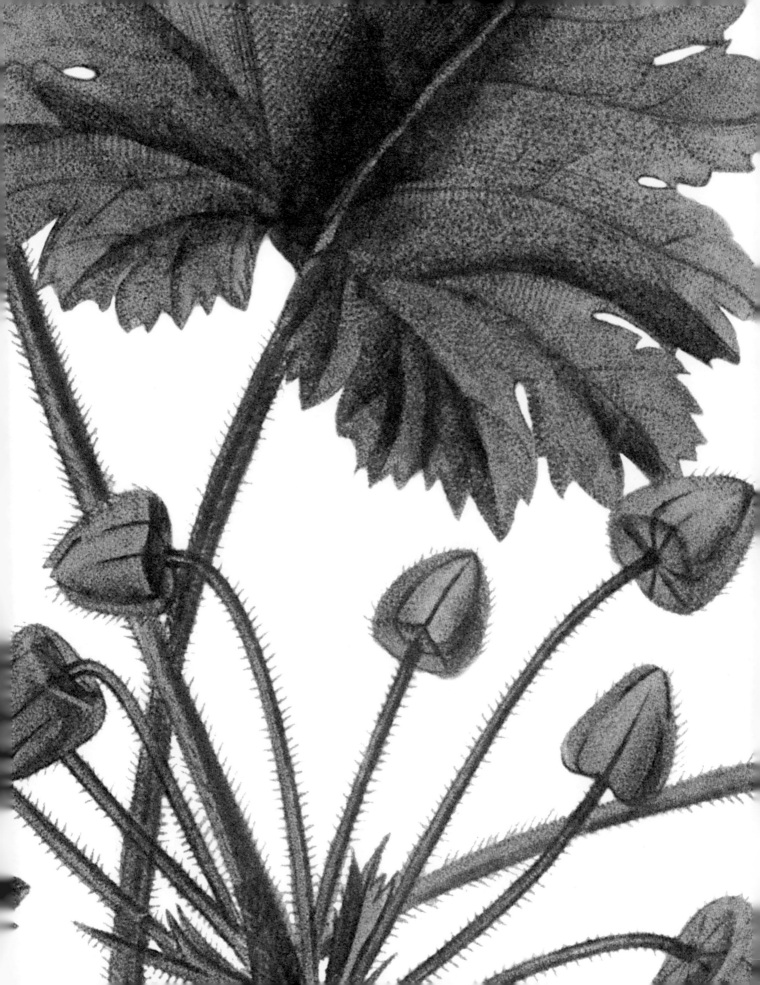

Augusta Withers
(1792–1869)

Augusta Withers, Painter in Ordinary to Queen Adelaide, was a prolific artist who contributed to scores of botanical tomes. She is best known for the dozens of orchid drawings she did for James Bateman's *The Orchidaceae of Mexico and Guatemala,* (1837–43). She also contributed more than one hundred plates to Benjamin Maund's *The Botanist* (1836–42). Withers exhibited at the Royal Academy from 1829 to 1846, as well as with the New Watercolour Society.

Withers probably gained her knowledge of flowers first hand, gardening at her Grove Terrace home. Her work for *The Orchidaceae of Mexico and Guatemala* displays a great flair for color and for depicting the orchids as botanically correct.

To be able to draw flowers botanically and fruit horticulturally . . . is one of the most useful accomplishments of you ladies of leisure living in the country. It is due to Miss Withers of Grove Terrace to state that her talents for teaching these objects are of the highest order. . . .

John Loudon, *The Gardener's Magazine,* 1831

Portulaca Thellusonii

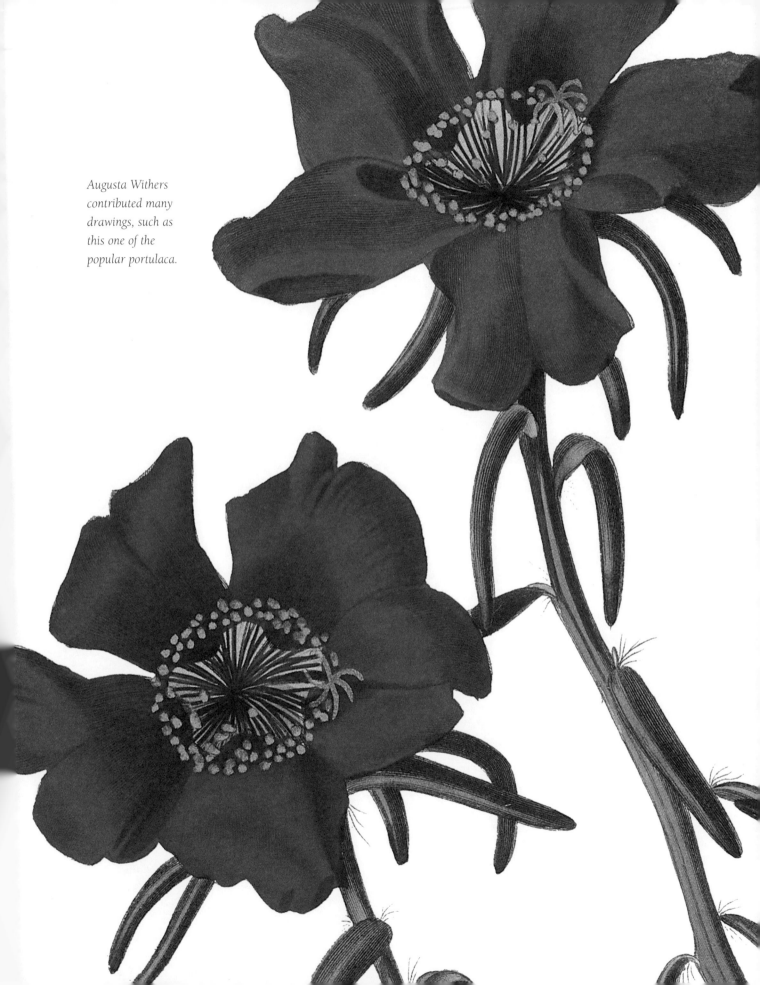

Augusta Withers contributed many drawings, such as this one of the popular portulaca.

Bibliography

Adams, Henry Gardiner. *The Language and Poetry of Flowers*. Philadelphia: Lippincott, 1866.

Anderson, Frank J. *An Illustrated Treasury of Cultivated Flowers*. New York: Abbeville Press, 1980.

Arber, Agnes. *Herbals. Their Origin and Evolution. A Chapter in the History of Botany*. Cambridge, England: Cambridge University Press, 1912; reprinted 1938, 1953, 1987.

Badger, Clarissa W. Munger. *Floral Belles from the Greenhouse and Garden*. London: n.p., 1867.

Barber, Lynn. *The Heyday of Natural History, 1820–1870*. New York: Doubleday, 1980.

Biddle, Moncuse. *A Christmas Letter*. Philadelphia: Biddle & Co., 1945.

Blunt, Wilfred. *The Art of Botanical Illustration*. London: Collins, 1950. Reprinted 1994, W. T. Stearn, Antique Collector's Club.

———. *Tulipomania*. Harmondsworth, England: Penguin Books, 1950.

Bridson, Gavin D. A., Donald E. Wendel, and James J. White. *Printmaking in the Service of Botany*. Pittsburgh: Hunt Institute for Botanical Documentation, 1986.

Buchanan, Handasyde. *Nature into Art*. London: Weidenfield and Nicolson, 1979.

Calmann, Gerta. *Ehret: Flower Painter Extraordinary*. Boston: New York Graphic Society, 1977.

Catlow, Agnes. *Popular Field Botany*. London: Reeve, Benham and Reeve, 1848.

Coats, Alice M. *The Book of Flowers*. New York: McGraw-Hill, 1973.

———. *Flowers and Their Histories*. London: Hulton, 1956.

———. *The Treasury of Flowers*. New York: McGraw-Hill, 1975.

Coats, Petra. *Flowers in History*. New York: Viking Press, 1970.

Comstock, J. L. *The Flora Belle, Gems from Nature*. New York: Magnos, n.d.

de la Tour, Charlotte. *Le Langage des Fleurs*. Paris: n.p., 1819.

Desmond, Ray. *A Celebration of Flowers: Two Hundred Years of Curtis's Botanical Magazine*. London: Kew Gardens and Collingridge Books, 1987.

———. *Dictionary of British and Irish Botanists and Horticulturists*. London: Taylor & Francis, 1994.

Dunthorne, Gordon. *Flower and Fruit Prints of the 18th and Early 19th Centuries*. Washington, D.C.: self-published, 1938.

Dykes, W. R. *Notes on the Tulip Species*. London: Herbert Jenkins, 1930.

Elliot, Brent. *Treasures of the Royal Horticultural Society*. London: Herbert Press, 1994.

Fennell, James. *Drawing Room Botany*. London: Joseph Thomas, 1840.

Hepper, F. Nigel, ed. *Kew: Gardens for Science and Pleasure*. Owings Mills, MD: Stemmer House, 1982.

Hey, Rebecca. *The Moral of Flowers*. London: Longman, 1835.

Hulme, F. Edward. *Flower Painting in Water Colours*. London: Cassell and Co., 1884.

Kramer, Jack. *Botanical Orchids and How to Grow Them*. London: Garden Art, 1998.

———. *Growing Orchids at Your Window*. New York: Van Nostrand, 1967.

———. *Growing Orchids Indoors*. New York: Barnes and Noble, 1999.

———. *Women of Flowers*. New York: Stewart, Tabori & Chang, 1996.

———. *The World Wildlife Fund Book of Orchids*. New York: Abbeville, 1989.

Lee, Mrs. R. *Trees, Plants, Flowers*. London: Griffith and Farran, 1759.

Leonard, Elizabeth. *Painting Flowers*. New York: Watson-Guptill Publications, 1986.

Lewis, Jan. *Walter Hood Fitch: A Celebration*. London: HMSO, 1992.

L'Héritier, Charles Louis. *Sertum Anglicum* (facsimile), George Lawrence Edition. Pittsburgh: Hunt Institute for Botanical Documentation, 1963.

Mallary, Peter and Frances. *A Redouté Treasury: 468 Watercolours from Les Liliacées of Pierre-Joseph Redouté.* London: J. M. Dent, 1986.

Martyn, Mrs. S. T. *The Ladies' Wreath.* New York: Martyn and Miller, 1846.

McIntosh, Charles. *The Flower Garden.* London: William Orr, 1838.

———. *The Greenhouse.* London: William Orr, 1840.

———. *The New and Improved Practical Gardener.* London: Thomas Kelly, 1860.

McTigue, Bernard. *Nature Illustrated.* New York: Abrams, 1989.

Metropolitan Museum of Art. *Metropolitan Flowers.* New York: Abrams, 1982.

Mille et un Livres Botaniques de la Collection Arpad Plesch. Brussels: Arcade Publishing, 1973.

Nesbit, Ethel. *Flower Painting.* Glasgow: Blackie & Son, n.d.

Nissen, Claus. *Die Botanische Buchillustration.* Stuttgart: Anton Hiersemann, 1966.

Norwood, V. *Made from This Earth: American Women and Nature.* Chapel Hill: University of North Carolina Press, 1993.

Osgood, Frances Sargent Locke. *The Poetry of Flowers.* New York: J. C. Riker, 1841.

Pascal, Antoine. *Redouté's Blumenmalerkunst,* translated from the French *L'Aquarelle ou les Fleurs Peintes d'apres la Methode de M. Redouté* by "an admirer of flower painting art." Leipzig: Quedlinburg amd Leipzig, 1839.

Plesch, Antoine. *Library of the Stiftung für Botanik.* Brussels: Arcade, 1973.

Pratt, Anne. *Flowers and Their Associations.* London: Charles King and Co., 1840.

Pritzel, G. A. *Thesaurus Literaturae Botanicae.* Leipzig: Brockhaus, 1851.

Rix, Martyn. *The Art of the Plant World.* Woodstock, NY: Overlook Press, 1981.

Scourse, Nicolette. *Victorians and Their Flowers.* Portland, OR: Timber Press, 1983.

Seaton, Beverly. *Language of Flowers: A History.* Charlottesville: University Press of Virginia, 1995.

Shoberl, Frederic, ed. *The Language of Flowers.* American edition, Philadelphia: n.p., 1836.

Sitwell, Sacheverell, and Wilfred Blunt. *Great Flower Books 1700–1900.* London: Collins, 1956. Reprinted 1990, New York: H.F.G. Witherby, Atlantic Monthly Press.

Smith, Bernard. *European Visions and the South Pacific 1786–1850.* London: Oxford University Press, 1960.

Sotheby's Magnificent Botanical Book. London: Sotheby's, 1987.

Stearn, William Thomas. *The Australian Flower Paintings of Ferdinand Bauer.* London: Basilisk Press, 1976.

———. *Flower Artists of Kew.* London: Herbert Press, 1990.

———, ed. *John Lindley.* London: Antique Collectors Club, 1999.

Stiftung für Botanik Library, three volumes. London: Sotheby's, 1975.

Swinson, Arthur. *Frederick Sander, the Orchid King.* London: Hodder and Stoughton, 1970.

Twamley, Louisa Anne Meredith. *Some of My Bush Friends in Tasmania.* London: Day & Sons, 1860.

Wakefield, Priscilla. *An Introduction to Botany.* London: Newberry, Darton and Harvey, 1796.

Waterman, Catherine H. *Flora's Lexicon: The Language and Sentiment of Flowers with an Outline of Botany.* Boston: Crosby and Ainsworth, 1856.

Wilkinson, Lady Caroline Catherine. *Weeds and Wild Flowers: Their Uses, Legends, and Literature.* London: John Van Voorst, 1858.

Wirt, Mrs. E. W. *Flora's Dictionary.* Baltimore: Lucas Bros., 1830.

Wunderlich, Eleanor. *Botanical Illustration in Watercolor.* New York: Watson-Guptill Publications, 1991.

Index

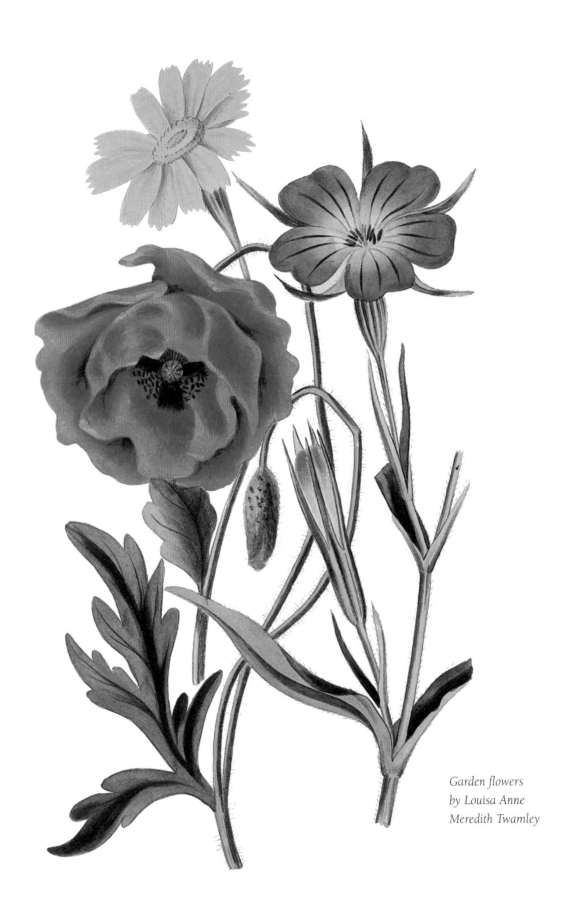

*Garden flowers
by Louisa Anne
Meredith Twamley*